JENSEN STERN
J·O·A·I·L·L·I·E·R
KETCHUM IDAHO USA

MASTERS OF THE MILLENNIUM

By Caroline Childers
and Roberta Naas

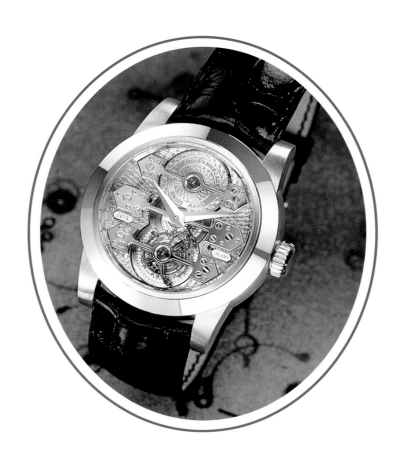

BW PUBLISHING ASSOCIATES, INC.
in association with

RIZZOLI
INTERNATIONAL PUBLICATIONS INC.

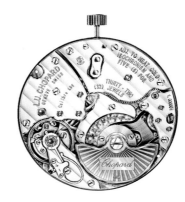

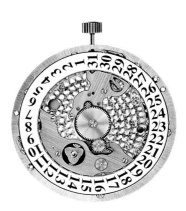

MASTERS OF THE MILLENNIUM

First published in the United States of America in 2000 by

Ms. Caroline Childers
And BW Publishing Associates, Inc.
11 West 25 Street, New York, NY 10010

In association with

INTERNATIONAL PUBLICATIONS INC.

300 Park Avenue South, New York, NY 10010

COPYRIGHT ©2000
BW PUBLISHING ASSOCIATES, INC.
ALL RIGHTS RESERVED
No part of this publication may be reproduced in any
manner whatsoever without prior permission in writing from
BW Publishing Associates.

ISBN: 0-8478-2276-1

LIBRARY OF CONGRESS CATALOG CARD NUMBER: 99-96164

Disclaimer: The information contained in *Masters of the Millennium*
has been provided by third parties. While we believe that these sources
are reliable, we assume no responsibility or liability for the accuracy of
technical details contained in this book.

Every effort has been made to locate the copyright holders of materials in
this book. Should there be any errors or omission, we apologize and shall
be pleased to make acknowledgments in future editions.

CHAIRMAN
Joseph Zerbib

CHIEF EXECUTIVE OFFICER AND PUBLISHER
Caroline Childers

PRESIDENT
Yael Choukroun

LOGO BY DANIELLE LOUFRANI

PRINTED IN HONG KONG

FRONT COVER
Longines movement, caliber 262
in 1968.

FRONT INSIDE FLAP
Longines DolceVita in 18K gold
with diamonds.

BACK COVER
Francillon skeleton in 18K yellow gold.

BACK INSIDE FLAP
Longines DolceVita Heritage
in 18K yellow gold.

TITLE PAGE
The Automatic Tourbillon with Three
Gold Bridges by Girard-Perregaux.

THIS PAGE
TOP
The LUC 1.96 movement by Chopard.

FACING PAGE
Men's watch housing the LUC
1.96 movement. Model in 18K yellow
gold with silvered "guilloché" dial.
Also available in platinum, rose
and white gold. Limited, numbered
series of 1860.

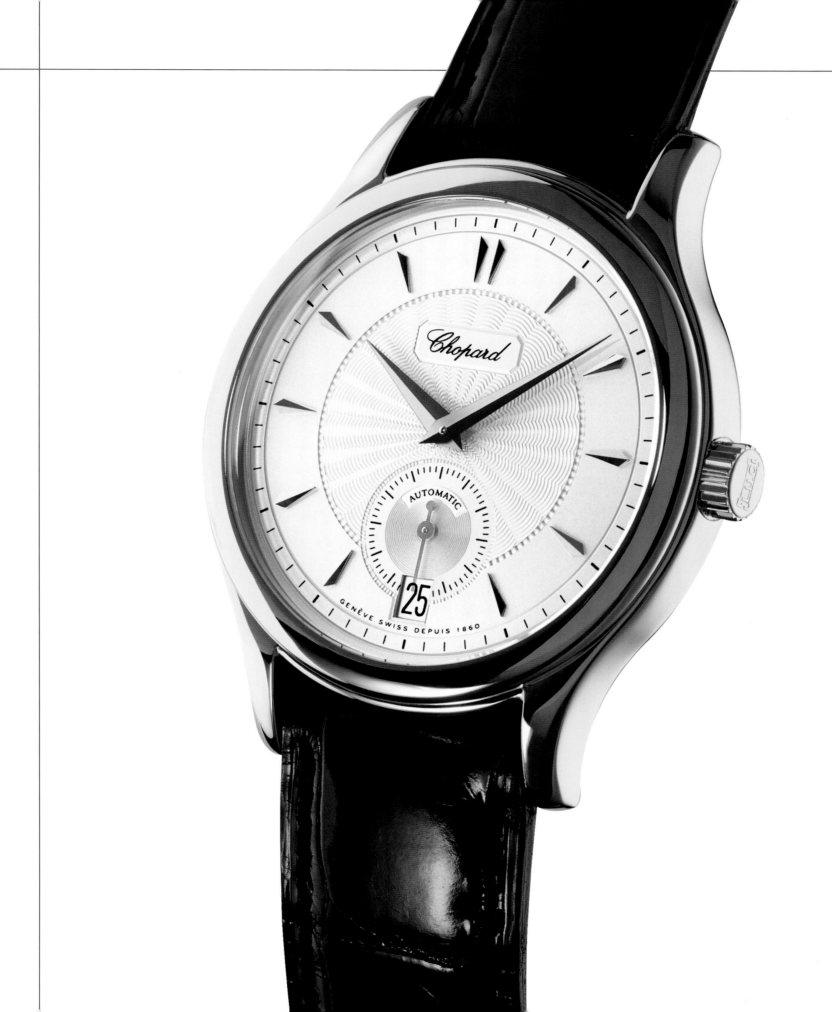

CONTENTS

Movement of the first Chopard pocket watch, 1860

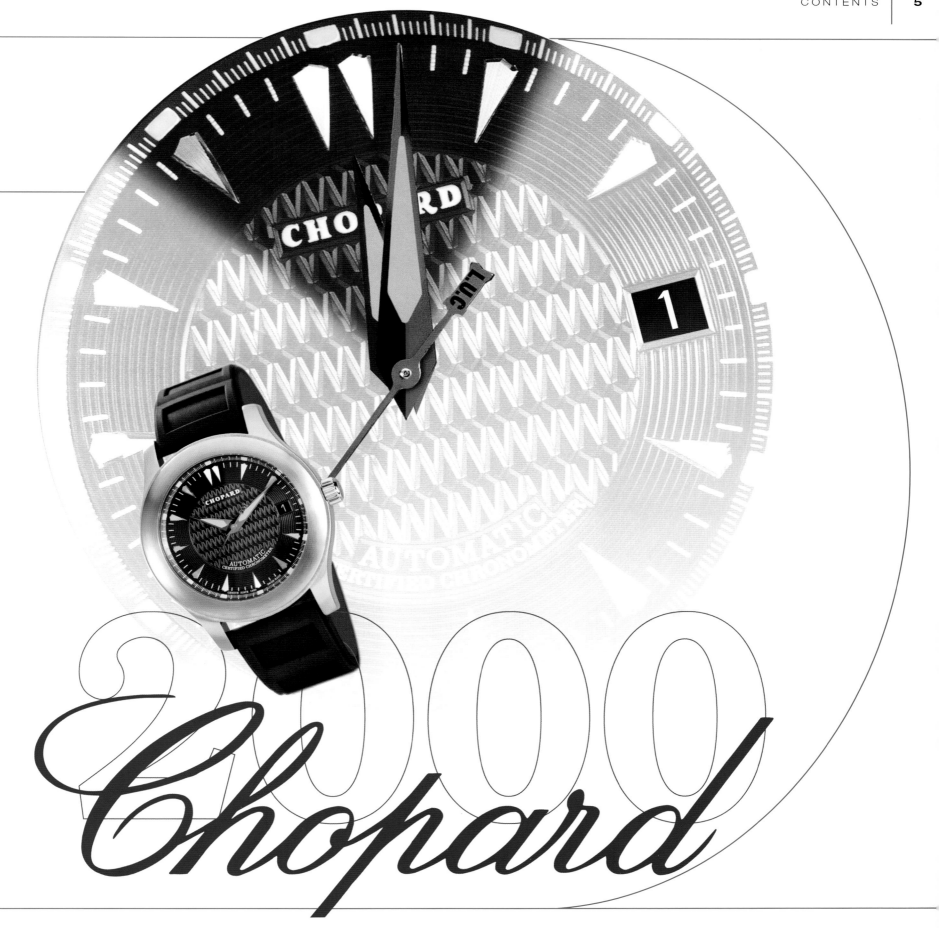

2000
Chopard

The watch is the perfect alliance between functionality and sophistication, between science and art. It is, in fact, one of the most fascinating inventions man has ever made. To infuse with beauty something so practical is nothing short of genius. ■ With the earliest sun dials dating back to ancient civilizations man began, millenniums ago, his quest to harness time. When we glance at our wrists and admire the sleek metallic gleam of a razor-thin face or the glitter of a bezel-set diamond case or the classic golden Roman numerals on an oversized face, we do not think of the enormous calculations and minute mechanical devices that lie underneath the beautiful facade. We take for granted that we are able to track time down to a split second. It is the watch's charms to which we are drawn. ■ The watchmaker is both artist and craftsman. He is an alchemist, infusing with life an otherwise inanimate object. The watch moves and changes and, further, takes note of the moments while we move and change. It is no wonder many people feel naked when not wearing their watches. ■ Perhaps no other accessory can claim the diverse array of styles the watch embodies. The watch transcends fashion trends, remaining, always, timeless. Today, there is a watch for every occasion. Elegant, diamond-laced bracelet watches march down the wedding aisle. Sporty, rubber-strapped, backlit divers' watches descend to the furthest depths of the ocean. There are business watches, everyday watches, formal watches, fun watches. And when we wrap a watch around our wrist we tell more than the time. We give away a bit about ourselves. We reveal something of our very essence.

CAROLINE CHILDERS

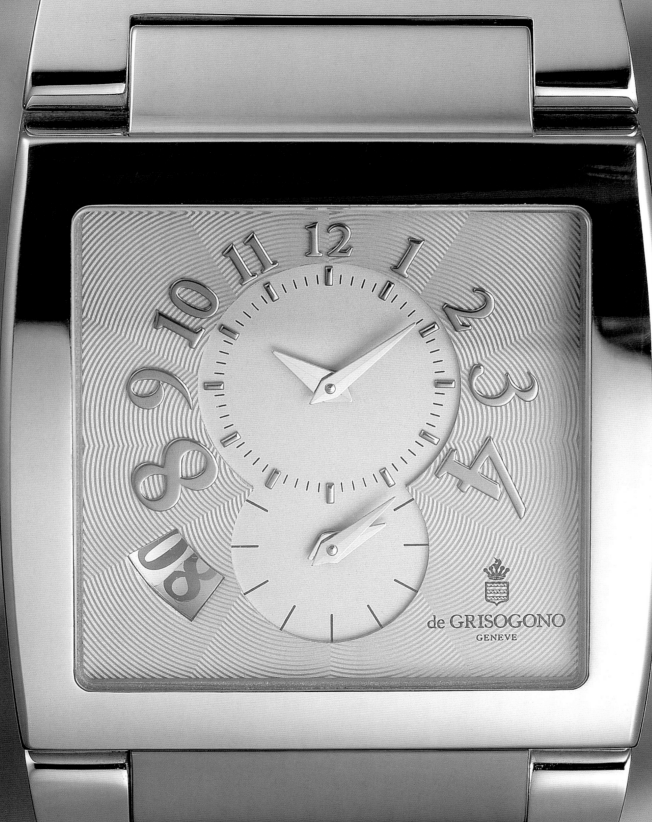

de GRISOGONO
GENEVE

his book could not have been produced without the assistance and kindness of many people who generously shared with us their knowledge of and experience with the watchmaking industry. We want to thank Mr. Peter Laetsch, President of the Federation of the Swiss Watch Industry of America, and his wife Sylvia for their enduring friendship and support. We want to express our gratitude to all the individuals and companies who devoted their time and patience: Mr. Maurice Altermatt of the Federation Horlogere; Mr. Olivier Bacher and Ms. Pauline Bochot from Audemars Piguet, Switzerland; Mr. Carol Tang from Audemars Piguet, New York; Mr. Christian Bedat, Mrs. Simone Bedat, Ms. Peggy Azrak from Bedat & Co., Geneva; Ms. Murielle Blanchard, Ms. Claudine Sablier, Ms. Sophie Brun, Mr. Jean Claude Le Rouzic, Mr. Alain Boucheron from Boucheron, Paris; Mr. Gerard Pichon-Varin, Ms. Kari Allen, Ms. Liz Thurber, Mr. Jason Baker from Boucheron, New York; Ms. Valerie Burgat from Breitling, Switzerland; Ms. Kimberly Grogan from Breitling, USA; Ms. Ann Walle from Cartier, New York; Ms. Caroline Gruosi-Scheufele, Ms. Annick Benoit-Godet, Mr. Karl Friedrich Scheufele from Chopard, Geneva; Mr. Thierry Chaunu, Ms. Béatrice de Quervain from Chopard, New York; Ms. Jeanne Massaro, Ms. Diana Moran, Mr. Harry Viola, Ms. Livia Marotta, Mr. John Rooney, Ms. Nancy Mendez-Booth, Ms. Debra Gibson from Movado Group for Concord, USA; Ms. Andrea V. Suriano from Daniel Roth, New York; Ms. Andrea V. Suriano from Gerald Genta, New York; Mr. Luigi Macaluso, Ms. Sylvie Rumo, Ms. Jaqueline Briggen from Girard-Perregaux, Switzerland; Mr. Ronald Jackson from Girard-Perregaux, USA; Ms. Linda Passaro, Ms. Missy Roxas from Hamilton, USA; Mr. Luigi Macaluso, Ms. Sylvie Rumo, Ms. Jaqueline Briggen from Daniel JeanRichard, Switzerland; Mr. Ronald Jackson, Ms. Tricia Power from Daniel JeanRichard, USA; Ms. Michele Reichenbach, Mr. Pascale Chamay, Mr. Fawaz Gruosi from de Grisogono, Geneva; Ms. Angela Arnaboldi, Mr. Gabriel Feuvrier from Kelek, Switzerland; Mr. Maurice Avenaim from Kelek, USA; Ms. Yolanda Perroulaz, Mr. Juan Carlos Capelli, Mr. Charles A. Villoz, Mr. Walter Von Känel from Longines, Switzerland; Mr. Michael Benavente, Ms. Janet Cerruti from Longines, USA; Mr. Herman Plotnik, Mr. Gerald Clerc, from Clerc New York; Ms. Jeanne Massaro, Ms. Diana Moran, Mr. Harry Viola, Ms. Livia Marotta, Mr. John Rooney, Ms. Nancy Mendez-Booth, Ms. Debra Gibson from Movado Group for Movado, USA; Mr. Michael Parmigiani, Ms. Sylvie Grass, Mr. Don Lucke, Mrs. Anne Bieler from Parmigiani, Switzerland; Ms. Barbara Bucheli, Ms. Sylvia Trummer, Mr. Franco Pizzi from Paul Picot, Switzerland; Mr. David Gouten from Perrelet, Switzerland; Mr. Christian Viros, Mr. Luc Perramond, Mr. Jean-Louis Poiroux, Mr. George Sarne, Ms. Sophie Valdmann from Tag Heuer, Switzerland; Mr. Giovanni Mattera from Gianni Versace, New York; Mr. Oscar G. Gonzalez from Gianni Versace, Geneva; Ms. Guiditta Mosetti, Mrs. Donatella Versace from Gianni Versace, Italy; Mr. Jean Siegenthaler from Editions Scriptar S.A. for the use of Watchmaking: History, Art and Science by Catherine Cardinal and Masterpieces of Watchmaking by Luigi Pippa.

This book required the careful attention of all those involved in its production: Mrs. Roberta Naas, Ms. Nicole Coppey, Ms. Natalie Warady, Ms. Cynthia Redecker, Ms. Gabrielle Pecarsky, Mr. Mark Goetz, Mr. Dennis Hayoun for his photographic expertise, Ms. Martha Hallett, Mr. John Brancati, Mr. Antonio Polito from Rizzoli International Publications who guided us through each phase of production. To my best friends The Frenchway Travel, who make my impossible "trip" possible — with passion. To my children and my family for their undying love and understanding.

CAROLINE CHILDERS

*Our most heartfelt and grateful thanks
is extended to our chairman,
Mr. Joseph Zerbib and his wife Diana,
a tireless source of strength who
supported and believed in us every step
of the way and with out whom*
MASTERS OF THE MILLENNIUM
would not be possible.

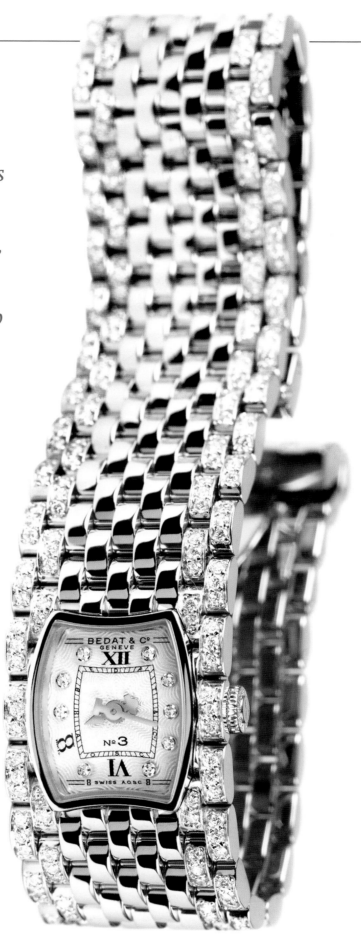

To my parents

. . . with all my love and gratitude.

RIGHT
Breitling's Chronomat GT displays an unmistakable precision-instrument dial face, which features totalizers accented by a raised circular frame that helps focus the eyes on accumulating minutes and hours during chronograph timing operations.

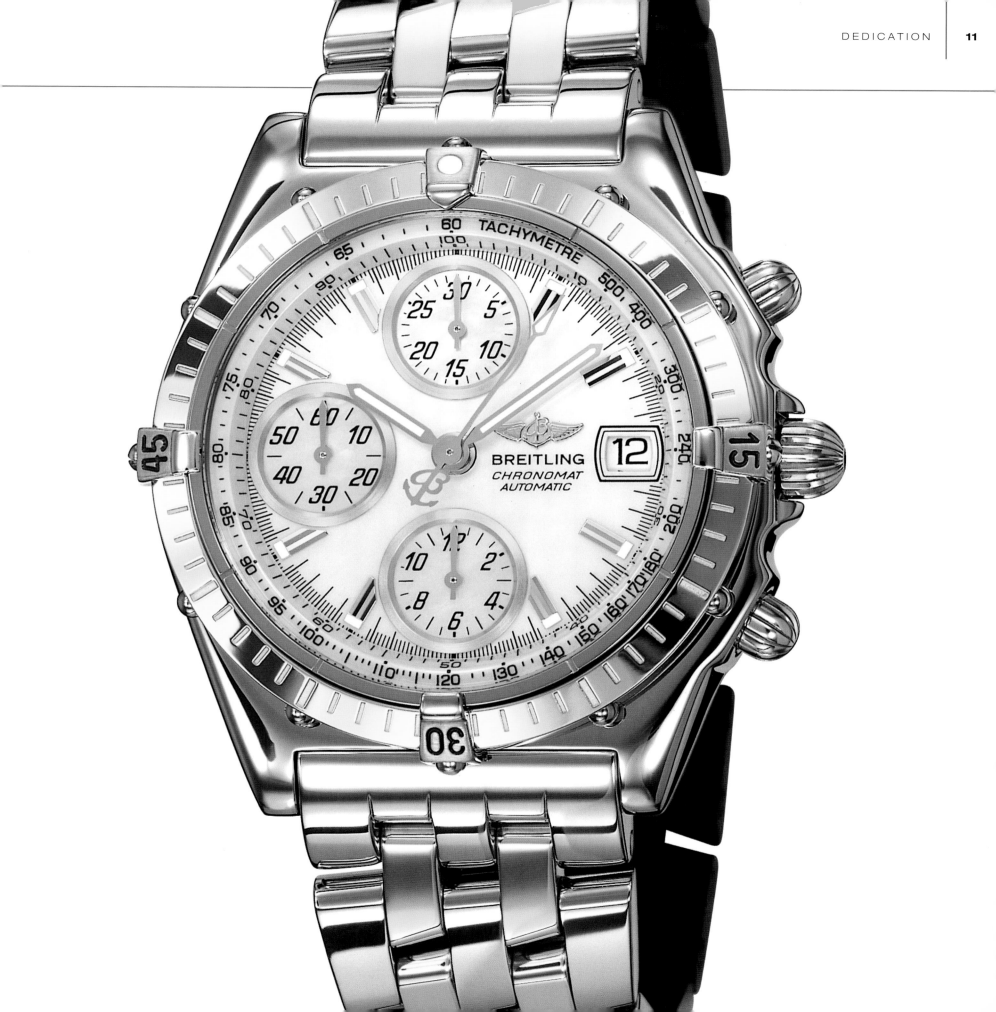

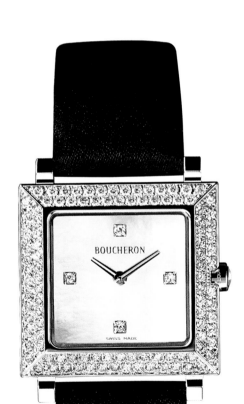

*B*oucheron watches don't just keep time. They create visions. These exquisite timepieces, in fact, are designed to appeal to the senses, evoking and igniting a vast range of emotions. There is, for example, the pleasure you get from touching the watch, the sensual feel of leather against skin, and the satisfying weight of the stainless steel or gold. Then there is also the visual delight you experience from seeing a beautiful piece of art, something akin to a Baudelairian-type vision where all is luxury and calm. ■ It is no wonder then that all our watches are made by jewelers. This means they are conceived and fashioned by skilled artists well versed in the mystery of precious stones and committed to producing only the highest caliber timepieces. Every Boucheron creation—from our priceless jewelry to our elegant watches and fine perfume—reflects the distinctive sensibilities of a firm totally committed to excellence and tradition. ■ Historically, we have produced exquisite timepieces for a select clientele. But it is during the last eight years that we've expanded the diversity our collection, while maintaining the Boucheron image of quality and exclusivity. Boucheron's reputation has been that of a well-renowned brand worldwide for more than a century. In the last decade, we've

begun to establish a more prominent position on this side of the Atlantic. The process began with our fragrance, which comes in a bottle shaped like a ring. Last fall—in time for the Millenium—we decided to raise our profile with the introduction of our two watch collections. Soon our elegant timepieces will be prominently displayed in exclusive stores throughout the United States. Both watch silhouettes—one rectangular, the other round shaped—are fashioned in the inimitable Boucheron style. The classic rectangular design has been part of our collection since 1947. Two years ago, I conceived the round scheme, inspired by Kandinsky's famous "Circle in the Square" paintings. All this came about as I was studying these playful circles and squares, and I suddenly realized the possibility of a watch design where circles and squares work together. This was quite a leap because circles and squares traditionally don't mix in watches. But I found a way to incorporate both in a single design. ■ What's common to all our timepieces is that they feature "godrons" on the surface, a series of indented contours modeled on the female form. They also offer interchangeable bands that enable them to take on new looks at a moment's notice. These bands conveniently detach at the case frame, giving the impression of a graceful unbroken line that follows the natural curve of the wrist no matter which band is selected. The end result of all this work is that our Swiss-made timepieces look more like jewelry than they do watches. Of course, this is not surprising, considering their provenance.

Alain Boucheron

ALAIN BOUCHERON

FACING PAGE
Boucheron watch "Diamant" with diamonds on white gold framing a mother-of-pearl face.

*S*ophistication and classic style are the most elegant transports of time—and these details are the essence of Bedat & Co. Each timepiece is carefully and precisely designed to reveal modern style that will appeal for generations. Just as a pocket watch continues to captivate, one hundred years after the wristwatch super-ceded it as the more practical choice, there are essential qualities in design that endure through innovation. At Bedat & Co., we select these characteristics to determine the look and design of the ChronoPocket — truly the first contempo-rary pocketwatch—and we are successfully conveying the spirit of early timekeeping in a manner that is attractive today. The ChronoPocket, for me, is a success for its innovation as well as the manner in which it embraces tradition. ■ More than ever in the watchmaking industry, image looms over product. This means that it is an exciting and challenging time to run a watch company. Not only does the product have to be good, its image has to be precisely defined and extremely well thought out. Since the moment we decided to create our own col-lection, we understood that each detail of every watch produced at Bedat & Co. must reflect the desires of those who wear timepieces as much as an object of pleasure as an essential item. It is this unique formula

that has granted us early success, and it is this same principle that will allow our industry to flourish. ■ As we contemplate the millennium, it is wondrous to consider how much has changed even while the definitions of elegance and sophistication remain the same. In the Swiss watchmaking industry, we take pride in knowing that future generations may wear our watches with the same pleasure as they are worn today. And in some instances, it may please us even more to consider that watches today would be prized by the earliest watchmakers.

CHRISTIAN BEDAT

"small cog in a huge machine" is how someone described the watch industry within the context of the world's total manufactured output. True enough. But not quite enough. For even with an aggregate production value of some ten to fifteen billion dollars, far less than the automotive or telecommunications industries for instance, the small cog is no less a strategic component for all that. After all, many of today's most advanced technologies rely on time bases developed by the time-products industry.

In Switzerland itself, watchmakers remain the country's third largest exporters. Their production today represents well over 50% of the total value of the industry's ex-factory sales worldwide. Leading this constellation is the Swatch Group's roster of more than 15 brands, covering the market from top to bottom, making it the world's leading single source of complete wristwatches.

Within the Group, Longines has a key role to play, as a producer and marketer of quality timepieces to discerning, forward-looking and value-conscious consumers across the world - men and women who appreciate the solid achievements of a brand born nearly 170 years ago.

As it enters the new millennium, the watch industry faces challenges both familiar and unfamiliar. They center largely on its products, the mechanical and quartz electronic timepieces so steadfastly - and successfully - improved over the past four centuries or so.

With mechanical watches, practically all of which feature a classic hands-on-dial display of the time, emotional values such as tradition and craftsmanship will surely continue to guide the consumer's choice. Further improvements to mechanical movements are, as I write, a self-fulfilling prophecy. As costs are compressed and processed streamlined ever further, quality can be expected to improve accordingly across the board. New or still-exceptional functions will become commonplace, provided by a variety of proprietary movements, often specifically finished and decorated.

Switzerland has invested hundreds of years of ingenuity and inspired craftsmanship in this area. Understandably, it intends to benefit from the increasingly widespread urge among consumers in more and more markets and walks of life to seek "something special". This we can, and enthusiastically shall, provide.

In the ever-expanding electronic sector of the industry, challenges focus for instance on bypassing the replaceable battery as a power source with such devices as the rotor-recharged accumulator and the solar cell and, even, further down the road, by harnessing the human body's own heat to power the watch - with impeccable ecological credentials.

Watches either all-digital or hybrid - i.e. with watch hands and discrete digital displays sharing the various functions between them - already exist of course. Over time, they should acquire a variety of other horological, communications and for instance geographic positioning capabilities, not to mentions computing and medical monitoring power.

Value-added wrist instruments of this kind naturally present attractive commercial possibilities, all the more so that, with every passing year, the street price of the basic all-electronic timepiece is being inexorably compressed by low-cost producers.

In all this, where does Longines stand? Solidly at the center of things. As a proudly traditional Swiss watch make, our company has a clearly defined role in the constellation. We are, quite deliberately, providers of value: a wide but manageable range of rationally conceived, high-quality timepieces, readily identified as such by the consumer and sold at fair-value prices. With Longines, we like to believe, you always get your money's worth. This is perhaps not quite as simple as it may sound. To start, it entails a careful selection of movements, both mechanical and quartz-piloted, with a thoroughly proven track record. It then demands a great deal of

thoughtful design and styling work to produce time-pieces with genuine, lasting market appeal.

Clarity of product profile is matched at Longines by clarity of the overall communication concept, of Longines' image to the world. From print advertising to sales literature to point-of-purchase material to public relations and sponsoring activities, Longines has come forward with a simple, clear, unambiguous and believable message: "Elegance is an attitude".

Our message makes its point this simply and this clearly above all for

one all-encompassing reason: there are something like six billion of us on this planet and, over the coming decades, practically all will be wearing or wanting a wristwatch. When you talk to every culture, every kind of mind-set the world has to offer, shouldn't we rejoice in a simple answer.

-"Longines?" -"Yes!".

Walter von Känel
President Longines

Longines DolceVita Heritage

RIGHT
Repeater watch by Concord indicates
the time for major cities in the
world. Activated by slide, repeater
mechanism strikes hours, quarter
hours and minutes.

O ne thousand years ago, time was measured with candles or water clocks. As the centuries passed, so too did timekeeping methods and timekeepers. Various countries emerged as leaders in watchmaking and technical prowess. ■ Halfway through this past millennium, Switzerland emerged as the preeminent country in the world of watchmaking, quickly taking on the task of developing portable clocks, portable watches, and, ultimately, wristwatches. Despite religious and world wars and financial and political havoc, Switzerland has maintained its premier position in the world of luxury watchmaking. ■ Now, poised at the turn of not only the century, but also the millennium, the watchmakers of this tiny country look back to past accomplishments and ahead to new frontiers. In *Masters of the Millennium*, we take a comprehensive look at the different categories of wristwatches mastered by these geniuses--exploring their rich pasts and their lucrative future. ■ The first chapter, Luxury and Technology, takes a close look at several distinguishable areas of watch design and technology. Such segments include the luxurious flora and fauna watches, whose inherent beauty transcends time. Diamond and gemstones—captivating since the dawn of man—are a watchmaker's favorite, and this chapter explores the allure and craftsmanship

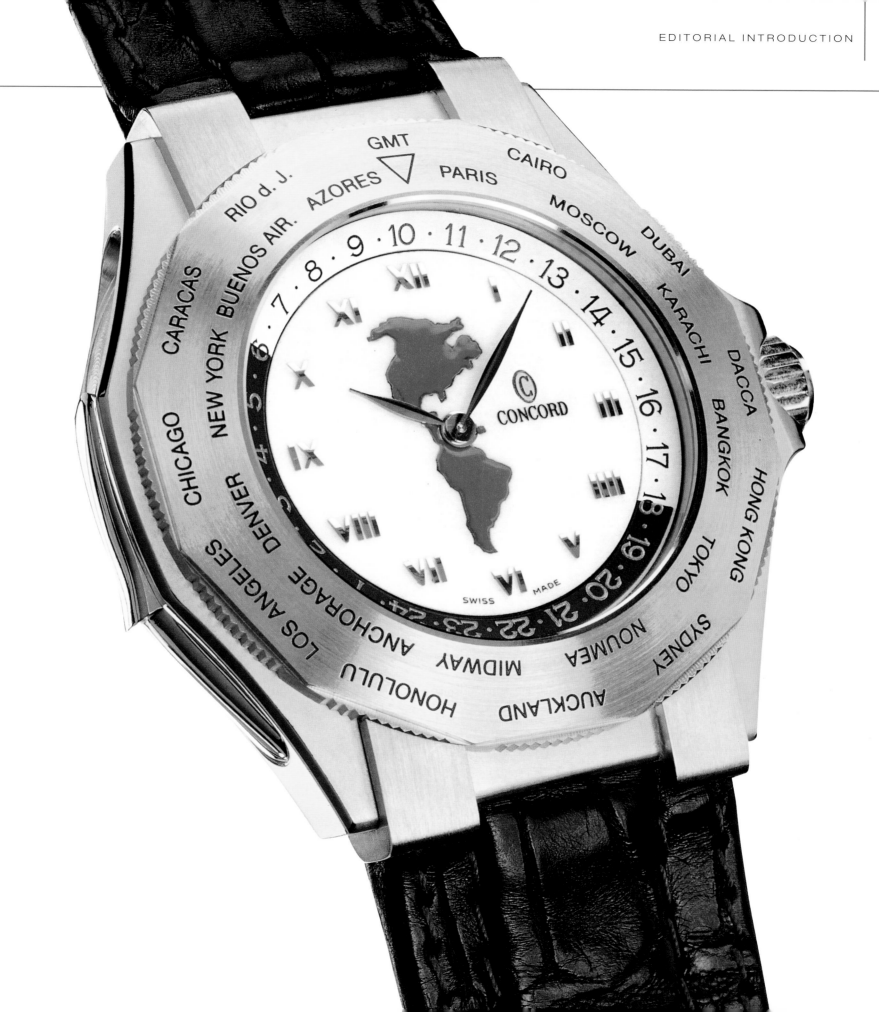

that is embodied in these masterpieces. ■ In terms of technological advancements and strides, this chapter also reviews the fine art of complicated watchmaking and of building perpetual calendars and moonphases that traverse the centuries. Finally, this chapter takes heed of the pervasive arena of split-second chronographs and chronometers—timepieces necessary in the hectic, fast-paced lifestyles we lead today. ■ Design and Fashion, the second chapter, gives insight into the crossover between the worlds of fashion, jewelry, and timepieces. Fashion has always influenced watch design; however, as watches themselves became all-important statements of image and personality in the last quarter of the twentieth century, fashion designers and jewelry houses alike took an avid interest in creating their own timepieces. This chapter reviews some of the design directions and elements of style that have propelled timepieces to new levels relating to fashion and lifestyle. ■ Last, but certainly not least, the final chapter, Future Masterpieces, looks to the fields of exploration and the watches that are made for them—dive watches that reach new depths and aeronautical watches that attain new heights. This chapter reviews the use of precious materials, such as natural fancy-colored diamonds and platinum, as watchmaking ventures into a new century. Similarly, it describes how other fields of technology have infiltrated the watch industry, bringing exciting high-tech materials such as titanium, ceramic, and carbon fiber to luxury timepieces. ■ This chapter also unveils some cutting-edge, new-millennium designs by individual watchmakers as well as some top watchmaking houses that are entering not just another century, but in some cases, their third century of existence. The designs of the first decade of the twenty-first century run the gamut from timepieces inspired by nostalgia to futuristic styles that make bold and individual statements. *Masters of the Millennium* pays homage not just to the heritage of watchmaking, but to the future of this all-important part of life: timekeeping.

Roberta Naas

ROBERTA NAAS

RIGHT
Patek Philippe's Annual Calendar self-winding wristwatch is the first of its kind — Caliber 315SQA automatic movement with day, date, month, sweeping seconds and a 24 hour indicator with luminous hands and numerals in an 18K yellow gold case.

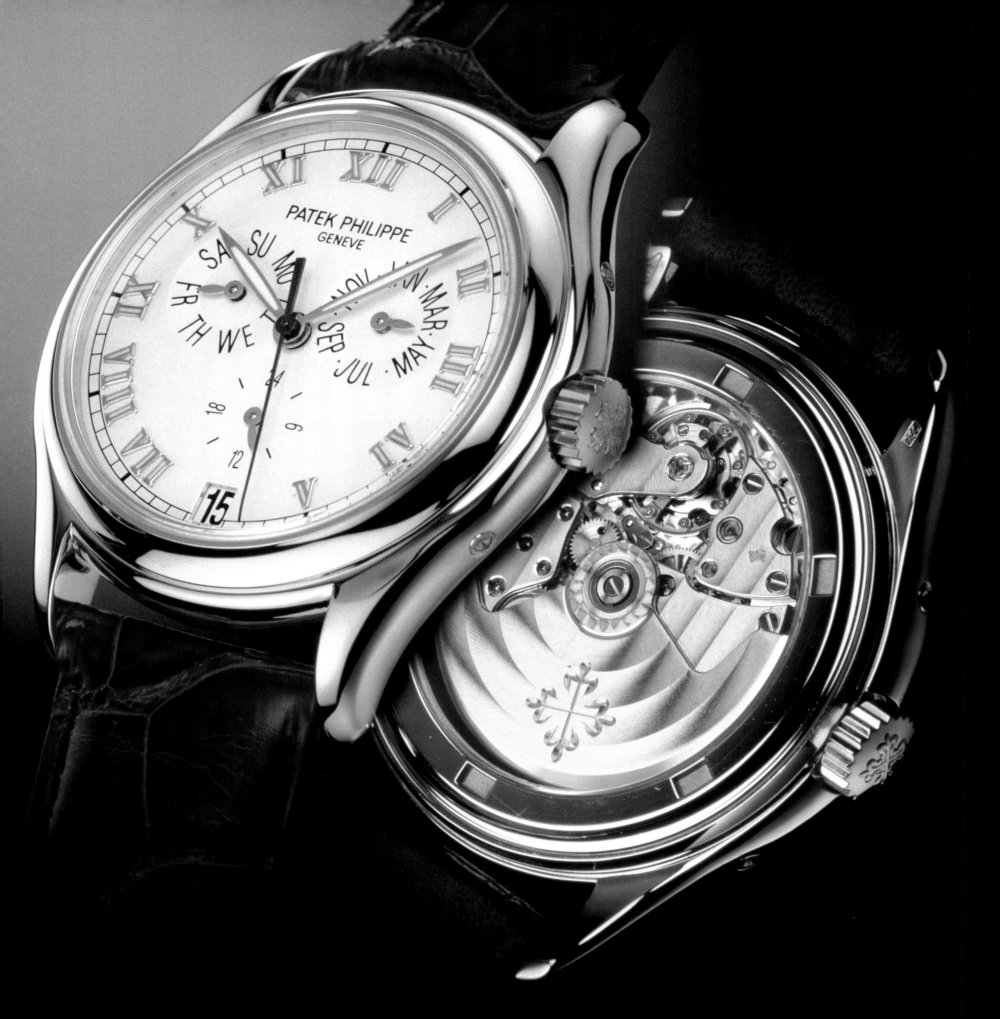

LUXURY & TECHNOLOGY

Time never simply passes by unnoticed — especially in the world of watchmaking. Over the centuries, incredible developments have been made in the realm of watch technology and design that bring a wealth of visually beautiful, technically advanced timepieces. ■ Watchmakers began embellishing watch cases almost at their inception with elaborate engravings, enameling, and even by adorning them with diamonds and gemstones. All of these design techniques have progressed over the centuries, and each is still utilized today by the finest watchmakers in the world, as they strive to offer interesting, luxurious craftsmanship indicative of their heritage. ■ Technology made leaps and bounds over the centuries, as well. Spring mechanisms led to pendulum mechanics, and later technology eventually brought automatic timepieces. Recent decades witnessed the emergence of quartz, digital and solar technologies. Watch functions have progressed as well, as time-honored traditions of complicated watchmaking are reinterpreted today. Exciting new functions such as multiple time zones and alarms also now appear on watches in answer to the hectic lifestyle of new-millennium consumers. Indeed, when it comes to luxury and technology, fine watches are on the cutting-edge.

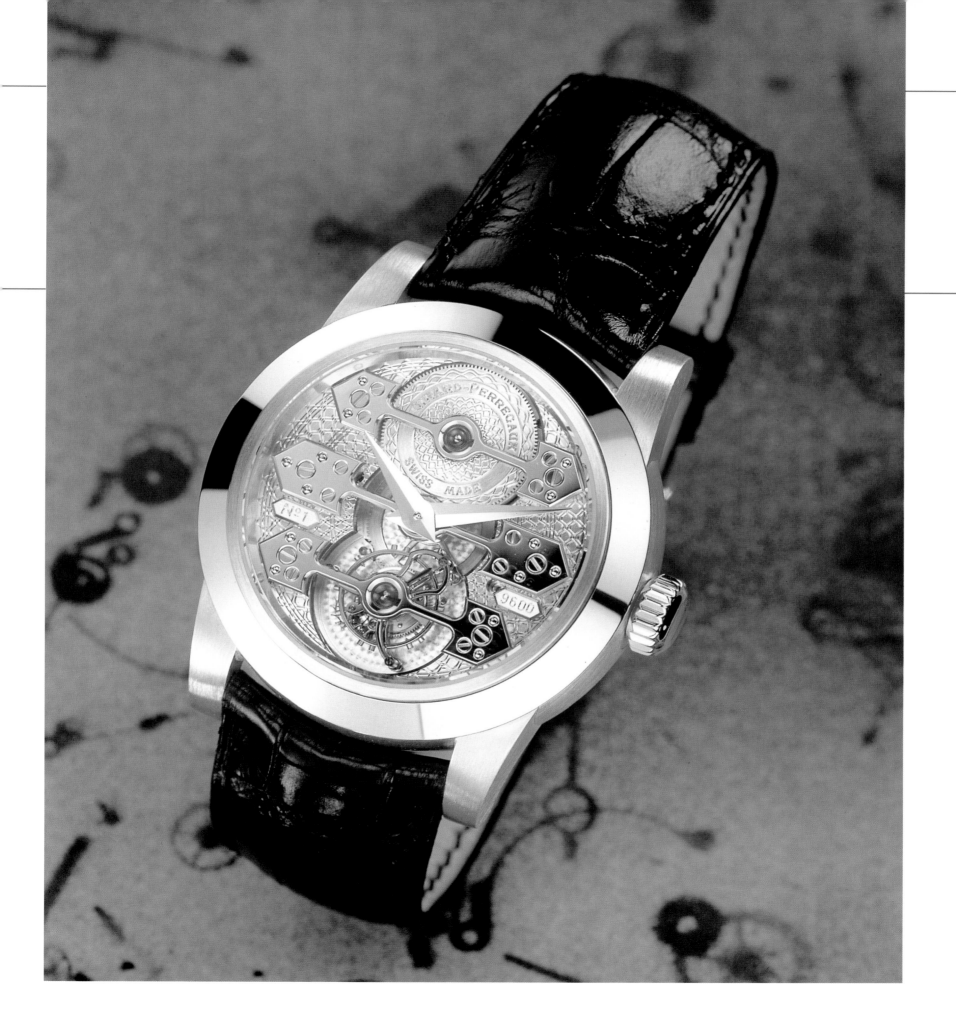

Flora & Fauna

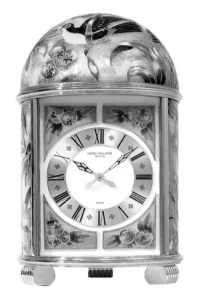

Few things in life are as beautiful as nature's flowers or as endearing as nature's animals. Thus, it stands to reason that as clocks and watches developed and emerged, their designers would ultimately turn to this compelling part of life for inspiration. It was in the eighteenth century—when clocks were a staple in most homes of the wealthy and travel watches were commonplace—when new design motifs on travel and pocket watches flourished. Designers first engraved in gold or copper and then turned to enamel and inlaid semiprecious stones as decorative vehicles. While religious scenes and themes of love and beauty were popular motifs, it was flora and fauna that stole so many watch designers' hearts. ■ English watchmakers in particular were celebrated for their artistry in decorating watch cases with engraved garlands, vines, and intricate rosettes. Open-worked metal, known as piercing, allowed for elaborate patterns of leaves and flowers. While centuries earlier, clockmakers had utilized ornamental animals to serve as clock-holders, it was in the mid-eighteenth century that this practice was translated to watch design as heraldic lions and horses were engraved onto watch case

covers. Swiss watchmakers carried this tradition into the next century, with companies such as Patek Philippe offering elaborate representations of hunting scenes complete with dogs, horses, and even wolves.

By the mid-eighteenth century, watch designers paid closer attention to enameling as a decorative art. It was the Geneva artisans, in particular, whose work excelled. They had a soft, almost translucent look that offered refined elegance. Flowers inspired enamelers of the late eighteenth century in ways never witnessed before, and floral bouquets, hangings, and outdoor gardens made a strong appearance—one that lasted well into the nineteenth century.

In the mid-nineteenth century, watchmakers turned to animals and birds in a more luxurious way. Elegant enamels depicted galloping horses, birds in flight, and stately hunting dogs—all executed with perfection.

OPENING PAGE
Tourbillon with three gold Bridges watch by Girard-Perregaux is a technical achievement in miniaturizing and revealing the three bridges on the dial side.

FACING PAGE
The fine art of enameling thrives at Patek Philippe's workshops, as evidenced by this incredible domed cloisonne clock, which contains approximately 60 colors, all built up in layers to create shading and depth.

THIS PAGE
TOP LEFT
From Boucheron this gold quarter repeater pocket watch, ca. 1760, features an engraved and pierced inner case. The outer case is elegantly enameled and set with rubies.

LEFT
Boucheron's square pocket watch, Adam and Eve, ca. 1920, is crafted in gold and platinum and enameled.

BOTTOM LEFT
This elaborate enamel work by Vacheron Constantin is inspired by the work of 19th century U.S. naturalist J. J. Audubon, whose subjects have been miniaturized on wristwatch dials.

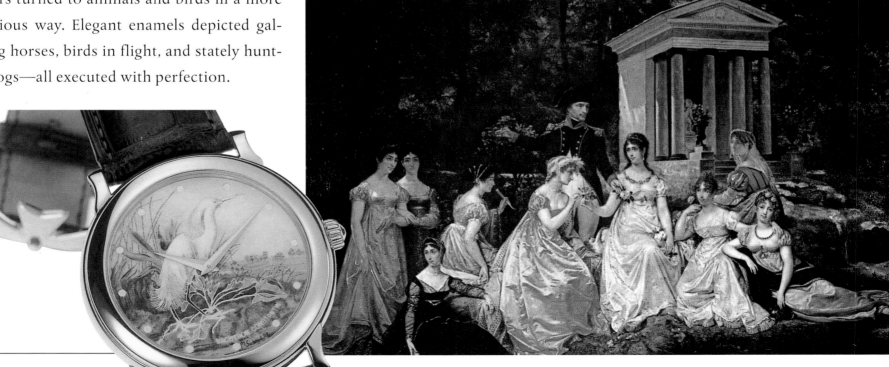

RIGHT

This Patek Philippe floral timepiece whispers with its own white magic. It is set with Top Wesselton flawless diamonds totaling more than one and a quarter carats of diamonds. The petal pattern of the diamonds is echoed in the elegant bracelet.

BOTTOM RIGHT

This floral masterpiece by Chanel consists of a ruby and diamond flower on a pearl and diamond bracelet. The flower head lifts to reveal the watch beneath.

BELOW

From Van Cleef & Arpels this stunning floral masterpiece in sapphires, diamonds and rubies is a creation from the mid-1940s.

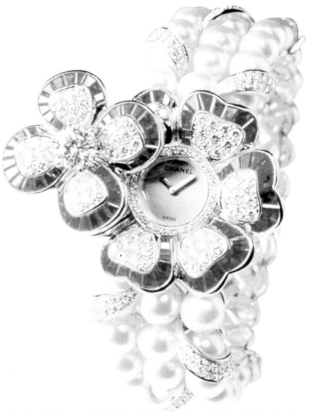

In 1846, Vacheron Constantin produced an elaborate painted enamel pocket watch for the Chinese market. The case was outlined in pearls, and within it were two white doves resting on vibrantly colored flowers. It sparked a new demand internationally for the exquisite art of enameling and the exclusive beauty and refinement it could offer. Enamels were experimented with in greater detail, and a range of offerings—from translucent to opaque enamels in brilliant colors—became available on watch cases.

Today, the meticulous fine art of enameling is carried on by only a handful of the finest Swiss firms—either in the traditional translucent Geneva

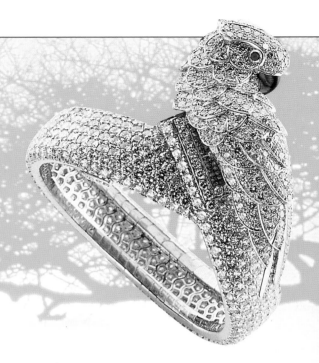

LEFT
The plumage of this stunning parrot is elegantly crafted in diamonds by Cartier. The parrot's head opens to reveal the watch below.

CENTER
Incredibly adept at recreating nature, Cartier's panther sits languidly atop this sapphire and diamond watch.

BELOW
Circa 1920, this gold enameled hunter watch from Longines features the king of beasts; it is double sided and contains a chronograph movement with moonphase and calendar function.

style or in bold new designs. Companies such as Vacheron Constantin, Patek Philippe, Jaeger-LeCoultre, and Parmigiani employ some of the world's finest artisans, who spend hour upon hour painting scenes with a single-hair brush. Enameling in miniature is a painstakingly precise craft, and enamelers can devote only five hours a day to such intense work.

In enameling, colors cannot be mixed by blending. Instead, to achieve a color one must paint the first color and fire it on, then apply another color over the first in the right technique to achieve a new hue or tone. This complex process of layering colors on top of one another, each time with a successive firing, adds to the time and effort it takes to achieve depth, dimension, and richness of color.

To complete one timepiece can take upwards of four hundred hours of intense,

RIGHT

This sterling silver Savonnette from Chopard is etched with fine riding horses and ensconced in leaves, circa 1915.

FAR RIGHT

Sarcar's Magic Moon series elegantly offers a variety of animals. This horse spins around the watch dial as the wearer's wrist moves, creating a dazzling gallop.

BELOW

Hublot combines enamel and gold craftsmanship with realistic results in this beautiful horse.

absorbing labor. This is not to mention the approximately twenty oven firings that each enamel watch goes through. With all of this concentrated work, it is not difficult to understand why today's finest enamel watches easily command tens—often hundreds—of thousands of dollars and are quite sought after.

Flora and fauna began to influence another aspect of wristwatch design in the late 1700s and early 1800s: the practice of creating actual animal or floral shapes from the watch dial or case itself. In the past, these luxurious pieces of jewelry typically had covers that

lifted to reveal the watch dial beneath, a design feature few watch companies still continue. Today, jewelers such as Chopard and Van Cleef & Arpels are masters at floral designs, often creating flowers—such as poppies, daisies, and sunflowers—using rubies, emeralds, and sapphires.

Similarly, Cartier continues to carry on its flora and fauna tradition—replicating panthers, parrots, and even dolphins in spectacular jeweled wristwatches that have lives of their own.

To those in the know, hand-enameled and bejeweled watches of this quality are a rarity meant to be the heirlooms of generations to come.

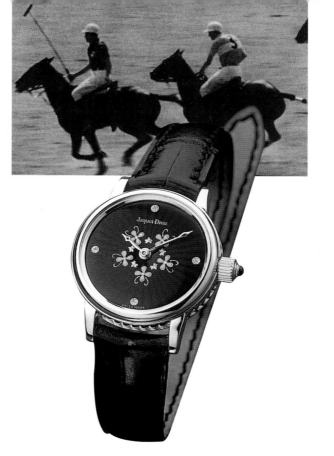

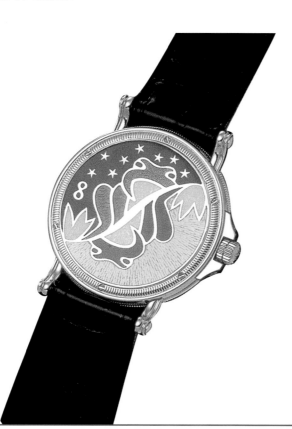

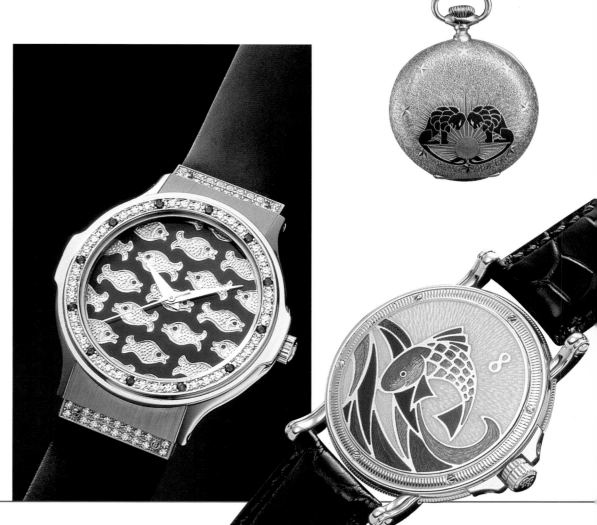

LEFT
This lady's watch by Jacquet-Droz is hand enameled with decorative miniature florettes in the eighteenth century style.

BELOW
Boucheron's engraved gold pocket watch features two lions in black enamel.

BOTTOM RIGHT
From Paul Picot, this enamel Fish is created in a limited edition of just 30 pieces.

BOTTOM CENTER
Creatures of the sea are not forgotten in fauna art, as evidenced by Hublot's repeating fish series.

BOTTOM LEFT
With surreal beauty and elegance, Paul Picot depicts the frog and its reflection in a special cloisonne' dial.

Diamonds & Gemstones

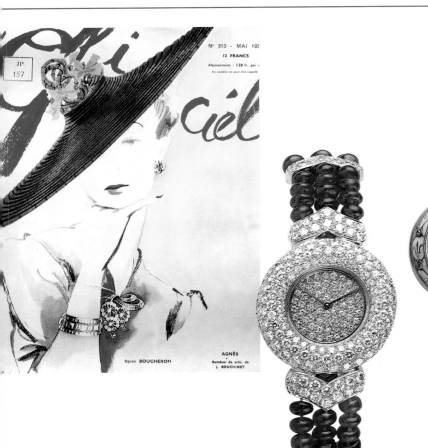

Perhaps one of the most memorable songs from a motion picture comes from the 1953 film Gentlemen Prefer Blondes when the legendary Marilyn Monroe seductively sang "Diamonds Are a Girl's Best Friend." Monroe was sexy, sincere—and correct. Diamonds and gemstones have been counted among the best friends of women and men throughout time. The most dazzling and scintillating of earth's treasures, diamonds and gemstones captivate, motivate, and ensnare. They have been used throughout the centuries to cast spells, toward off danger, to heal, and to indicate love, passion, and desire. For a longer period than the entire millennium that has passed, diamonds and gemstones have been used in jewelry. In fact, the first use of colored stones in jewels can be traced back to the third century B.C. But it is only in the past few centuries that watchmakers have turned to these rich beauties as adornment for watches. ■ The earliest high-jeweled timepieces date back to the days of Calvinism, at the turn of the sixteenth century. Religious leader John Calvin, who was living in Geneva, banned the wearing of jewelry—but not of watches. It didn't take

FACING PAGE (LEFT TO RIGHT)
Boucheron elegantly brings together
diamonds and sapphires for a
stunning effect.

This pendant watch from Boucheron,
ca. 1880, is crafted in a
fleur-de-lys.

THIS PAGE

LEFT
Chopard's mastery at mixing stone
cuts, calibers and type once again
shines through in this illustrious sap-
phire and diamond timepiece.

CENTER
Daniel Roth knows that diamonds are
a girl's best friend and so he encapsu-
lated this classic timepiece in a case
of 221 diamonds.

BELOW
Called the Sympathie jewelry wrist-
watch, this Roger Dubuis timepiece
hosts 126 diamonds and is created in
a limited edition of just 28 pieces.

long for the watchmak-
ers and jewelry makers
of the time to combine
talents and introduce
jeweled watches. Little did
they know that in their effort to survive, they
were creating a concept in timepieces that
would span well into the next millennium.

For the next few hundred years, gem-
stone timepieces were predominantly made
to order and were typically created for roy-
alty. It was not until the early 1900s that
gemstone-adorned wristwatches were
widely in demand. As wristwatches
became the preferred timepiece and

RIGHT

Girard-Perregaux's pastel-strapped timepieces feature exquisite diamond cases in pink, yellow and white.

BOTTOM RIGHT

This elegant Boucheron wristwatch features a stunning pearl bracelet that is sumptuous on the wrist.

BOTTOM LEFT

Piaget's Haute Joaillerie mechanical watch is set in 18-karat white gold and features a 6.3 carat pear-cut emerald, in addition to another 28 emeralds weighing nearly 2 carats and 117 diamonds weighing more than 5 carats.

socializing became the preferred pastime, conditions were right for watchmakers to enter the diamond and gemstone arena. In the 1920s and 1930s, as literary greats, poets, fashion designers, musicians, and socialites gathered for intimate dinners, galas, and other events, they looked to the finest houses to dress them—from head to toe to wrist.

Particularly popular during this era were diamond watches with simple sapphire or ruby accents. As art deco designs emerged in all walks of life, watches were not forgotten. Many watchmakers introduced black-satin strapped watches with elongated diamond-encrusted cases typical of the art deco era. Geometrical shapes were juxtaposed in stunning creations

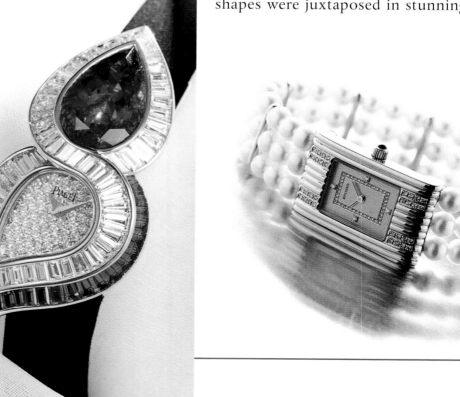

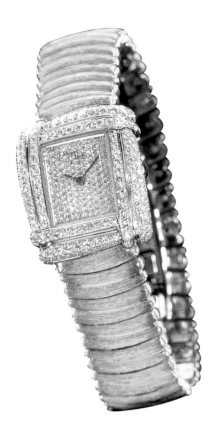

by such great houses as Boucheron, Cartier, and Van Cleef & Arpels.

Today, high-jeweled watchmaking has become a very special category of drama, elegance and passion. While some watchmakers use diamonds sparingly—as simple dial and case adornments, for example—others ensconce their timepieces in diamonds and gemstones of all sorts—from bracelet to case to dial. The artistry involved in making these flawless creations is akin to nothing else in watchmaking.

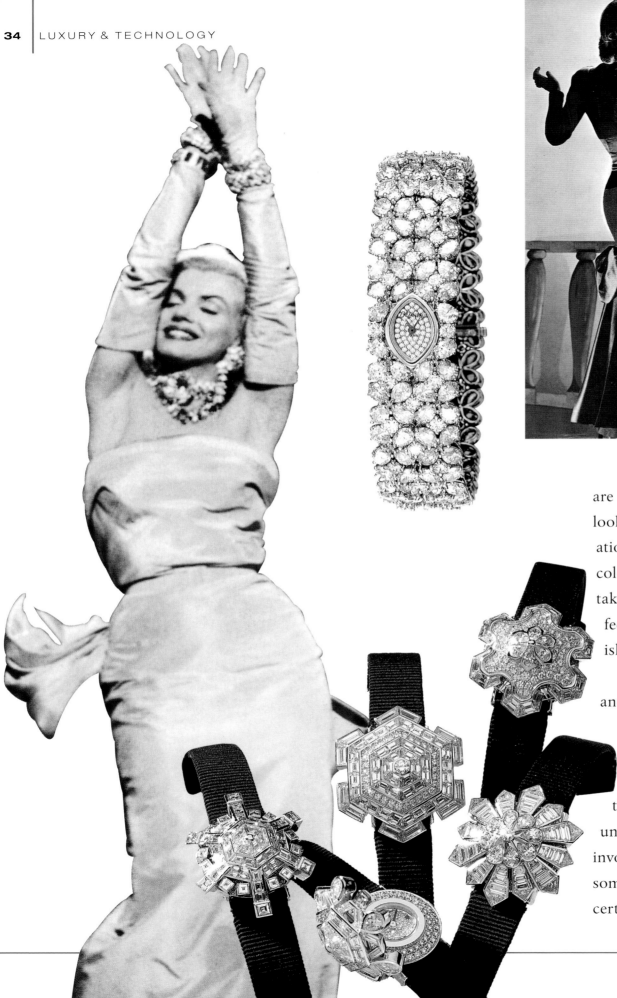

These luxurious designs are exquisite not only in their look, but also in their creation. Depending on the color of the gem used, it can take years to find enough perfectly matched stones to finish one timepiece.

Similarly, the cutting and setting of these wonderful gems is a time-consuming, painstaking process. For some of the more elaborate masterpieces that contain hundreds of stones, it is not unusual for hundreds of hours of labor to be involved in their cutting and setting. There are some legendary stories about the making of certain bejeweled creations, such as Vacheron

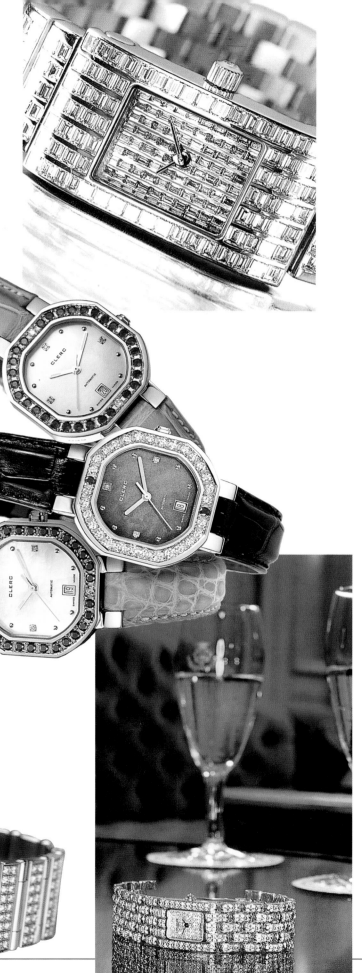

Constantin's Kallista watch, which took approximately six thousand hours to select and set the 130 carats of diamonds.

Because of the tedious work involved, many of these haute-joaillerie pieces take months, even years, to come to fruition. Naturally, these watches command high prices —anywhere from several thousand to several million dollars, depending on the creation.

Typically, these luxurious rarities feature the most precious of stones: white diamonds, rubies, emeralds, sapphires, and pearls.

Recently, though, some of the master jewelers have introduced watches adorned with fancy diamonds in colors such as blue, yellow, pink, and even black. These beauties are breathtaing, especially when the pastels are used in combination and set in coordinating metals, such as yellow gold, white gold, or platinum.

FACING PAGE

TOP

Called "Love Forever" this Delaneau creation is set with 300 pear-, round-, and pavé diamonds weighing nearly 60 carats.

RIGHT

The Concord La Scala Grande is a timepiece of exceptional achievement. Its design showcases nearly 200 invisibly set baguette diamonds and nearly 300 brilliant-cut diamonds.

BOTTOM

Diamonds and ice have never been so synonymous as in this *flocons de neige* (snowflake) collection by Audemars Piguet. Each snowflake lifts to reveal the watch dial.

THIS PAGE

TOP

This artistically channel-set diamond watch is a masterpiece from the great jewelry house of Boucheron.

CENTER

Make this photo large The phenomenal beauty of Clerc's unusually shaped timepieces, bedecked in diamonds and gemstones, offers breathtaking appeal.

BOTTOM RIGHT

Chaumet understand the need for time and relaxation and answers that call with an all-diamond Khesis.

BOTTOM LEFT

From the Cassiopeia collection of Omega's high jewelry watch line, named after one of the most beautiful constellations, this exquisite diamond and sapphire timepiece is crafted in 18-karat gold.

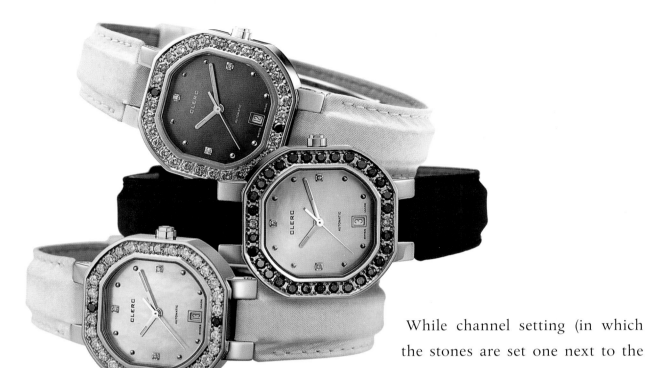

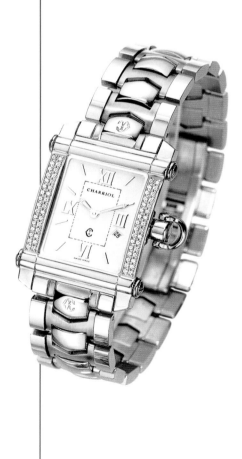

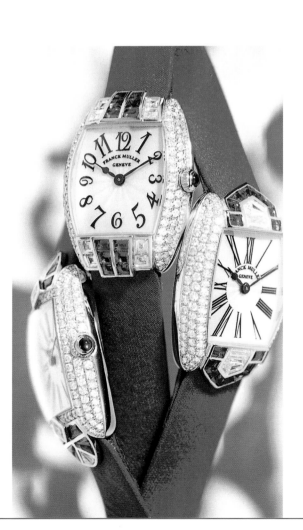

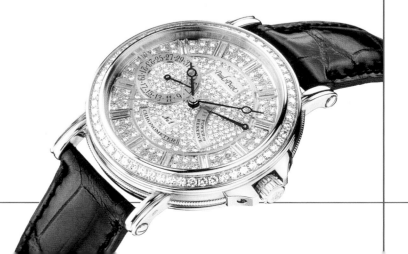

While channel setting (in which the stones are set one next to the other in a neat row with no metal showing) and pavé setting (where tiny diamonds are placed in such a way as to "pave" the surface with glitter) are the most popular used in jeweled watchmaking, some companies have gotten especially inventive, creating their own settings. Such is the case with Chopard's Happy Diamonds, where the diamonds seem to float freely on the watch dial, and Sarcar's Magic Moon, where rotating diamond-set motifs spin in the center of the watch dial.

Interestingly, watchmakers do not limit the making of gemstone watches to women's

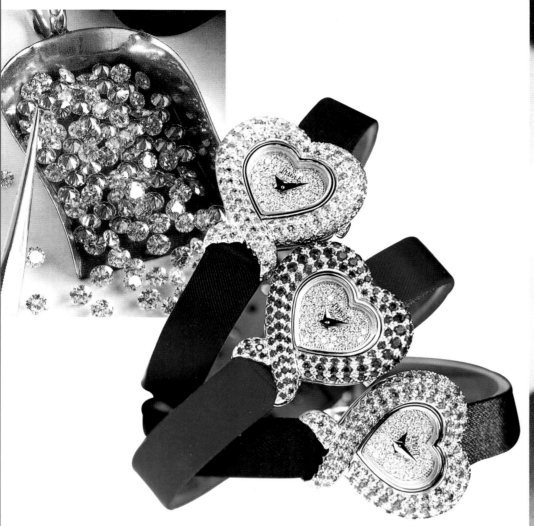

timepieces. Many companies also discreetly set diamonds and gemstones onto the case, bezel, or dial of certain men's watches in an effort to offer the discerning man his own style. Whether created for women or for men, these heirloom items hold a special allure, not only when acquiring and wearing them, but also when handing them down to the next generation.

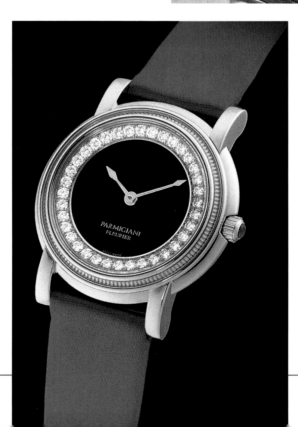

Skeletons

Often one tries to hide the skeletons in the closet, but in the case of watchmaking, skeletons are something to show off. A skeleton watch is one that has a see-through or clear crystal on the front or back of the watch (sometimes both sides of the case are transparent) so that the interior of the watch can be viewed. Typically, the interior mechanisms of these skeleton watches are intricately engraved and acutely chiseled; often as much as sixty to seventy percent of the metal typically found on a watch movement in a non-skeleton cased watch is removed in a skeleton watch to offer the viewer exquisite beauty and detail. These exquisite timepieces are both lovely in design and technologically advanced in their mechanisms to offer the wearer a special knowledge and insight into the world of watchmaking. ■ Skeleton timepieces were among the first type available—not out of the desire to create something different and breathtakingly beautiful (as is the case today), but simply because full outer cases had not yet beeninvented.

FACING PAGE

TOP

The Longines Francillon skeleton timepiece is reduced to the barest minimum of metal, and neatly engraved.

CENTER AND BOTTOM

In its most artistic endeavors, Girard-Perregaux created this skeleton pendant and pocket watches in 1970, piercing and engraving the movement to achieve the utmost in detail.

THIS PAGE

LEFT

In the 1800s, Breguet crafted skeleton pocket watches that were in incredible demand, such as this elaborate model that was owned by Marie-Antoinette.

CENTER

This exquisite Piaget skeleton pocket watch is invisibly set with five rows of diamonds and rubies for the most luxurious of time.

BELOW

In typical tradition, Girard-Perregaux's "Squelette" movement is one of the most delicate expressions of the watchmaker's art.

In the early days of clocks (the fifteenth and sixteenth centuries), the movement was easily viewed because most clockmakers did not fully enclose the inner metal works. Later, when clocks and portable watches donned cases, watchmakers embellished those cases with engravings that reflected the era. Still, watc makers had the desire to allow the wearer a view of the inner workings.

Thus, by the late eighteenth century, fine Swiss watchmakers were creating case backs that could be popped open to reveal the movement, and soon after they implemented see-through crystals to make the watches more

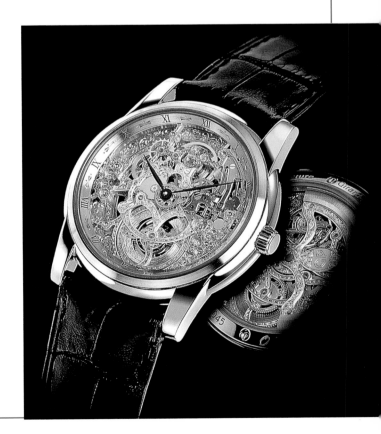

interesting and exciting for the owner. One such watch was Breguet,s "Grand Complication" (number 160). Originally intended for Marie Antoinette, it had a clear crystal, revealing the movement in all of its mechanical glory. Begun in 1783, this masterpiece of horology and craftsmanship was not completed until 1827. Several other houses followed suit, creating just a few watches with see-through crystals over the next few decades.

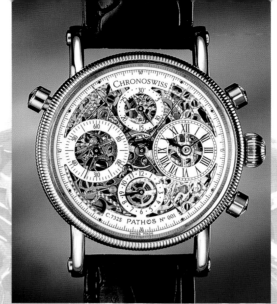

It was not until the early 1900s that watchmakers—content in their technological advancements in complicated watchmaking—once again turned their full attention to the harmonious appeal of the skeleton watch. There was a small burst of activity in this arena from the finest manufacturers beginning in the mid- to late 1920s, but the greatest popularity of this type of watch occurred in the early 1970s.

This was an era when watchmakers were striving to offer difference, elegance, and substance in their craft. Skeleton watches afforded a new view of what goes into the making of a watch. The world's greatest watchmakers drew

TOP
The Pathos from Chronoswiss is intricately engraved and elegantly portrayed.

LEFT
Perrelet's skeleton watch features a double rotor and is made in a limited edition of just 27 pieces, each individually hand crafted, engraved and numbered.

BOTTOM RIGHT
Perhaps no skeleton in the world is as complex as the Three Bridges Tourbillon by Girard-Perregaux, a classic.

BOTTOM LEFT
Today Breguet practices the fine art of skeleton watchmaking in an effort to depict to the world its craftsmanship and unique knowledge of horology.

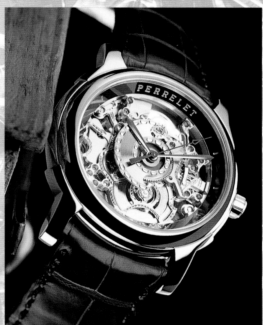

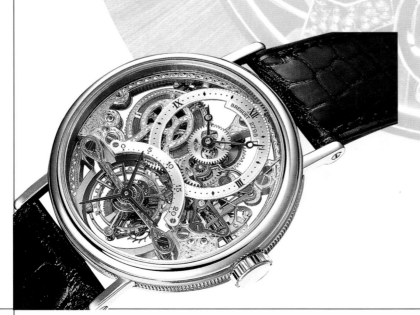

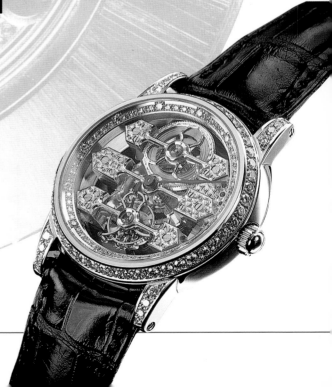

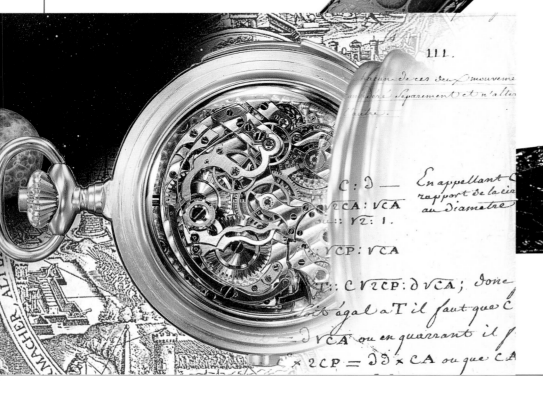

on the strength and character of their craftsmen to produce exquisite works of art. Watchmakers were called upon to fashion their already minute mechanisms even smaller and thinner. Top-notch engravers were hired to carve away excess metal and etch the tiniest, most succinct details into these minuscule pieces. Companies such as Patek Philippe, Breguet, IWC, Vacheron Constantin, Audemars Piguet, Piaget, and a few others scrambled to find the best talent in Switzerland: top engravers who could sit for hours

surrounded by loops and microscopes, execut-ing full-size drawings in miniature. These fine watchmakers continue to produce limited-edi-tion skeleton masterpieces that are incredible works of art, perhaps the most visually beauti-ful timepieces made today.

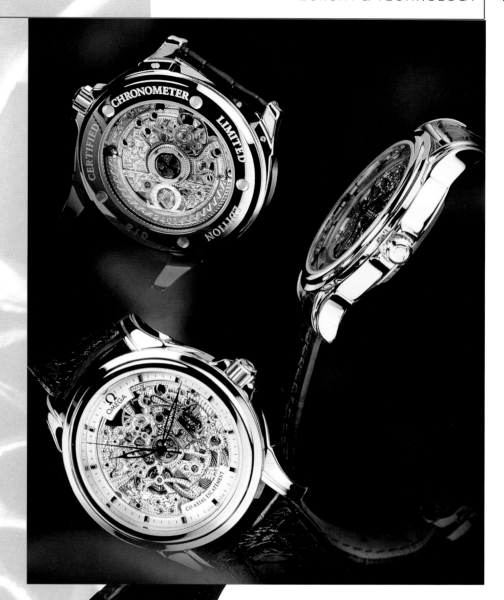

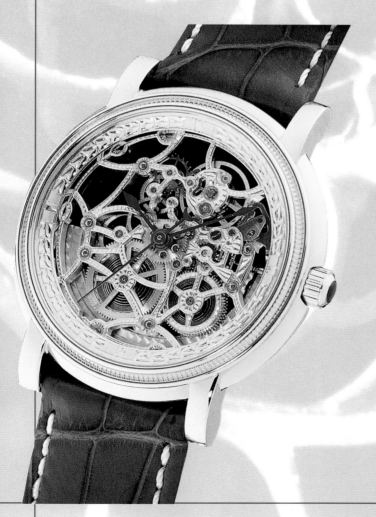

TOP
Omega's new De Ville Co-Axial skele-ton wristwatch is crafted in platinum or 18-karat yellow or red gold and produced in a limited edition due to the complexity of its movement. The coaxial escapement eliminates friction between the wheel and pallets, resulting in a longer lifetime for the movement and expected increased accuracy.

BOTTOM RIGHT
Blancpain, a company that boasts its mechanical prowess, works wonders with the skeleton watch.

BOTTOM LEFT
A master at ultimate craftsmanship, Parmigiani Fleurier is more than adept at the fine, detailed workmanship inherent in a skeleton wristwatch.

Tourbillons

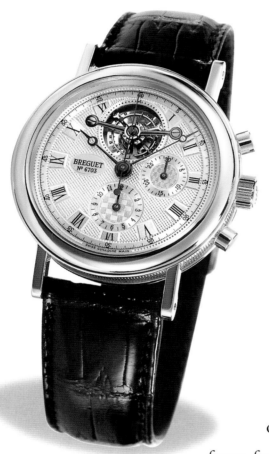

The world of complicated watchmaking, where it can take one watchmaker as long as a year to handcraft a single watch, is in a category by itself. The master watchmakers who spend their lives putting multiple complicated functions together into a mechanical timepiece are a rare breed. They work tirelessly day by day at a painstakingly minute and precise craftsmanship to produce an end result that is one of the highest achievements in watchmaking and technology. ■ Complicated movements are ones that offer specific functions and require anywhere from four hundred to seven hundred tiny parts to be assembled in a movement just a few centimeters in diameter. In these prized timepieces—which can cost hundreds of thousands of dollars—three-quarters of the value of the watch comes from the movement inside and the workmanship it took to put it there. The exclusivity of these watches and the profound respect they command make them among the most coveted watches in the world. Considered to be one of the most

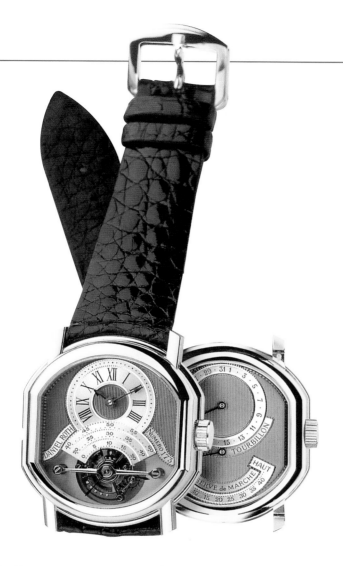

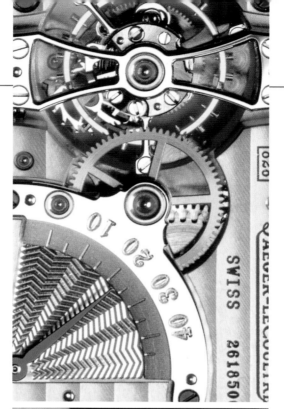

challenging creations, the tourbillon is perhaps most indicative of the watchmaker's ultimate skills. It is a highly precise regulator device created to eliminate errors in timekeeping that result naturally from the force of gravity on a mechanical watch. (Without this mechanism, as much as a second each day can be lost due to the flick of a wrist because mechanical watches run at a slight difference in the horizontal and vertical positions.)

Watchmaking legend Abraham-Louis Breguet, obsessed with solving the gravity problem, conceived of the tourbillon in 1795 (though

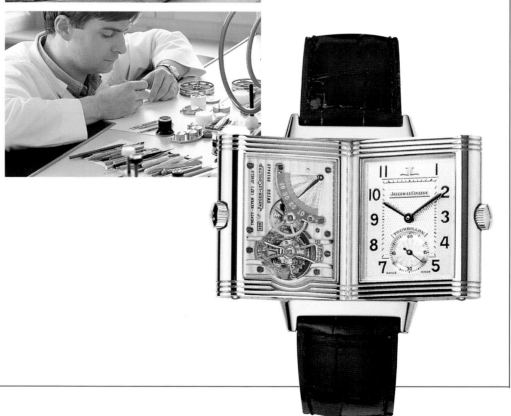

RIGHT
From Audemars Piguet, this Edward Piguet Tourbillon is encased in a tank-shaped case that is elegantly curved to fit the wrist.

BOTTOM RIGHT
This exquisite Four Seasons Da Vinci Tourbillon by IWC, International Watch Company, is a work of art outside as well as inside. It features the work of master engraver Wolfgang Sigwart and depicts four allegorical female figures representing the four seasons Only 20 pieces will ever be made.

FACING PAGE
CENTER RIGHT
The Imperial Tourbillon by Franck Muller is perfectly set in this tonneau case, reminiscent of tradition and elegance.

BOTTOM RIGHT
This Girard-Perregaux Tourbillon with single gold Bridge features a white gold guilloché dial crafted to reveal the architecture within.

BOTTOM LEFT
An inside look at the IWC Four Seasons Da Vinci Tourbillon.

it was not produced and sold until ten years later). Today, it is still considered to be one of the most precise mechanical timekeepers.

Essentially, in a tourbillon the entire device that regulates the power (the escapement) is put into a case; this complete assembly revolves continuously at the constant rate of one time per minute. With the recurrent rotation and the subsequent averaging out of the effects of gravity over one revolution per minute, the tourbillon eliminates errors in timekeeping.

Because of the complexity involved in creating tourbillons, only a handful of the top watchmakers produce them. Most of these houses offer tourbillons with see-through crystals or windows on the dial so that one can view the tour-

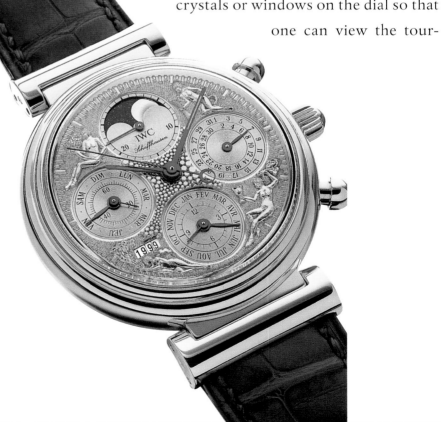

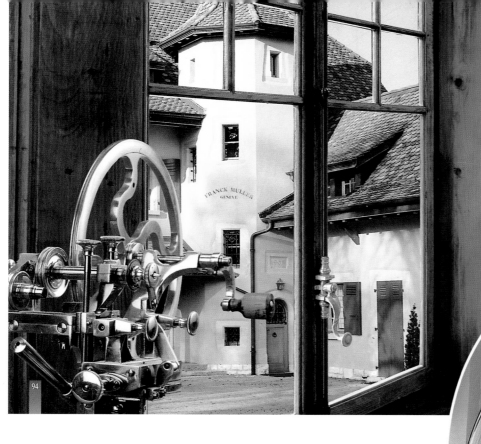

billon escapement's constant motion. Tourbillons are created in very limited quantities because of the demanding and time-consuming craftsmanship involved in their creation. It can take six months for a master watchmaker to complete a tourbillon, and longer if other complications are added to the timepiece. But rest assured that these magnificent feats of accomplishment are well worth the wait.

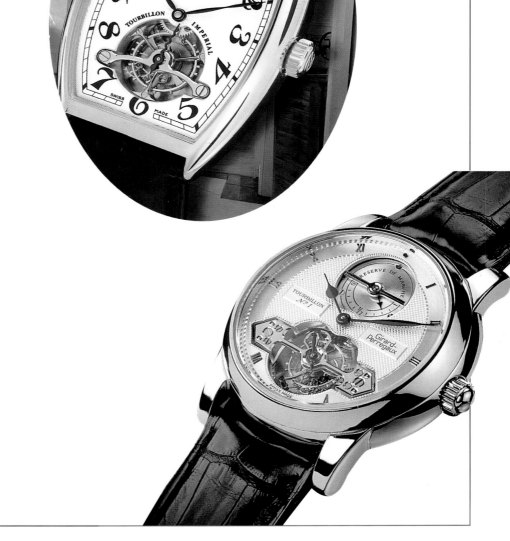

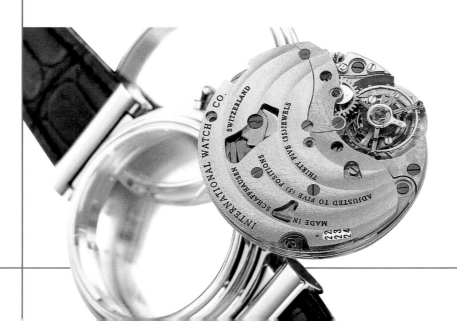

Minute Repeaters

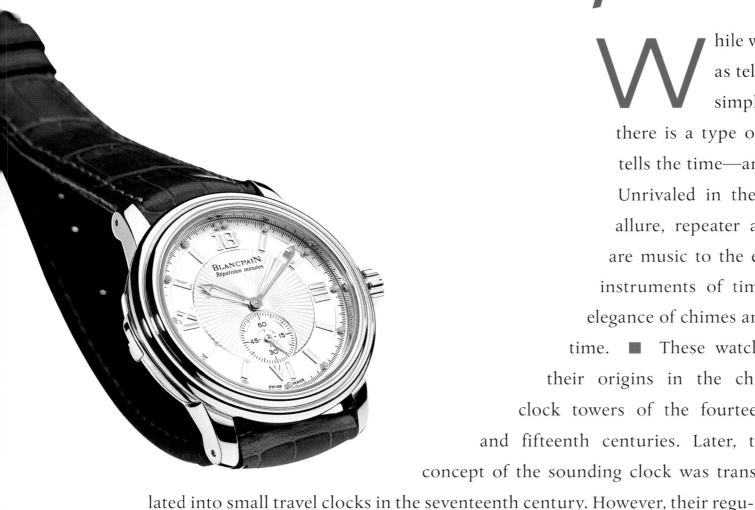

While we often refer to clocks as telling time, in fact, they simply show the time. But there is a type of timepiece that truly tells the time—and does so beautifully. Unrivaled in their craftsmanship and allure, repeater and sonnerie watches are music to the ears. These wonderful instruments of time offer the soothing elegance of chimes and bells to indicate the time. ■ These watches have their origins in the chiming clock towers of the fourteenth and fifteenth centuries. Later, the concept of the sounding clock was translated into small travel clocks in the seventeenth century. However, their regular use did not come into full play until the late eighteenth century, when Abraham-Louis Breguet created the gong spring, improving the sound quality and reducing the necessary thickness of the case. ■ While intrinsically beautiful, the minute repeater's original reason for being incorporated into

small clocks and watches was strictly functional: it was developed so the wearer could know the time at any hour of the night without having to light a candle or oil lamp. Over the centuries the sheer melodic beauty of the watch has kept it a much-loved timepiece—and a complicated one to create. Essentially, repeaters work via a series of gongs or hammers that are activated at will by the wearer with the push of a button or slide. The time is "told" by gonging or chiming sounds of different tonalities. Repeater watches are most often created as the "minute repeater," sounding the time with an elaborate series of tones to indicate the hours, quarters, and minutes. However, there also are "quarter repeaters" (the

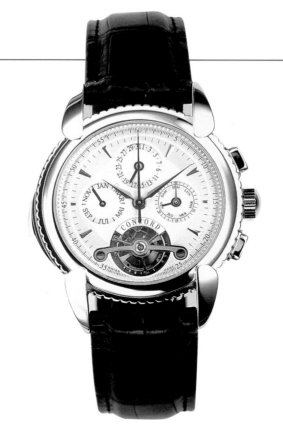

FACING PAGE
CENTER
In 1988, Blancpain introduced one of the smallest minute repeaters with an extra-slim movement. Designed for women, this complex minute repeater strikes the hours, quarter-hours and minutes, each with its distinctive sound and frequency. The timepieces is also water resistant to 30 meters due to a lock winding system, making it the world's first water resistant minute repeater.

BOTTOM RIGHT
Audemars Piguet has created some of the most melodious repeaters and sonneries of time. This Repetition Minutes Carillon is one of its most recent examples of technology, craftsmanship and beauty.

THIS PAGE
TOP
Concord's Impressario Minute Repeater features a fluted case and houses a tourbillon movement as well as the repeater.

BOTTOM RIGHT
In its true heritage and tradition, Breguet has crafted this minute repeater pocket watch in 18-karat rose gold and ensconced it in a bezel of 14 flawless baguette shaped Top Wesselton diamonds, weighing approximately 27.5 carats.

BOTTOM LEFT
This bold and beautiful Patek Philippe Minute repeater is a commemorative watch, designed in 1997, and is also a self-winding chronometer.

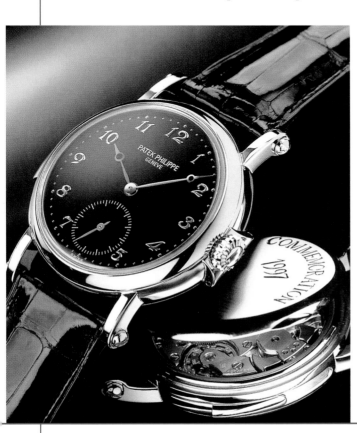

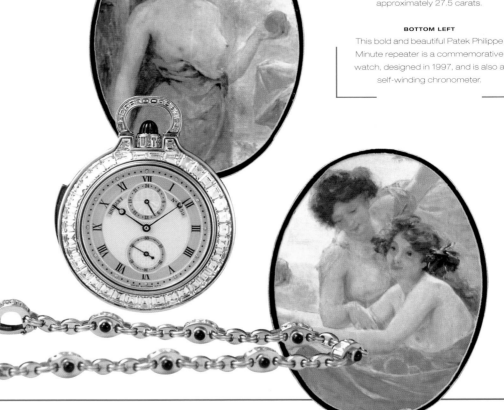

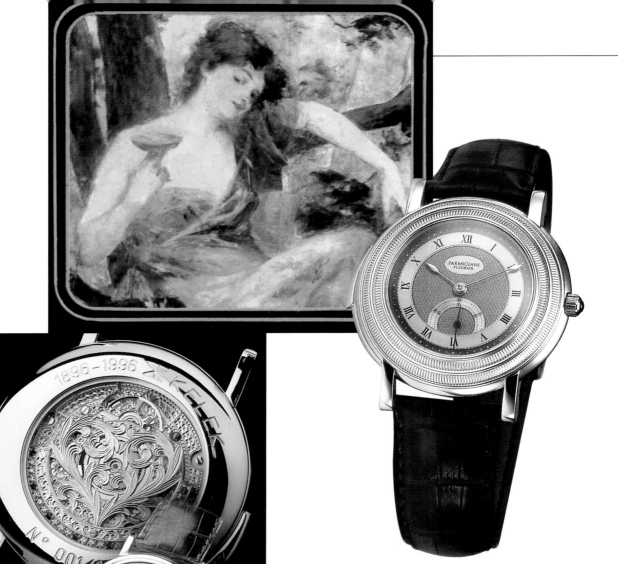

FAR RIGHT
Parmigiani Fleurier works hard on its chromatic designs, both inside and outside of its minute repeaters. This repeater is crafted in 18-karat white gold, but it also is created in 18-karat yellow gold with midnight dial.

CENTER
With exceptional engraving on the case back, this minute repeater from Kelek was created as a commemorative to mark the company's 100th anniversary in 1996. The repetition module was designed so that other indications could be incorporated in addition to the hour and repetition.

BELOW
This exquisite work of art is pleasure to the eye and ear. Piaget combines the minute repeater with the stunning beauty of diamonds and sapphires. It features as small seconds counter at the ninth hour.

hour and the quarter hour are indicated using two different pitched tones) and "half-quarter repeaters" (the hour, quarter, and nearest half hour are sounded).

Similar to repeaters are sonneries, which sound the time regularly without the wearer having to push a button or slide. The grand sonnerie strikes the hours and the quarter hours at each quarter, while the petit sonnerie chimes only the hours.

The complex mechanism requires untold hours of craftsmanship and a fine ear to achieve perfect tonalities. As such, only the

premiere watchmakers incorporate minute repeaters or sonneries into their watches. They strive for perfection, focusing on improving the sound system of the timepieces and implementing silencers or all-or-nothing devices (ensuring that if the pusher is not fully activated to chime the total time, no time will be chimed so as to avoid errors). Some watch companies have gone so far in their repeaters as to utilize Westminster chimes.

Understandably, due to the incredible craftsmanship and the unusual audiological aspect of these timepieces, they command prices that range from sixty thousand to close to one million dollars.

Perpetuals & Moons

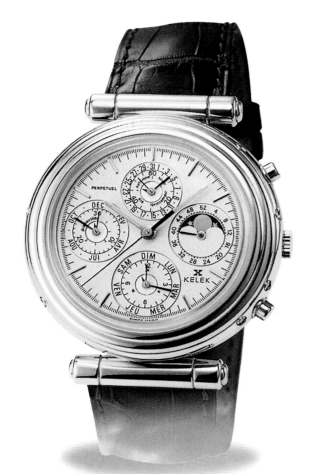

Ever cognizant of man's obsession with time, watchmakers satiate their appetites with a wealth of perpetual calendars and moonphase watches, and even offer equation-of-time functions that allow incredible precision. The perpetual calendar watch automatically tracks and displays the time, day, date, month, and often, the phases of the moon.

Perpetual calendars typically also account and adjust for short months and leap years.

■ Calendar watches, albeit not perpetuals, have been in existence since the sixteenth century in various forms. But it was not until 1853 that Louis Audemars developed a perpetual calendar system that utilized a circular cam consisting of forty-eight months to account for the differences in dates. Since Audemars's day, watchmakers have further perfected the perpetual system so that today they can offer precision for hundreds of years with just one or two simple adjustments.

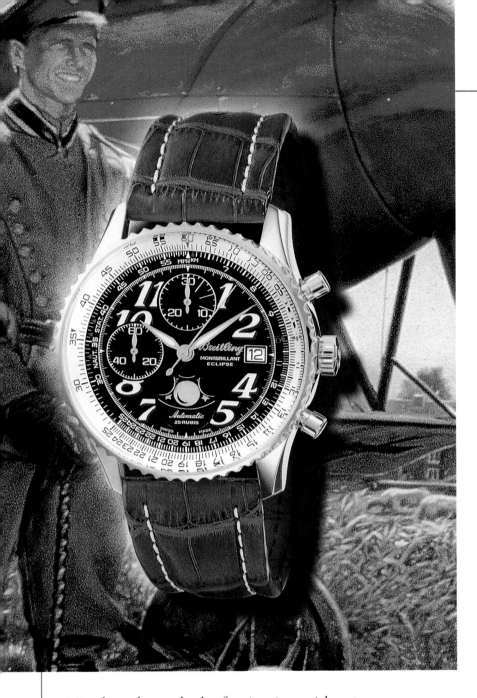

Man has always had a fascination with astronomy, the moon, and the sun, so it stands to reason that watchmakers would find ways to incorporate these aspects of life into their masterpieces. Moonphase functions, often built into the perpetual calendar watch, indicate—not surprisingly–the phases of the moon. Typically, these work via a small disk within the case that holds the phases of the

FACING PAGE

LEFT

Kelek's perpetual calendar moonphase watch is crafted in 18-karat gold.

BOTTOM RIGHT

Longines' VHP (very high precision) Perpetual Calendar Conquest watch offers clean dial and classic design.

THIS PAGE

TOP LEFT

The elegant black dial of this Montbrillant Eclipse moonphase watch by Breitling is strikingly enhanced with the gold and black moonphase display. It's large numbers bring it from the past, into the future.

TOP RIGHT

Crafted in platinum as part of the Master series from Jaeger-LeCoultre, this Master Moon is created in a limited edition of 250 pieces and features a hinged caseback with sapphire crystal and midnight blue dial that displays the hours, minutes, small seconds, date, day, month and phases of the moon.

BOTTOM

The Montbrillant QP by Breitling is set for those on the go. It is not only a perpetual calendar watch, but also a moonphase and chronograph.

TOP

The Oris Tonneau Complication features a mechanical movement, luminous hands and markers and stunning moonphase display at 12:00.

BOTTOM RIGHT

Called the Torus Quantieme Perpetual, this Parmigiani Fleurier masterpiece offers perpetual calendar in unusual half-moon shaped disk, and moonphase at 6:00. Crafted in platinum, it features retrograde date indication, day, month and leap year.

BELOW

This automatic moonphase watch from Patek Philippe features rapid setting of the date and moonphase by pushpieces in the case band. A safety device prevents damage when setting during automatic date change. It is created in 18-karat white, rose, yellow gold or platinum, and features a 48-hour power reserve indicator, with red warning marks during the last 12 hours of power.

moon and rotates in proper time to reveal the moonphase throughout each progressive month.

Moonphase clocks have their origins in the astronomical clocks of five hundred years ago. The first known astronomical clock was created by clockmaker Jacopo di Dondi's in the mid-1300s. However, it was not until the fifteenth and sixteenth centuries that clockmakers began earnestly creating clocks with moonphases on them. There is a wealth of examples from the mid-1500s, when metal disks were handpainted with depictions of the phases of the moon and installed in table clocks of the time. Centuries later, great Swiss

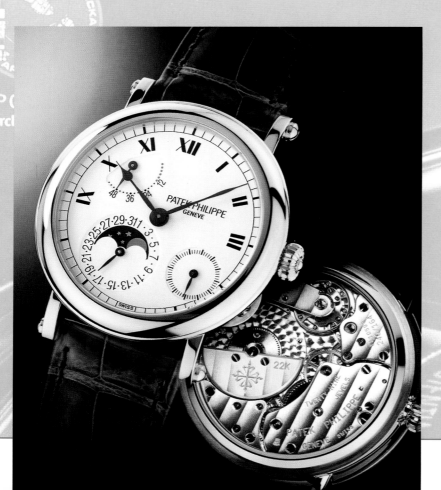

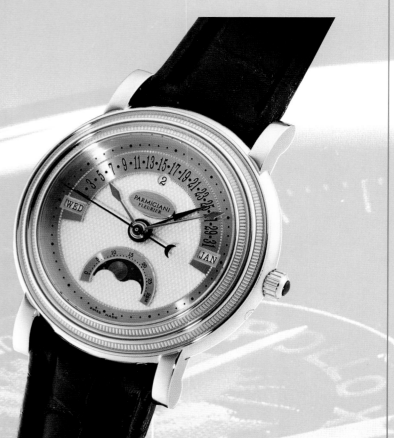

watchmakers such as Breguet and Ami LeCoul-
tre were quick to incorporate this feature in
their timepieces. Today's moonphases are typi-
cally featured on watch dials in enamel or lapis
lazuli.

Another complicated function some-
times found in calendar watches is the "equa-
tion-of-time." This function indicates the
difference between the "average sun day" and
the "true sun day" for the wearer. Astronomers
know that time is not consistent from one day
to the next in relation to the meridian. In order
to not have days of varying lengths, all of the
days in a year were calculated and an average
sun day was fixed at twenty-four hours. How-
ever, the true sun day, the interval of time that
passes between two passages of the sun at the
meridian, can vary from just over fourteen
minutes to over sixteen minutes on certain
days of the year.

This watch function, too, has roots in
the astronomical clocks of several hundred
years ago. It is presently found in very few
timepieces but remains one of interest due to
its complexity.

TOP
Chopard's moonphase on this rose
gold watch is an elegant blue and
gold disk that indicates day and night.

LEFT
Roger Dubuis encases his moon-
phase perpetual calender timepiece
in an unusual case shape, offering a
fresh perspective on time. Only 28
pieces will be made of this timepiece.

Chronographs

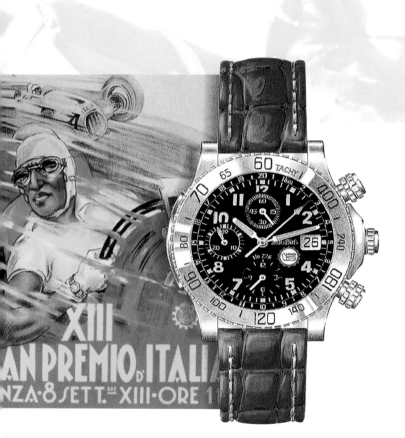

Obsessed with speed and with making and breaking records, man has always been desperate to develop a reliable way to measure activities, events, races, and the like. It took centuries to master the technology, but in 1821 a Swiss watchmaker announced his invention of the chronograph. ■ Stemming from the Greek language, the word "chronograph" translates liberally as "time writer." Nicolas Rieussec, whose invention is heralded today by watchmakers as bringing timing into a whole new realm, created his clock in 1822 and called it a chronograph because it literally wrote the time to be measured on the dial. It featured a hand that was constructed with a small pen that marked an ink spot on the dial at the beginning and end of the measuring period. The distance between the two spots represented the time that had passed from beginning to end. ■ While Rieussec's clock had a variety of problems—including the fact that the dial had to be

specially cleaned after every use—it set watch-makers around the world clamoring to perfect this newest timing method. It was forty years later, in 1862, that a chronograph pocket watch was first developed that could start, stop, and reset to zero—the main ingredients of today's chronograph—without having to stop the main timing mechanism. Still, watchmakers strove for perfection. In 1870, French watch-maker Joseph Winner introduced a chrono-graph that had two separate seconds hands to indicate the start and stop of the event. This concept was the forerunner to today's split-second, or rattrapante, chronograph.

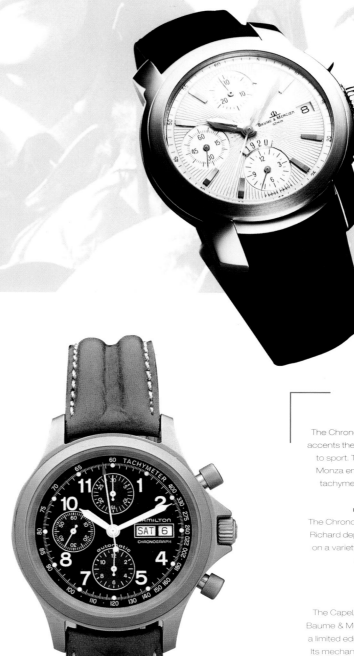

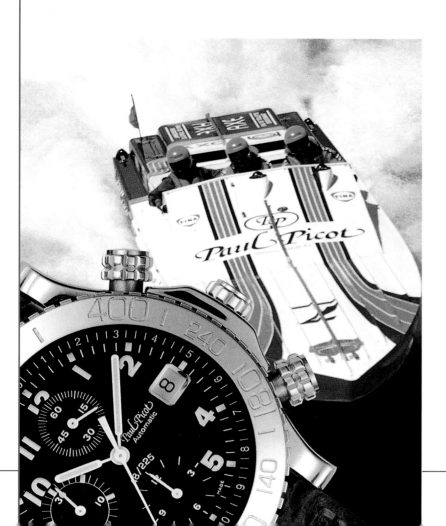

A chronograph is a watch that measures continuous or discontinuous events without interrupting the timekeeping process. A split-seconds chronograph has two hands, allowing the timing of several events starting at the same time but having different lengths. At the beginning of an event, both hands start off together. When one activity is complete, one hand stops; when the second activity is complete, the second hand stops. With the push of a button, the first hand catches up to the second so they are once again in sync. Some chronographs today are also equipped with a fly-back hand that returns to zero.

TOP

This automatic split seconds chronograph, called the S. F. Foudroyante, by Girard-Perregaux offers a jumping seconds that is extremely accurate, making it easier to read fractions of a second as the hands make their revolution on the seconds counter.

CENTER

The Bresel Chronograph from Daniel JeanRichard features a 51-ruby movement, grained silver dial and is created in a limited series of 500 pieces.

BOTTOM RIGHT

This chronograph from Kelek houses a self-wind movement that offers a 30-minute and 12-hour counter and an offset seconds hand.

BOTTOM LEFT

The Split-second Endurance 24 chronograph from Franck Muller features a platinum rotor and three-counter split second chronograph. It comes in a variety of bright-colored dials.

It was early in the twentieth century that wristwatches began to be widely equipped with chronographs. While early chronograph functions all worked off of one button on the side of the crown, in 1934 Breitling introduced a chronograph with two buttons to ensure against accidentally interrupting the timer. One button started and stopped the timing, and the other returned the hand to zero. This technology fast became the standard in chronographs.

Today, chronographs have evolved to state-of-the-art design and technology. They can measure even the tiniest fraction of a second, many measu

LEFT
Krieger's ingenuity comes forth in this sleek Velocita chronograph chronometer that can be color-coordinated with either a yellow or blue shark skin strap.

BELOW
The Diablo watch from Philippe Charriol has all of the right chronograph markings of an excellent race car driver, thanks to Charriol himself.

BOTTOM
The Heuer Monaco Reedition salutes its heritage. It was introduced in 1969 as the first chronograph with automatic winding, referred to as the Chronomatic. This redesign, the Monaco II Chronograph is produced in a limited edition.

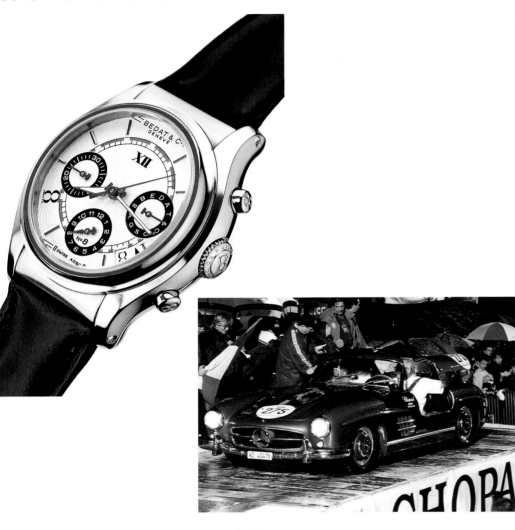

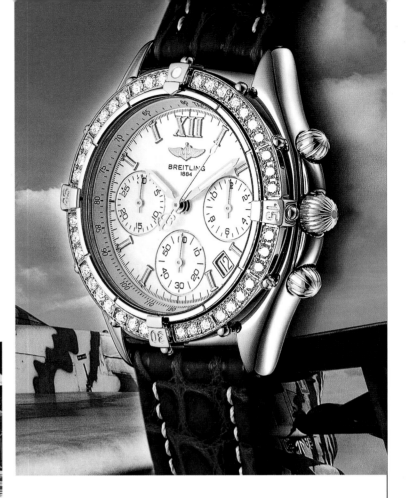

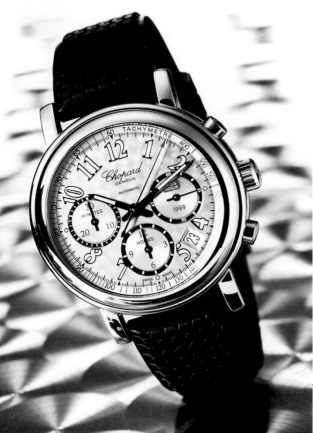

ing to 1/100th of a second. Often these watches are equipped with other functions that give them a more utilitarian purpose. There are chronographs that measure the distance, take a pulse, or incorporate slide rules for specific calculations. Some chronographs are also combined with complicated functions such as perpetual calendars or moon phases.

One of the most striking features about the chronograph is the subdials—usually either two or three—that grace the main dial. Subdials showcase intriguing beauty, as watchmakers have turned to color coordinated subdials, contrasting subdials, gemstone subdials, and even diamond-adorned subdials that blend into diamond dials.

ABOVE
This Model No. 8 chronograph from Bedat offers classic yet updated sports styling.

TOP RIGHT
Breitling's Chrono Jetstream chronograph offers functionality with beauty in this diamond adorned version. It features an inner tachometer scale for measuring speed.

BOTTOM
The 1999 Mille Miglia chronograph features a rubber strap with the Dunlop racing tire design, engine-turned silver dial, automatic movement and tachometer bezel.

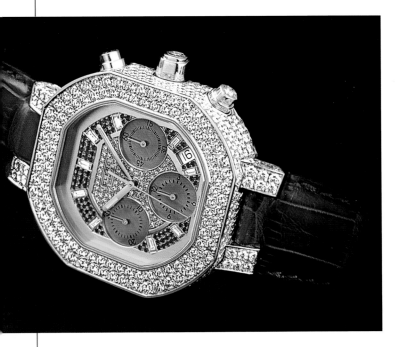

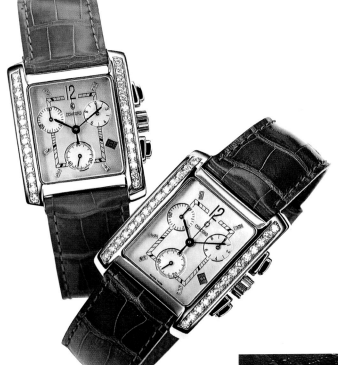

In fact, many people wear chronographs simply for the look and unusual design appeal they offer, rather than for their functionality.

Nonetheless, chronographs were perhaps the single most popular watch category in the last decade of the twentieth century.

FAR LEFT
Cased in the signature octagon case, this Clerc timepieces is a chronograph bedecked in diamonds and rubies that coordinates with red-colored chronograph subdials and strap, for ultimate elegance in action.

LEFT
The Concord Sportivo Chronograph is a signal of the new millennium. This diamond adorned sophisticated sport watch combines function and fashion.

BELOW
These Style de Chaumet chronographs are crafted in steel with black or white dials for intriguing accents.

BOTTOM CENTER
A hearty departure for Van Cleef & Arpels, this bold Roma chronograph offers freshness and technical appeal.

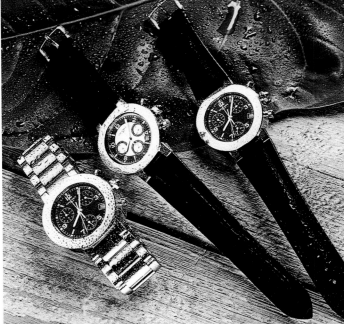

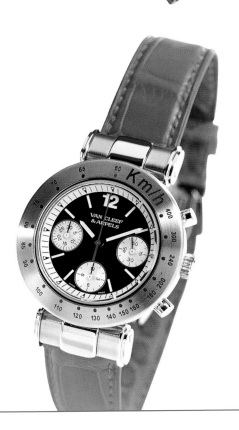

Chronometers

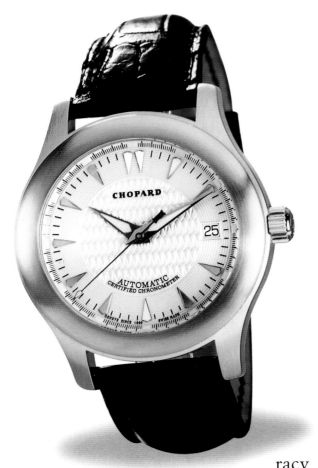

Perhaps more than anything else in a timepiece, precision, accuracy, and durability are key factors for the consumer. In answer to these demands, many watchmakers offer exceptional variety in chronometers—watches certified to withstand extreme conditions. ■ A chronometer is a timepiece that has undergone rigorous testing in several positions and under different conditions and is found to meet certain criteria. In order to be certified, the watch movement is exposed to stringent tests that confirm water resistance, shock resistance, and accuracy under temperature and pressure extremes. For instance, when exposed to temperature change, a chronometer wristwatch cannot vary in accuracy more than plus or minus .6 seconds per day. Typically, the watch movement is tested for at least fifteen days by a Swiss observatory or in some cases, in the watchmaker's own factory. The watches are judged by rigorous standards that are set with absolute limits; calculations cannot be rounded off. If the watch

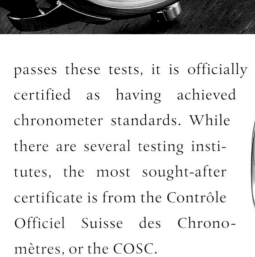

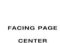

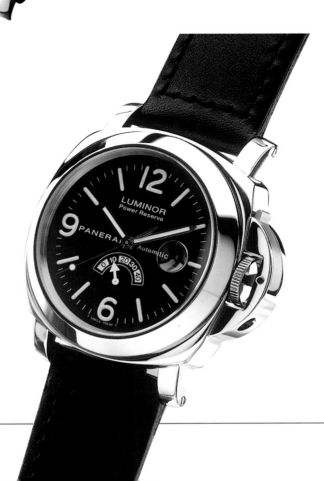

passes these tests, it is officially certified as having achieved chronometer standards. While there are several testing institutes, the most sought-after certificate is from the Contrôle Officiel Suisse des Chronomètres, or the COSC.

Borne of necessity, the chronometer was invented more than 250 years ago in an effort to solve the problem of finding longitude when sailing.

For centuries spanning as far back as the 1300s and 1400s, seafaring accidents plagued the countries of Europe because captains could not find their longitude. Determining longitude requires precise knowledge of the hour in two different places (aboard ship and at the homeport) simultaneously. The two times allow the navigator to convert the time difference into a geographical separation that determines longitude.

FACING PAGE
CENTER
Chopard's L.U.C Sport 2000 chronometer features a 65-hour power reserve and is water resistant to 100 meters. The rotor is black nickel. It is created in a numbered series of 2000 each in 18-karat gold or steel.

BOTTOM RIGHT
The Sea Battle Porto Bello Chronometer pocket watch from Ulysse Nardin depicts in the finest enamel miniature, the battle in 1708. During the war of the Spanish Succession, the English sank the Spanish galleon "San Jose."

THIS PAGE
TOP LEFT
Perrelet's limited edition automatic chronometer features a double rotor, with an upper rotor that is finely worked in 18-karat white gold and set into an 18-karat white gold case.

CENTER
The Firshire Power Reserve Chronometer by Paul Picot features a self-widing movement, is water resistant to 50 meters and features a power reserve of 44 hours.

BOTTOM RIGHT
Officine Panerai, long-time supplier of naval watches, offers the Luminor automatic chronometer with power reserve, magnified date window and protective crown lock. It is water resistant to 300 meters.

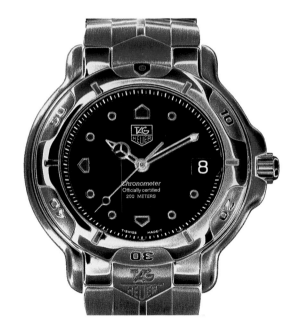

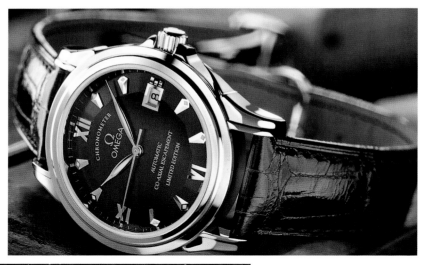

However, most ships' clocks were unable to operate accurately once they were exposed to the rolling ship decks, salt air, changes in temperature, and overall brutal elements of life at sea. Because of erring clock times, countless lives were lost at sea. Captains often made disastrous navigation decisions because of longitude miscalculations, and ended up roaming aimlessly across the ocean or coming upon unknown shoals and reefs and being shipwrecked.

In one incident in 1707, more than two thousand men lost their lives on homebound British ships. As a result, the British Parliament set the Longitude Act of 1714, offering a prize equal to several million dollars today for a "practicable and useful" way to determine longitude. The search for the solution traversed many professions. Astronomers and scientists such as Galileo, Newton, and Halley devoted time to the issue, sailors tried their hand, as did inventors and clockmakers.

In 1730, the British clockmaker John Harrison set his sights on the longitude prize. Born of meager means, he strove to develop a portable clock that would carry the true time from a homeport to any corner of the world. He spent more than forty years of his life trying to build the perfect timekeeper for sea, creating several versions and ultimately creating what is now known as the chronometer.

Thanks to advanced technology and superb craftsmanship, watchmakers today offer a variety of chronometer wristwatches that run the gamut from sporty to dressy in style. Many of the sportier models also feature chronographs or other functions such as tide indicators, pulsimeters, alarms, multiple time zones, or even more complex additions such as calendars and moonphase features.

TOP LEFT
Breitling's Chronoracer Rettrapante is an exceptional chronograph which draws on the two main technologies used in watchmaking —electronic and mechanical engineering.

ABOVE
Breitling's Shadow Flyback Chronograph Chronometer features an automatic movement, date, and tachymeter to measure speed. It is water resistant to 100 meters and features a three-gasket crown an unidirectional rotating bezel.

BOTTOM
Krieger's Aficionado Chronoscope chronometer Collection features scratch-resistant sapphire crystals with anti-reflective coating on the top and inside. Each is also a chronograph and offers pulsometer (for checking pulse rate) function. The back crystal provides a view of the automatic self winding movement. Water resistant to 100 meters.

Time Zones & Alarms

As lifestyle paces move faster and faster, watchmakers strive to develop some technologies and functions that answer to the demands of this hectic pace. Among the functions now included in many fine wristwatches are dual and multiple time zones, Greenwich Mean Time (GMT) readouts and alarms. What's more, some watch companies have even made their wristwatches convertible so they can double as a bedside table clock. ■ Because friends and family can be halfway around the world, and because business is conducted globally for so many people, having the time zone differences at one's fingertips is critical. It is this immediacy that has led to one of the watch industry's greatest tools: dual- and multiple-time-zone watches. As their names indicate, these timepieces tell time in two or more zones simultaneously. ■ Centuries ago, the sun was the only indicator people had by

which to estimate time. When the sun was directly overhead, it told people that it was noon at their location. Of course, it gave them no indication of time in another place, but in the days of solar timekeeping, that bit of knowledge was probably useless. As the people of the world began to traverse the oceans, it became more and more important to recognize the existence of different time zones.

It was in 1883 that "standard time" was fixed. At every fifteen degrees longitude on the map, lines were drawn to create twenty-four different international time zones. Each zone differed from the preceding and following zone by one hour. Thus, by looking at a map and making minimal calculations, seafarers and other adventurous travelers could calculate time differences.

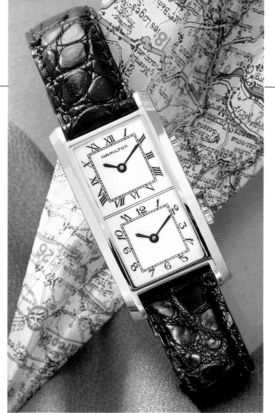

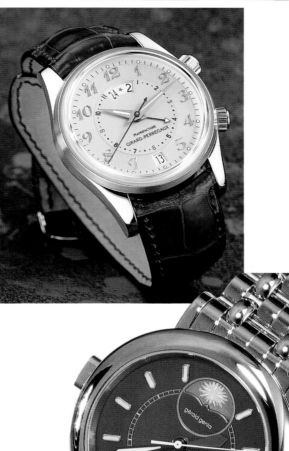

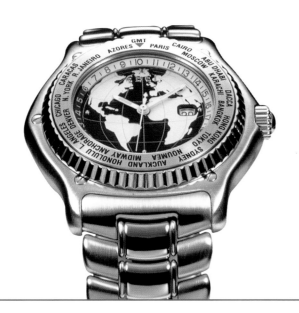

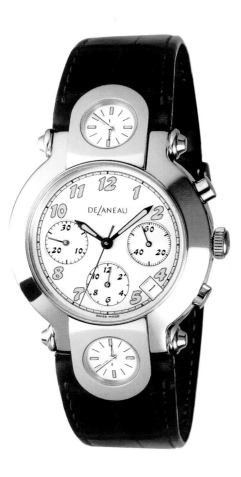

Still, as travel quickened and technology advanced, many of the watch companies of the world recognized the need to make the time zone changes more accessible. Up until a couple of years ago, most dual-time-zone watches were timepieces that featured either two faces on the main dial, one subsidiary dial on the main dial, or a second time zone on the flip side of the watch. Recent technology has allowed more adventurous design.

Aside from the traditional way of displaying dual time zones on the watch face, another method is with a "hidden" hand. The watches that utilize this approach typically feature traditional hour, minute, and second

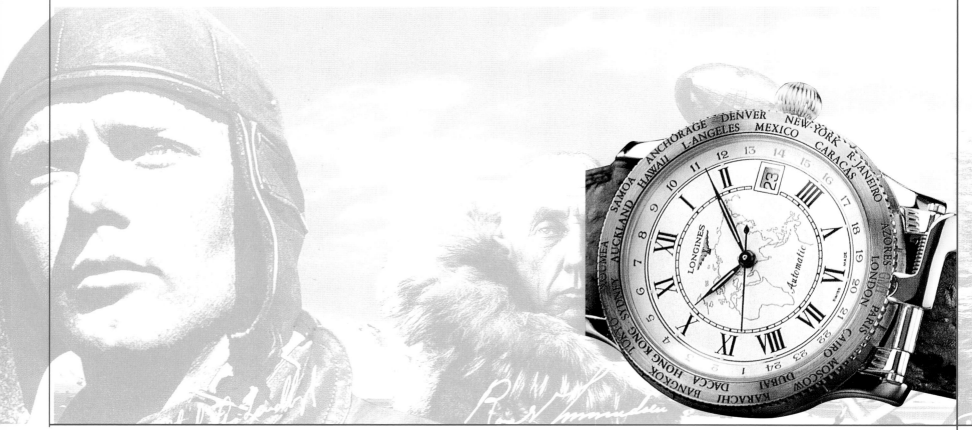

hands, with another hour hand tucked away beneath the top hour hand. The lower hand is the second time zone indicator. To activate the second time zone function, the wearer simply adjusts the lower hour hand (which is a different color than the other hands) to the second time zone. The watch functions automatically until the wearer no longer needs the two-time zone function and hides the hand away again.

This design, which several watch companies now utilize, allows for versatility. The person who does not always need a second time zone can have a classic watch in the interim. What's more, some of these designs offer an instant-set button that allows the wearer to change the hour of the second time zone hand without moving the main hands.

In addition to dual-time-zone watches, some companies offer triple time zones. The third zone is usually read off of a digital display window or sometimes off of the bezel, as is the case with many twenty-four-hour watches. These tools of the trade typically feature an

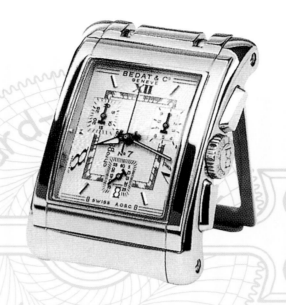

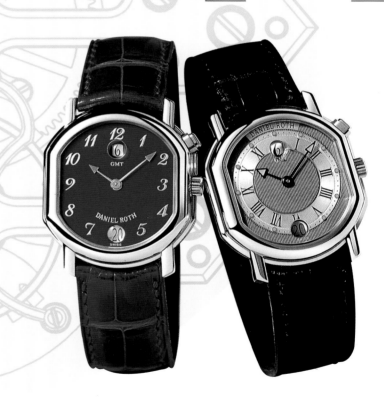

TOP

With Bedat's Chronopocket No. 7, one never needs to bring along a travel clock. The case and dial of this wristwatch easily detach and fold to stand alone on a table.

BOTTOM RIGHT

These exquisitely clean and elegant GMT watches from Daniel Roth offer alternate time through a window aperture.

LEFT

Corum's elegant Tabogan Carillon wristwatch is created in a limited edition of 300 pieces in each gold color of yellow, pink or white. Not only does the watch double as a night-stand watch because it sits up out of its flat position, but also it offers an integrated chime and calendar, for a discreet way to signal a meeting, rendezvous, etc.

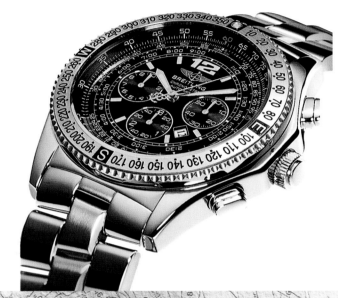

outer bezel that is a twenty-four-hour ring indicating the time in another place.

Also available are watches that offer GMT—or Universal Time—as a tool, allowing the wearer to calculate the time in any of the twenty-four time zones around the world. These timepieces operate on the concept of "mean solar time." Mean, or average, solar time is determined by the meridian that runs through Greenwich, England. This mean solar time is called either GMT or Universal Time. Greenwich is zero degrees (referred to as the prime meridian), and from there, longitudes around the world are measured. GMT is used for scientific purposes worldwide, in astronomy, and as a navigational tool on the sea as well as in the air.

On wristwatches, GMT or Universal time is indicated in a variety of ways, depending on the manufacturer. But no matter how they function, these are the watches for the person obsessed with knowing the time everywhere in the world. These timepieces typically require some calculation on the part of the wearer,

but special indicators make these additions or subtractions a snap.

As international business and travel have exploded, the ability to calculate time has become increasingly important. Along with this, the need for an alarm function to keep one on track while traversing the globe has become, for many, not only an impressive extra feature, but an invaluable one. As a result, this function is often incorporated into multiple-time-zone and GMT watches—the timepieces of immediacy.

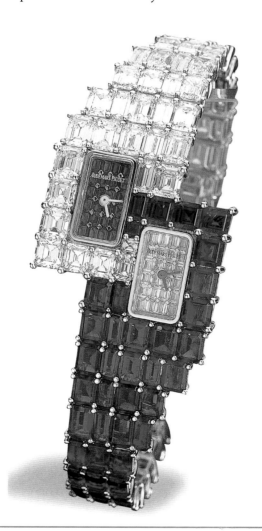

DESIGN & FASHION

*I*n the last half of the twentieth century, designers of all types took an interest in timepieces. No longer were watches considered simply a functional item; they took on a new dimension as vital fashion accessories. Among the first to take an interest in creating watches were the great jewelry houses. Some had already delved into this arena earlier in the century, while others took to it anew, creating luxurious watches that bespoke their eminent origins. ■ Clothing designers were another important group to recognize the fashion and design potential of watches. Many savvy fashion designers embraced timepieces as though they had been created explicitly for them—producing watches that mimicked either the designer's logo, clothing styles, fabrics, or overall image. ■ The time and effort that these players put into the development and marketing of watches as fashion accessories and elements of style propelled the world of timepieces to new heights. By the close of the twentieth century, nearly two dozen top designers and jewelry houses had made their mark in the world of watches.

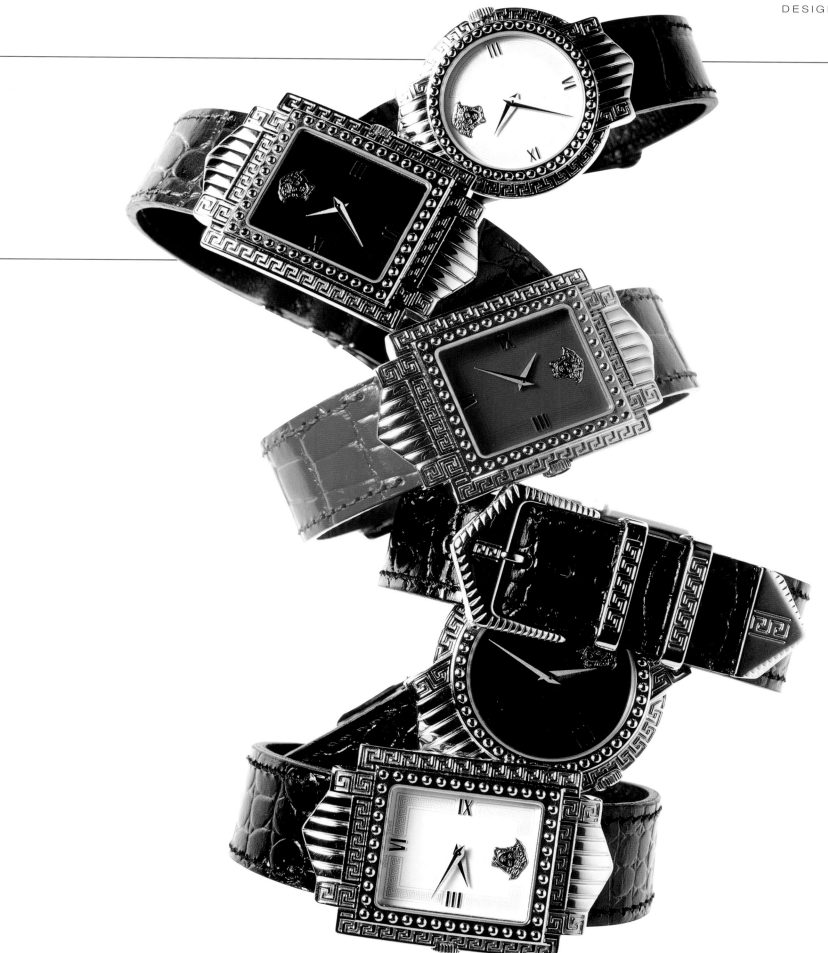

Jewelers Step In

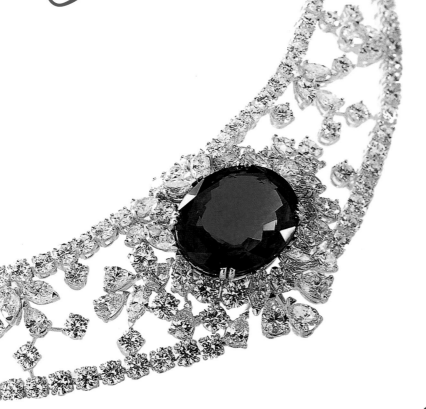

The world of timekeeping is closely linked to the world of elegance—so closely that the lines of "who designs what" can sometimes become blurred. Some of the world's greatest jewelry-making houses, such as Boucheron, Cartier, Chaumet, Chopard, and Van Cleef & Arpels, launched into the sphere of timepieces early on in their history—some even designing watches in the nineteenth century. Other great houses, such as Harry Winston, Tiffany, Bulgari, and Fred, pursued this arena later in life, introducing their first watches in the twentieth century. ■ No matter when they got their start, these great houses have become known as full-fledged watch and jewelry designers. They create some of the most stunning and sumptuous wearable works of art. Often, the watch design takes its inspiration from a jewelry design, though sometimes it's the other way around, with the watch as the impetus for the jewelry collection. In other instances, designers are inspired

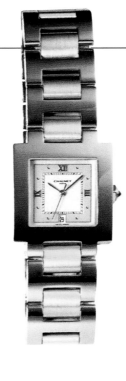

OPENING SPREAD

LEFT PAGE

Gianni Versace and
Donatella Versace.

RIGHT PAGE

Versace Meduse watches in
a rainbow of colors.

FACING PAGE

CENTER

This exquisite open-worked necklace
is crafted in a pattern Boucheron calls
a marquis crown. It features fifty
carats of diamonds, with a 35thirty-
five-carat faceted center sapphire.

BOTTOM RIGHT

In pure beauty indicative of Cartier's
master stone- setters, this jeweled
Tank watch is bedecked in diamonds
with signature sapphires.

THIS PAGE

TOP LEFT

From Fred Joaillerie, this exquisite eigh-
teen-karat white gold and diamond
ring offers flowing drama and beauty.

TOP RIGHT

This Style de Chaumet wristwatch
features a two-tone dial
and classic Chaumet design.

CENTER

From the Gioia Collection, these gold
bracelets with inset stones are
classically elegant and reminiscent of
Chaumet's style.

BELOW

Versace steps ahead with bold jew-
eled adornments from head to toe.

by outside elements such as architecture, nature, or even the stones they're using in their creations. Some of these great houses have even been inspired to go a step further, comple-menting their jewelry and watches with other accessories such as scarves, fragrances, and tabletop items.

Just as jewelry houses made their foray into watchmaking, certain top watchmakers—such as Piaget, Movado, and Audemars Piguet—branched out into the world of jew-elry design˜further blurring the distinction of "who designs what." The results are magnifi-cent combinations of style and distinction. Design has never come into play as succinctly

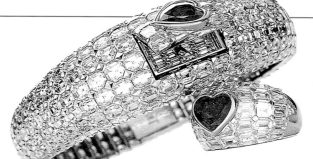

as in the finished pieces these houses create. Often, watches are bedecked in diamonds and gemstones of all shapes, sizes, and cuts. Rows of soft pearls or finely worked gold or platinum compose the bracelets of these beauties.

Overall design and accompanying accents have always been the most important factors to these firms, as they have both paved the way for and embraced the styles of each era. As art nouveau gave way to art deco, these great houses moved from floral motifs to geometric designs, from scrolled and etched gold

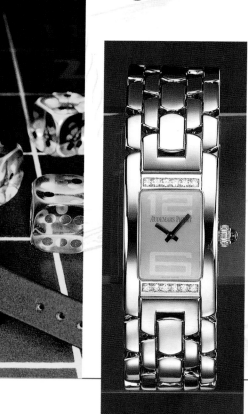

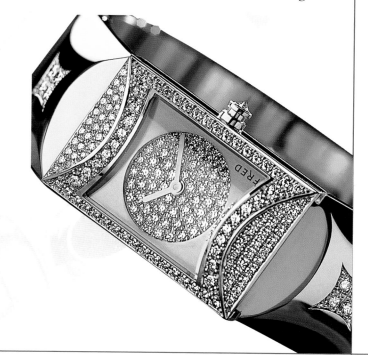

to marcasite, onyx, turquoise, lapis lazuli, and jade.

As the thirties brought forth the socialite and traveler, a new opulence entered the world of jewelry and watchmaking. Diamonds became particularly prominent through new square cuts, and precious gemstones began emerging in exciting new designs. The post-war era of the forties ushered in an interest in flora and fauna, and many of the great houses introduced jewelry

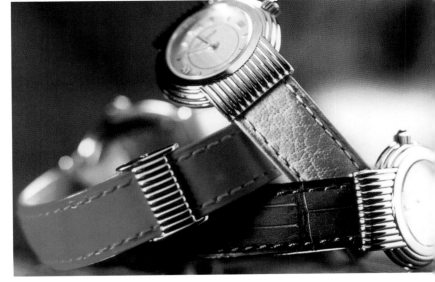

TOP CENTER
Movado, a word signifying "perpetual motion," lives up to its name sake with its innovative, always changing, collection of *objets d'art* and watches.

TOP RIGHT
This hand-made conical coffee pot by Movado is crafted in sterling silver and accented by art glass on the handle and peaked lid.

CENTER RIGHT
Boucheron watches with interchangeable straps are sleek and stylish.

LEFT
From Fred Joaillerie, this exquisite eighteen-karat white gold and diamond ring offers flowing drama and beauty.

BOTTOM CENTER
From the Haute Joaillerie collection by Chopard, this Ice Cube watch is set with more than two thousand diamonds.

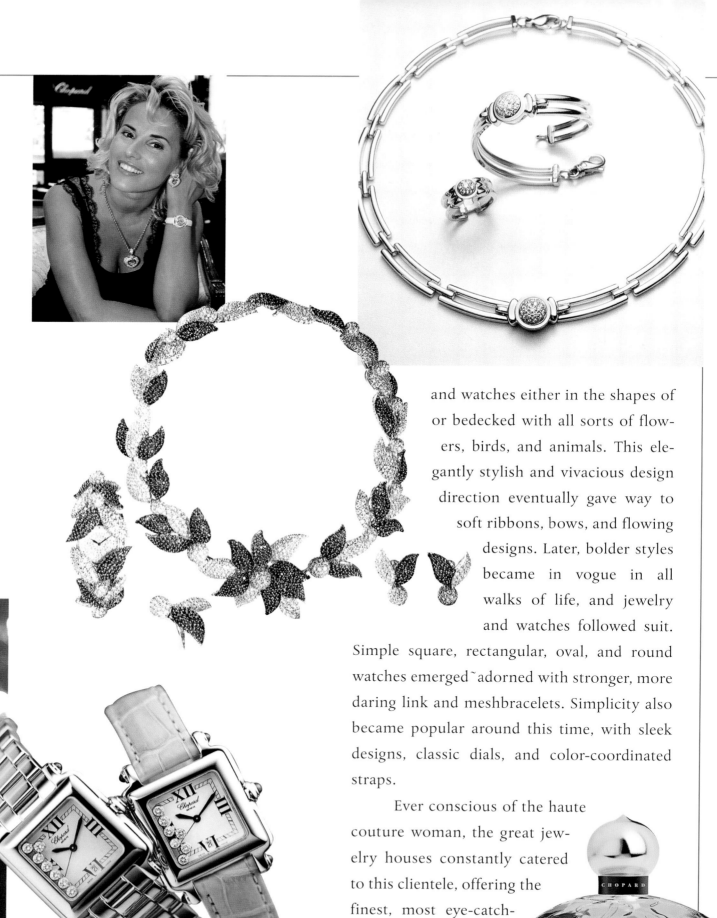

TOP LEFT
Sophie Favier wears Chopard's Happy Diamonds collection.

TOP RIGHT
Movado's classic lines are carried over into their jewelry line with precious stones and diamond accents.

CENTER
Piaget's art of jewelry and watchmaking shines in this emerald and diamond floral ensemble.

BOTTOM CENTER
Chopard's Happy Sport watches are a signature of this great house, which creates jewelry and watches with the free-moving diamonds.

BOTTOM RIGHT
Chopard's perfume bottle.

and watches either in the shapes of or bedecked with all sorts of flowers, birds, and animals. This elegantly stylish and vivacious design direction eventually gave way to soft ribbons, bows, and flowing designs. Later, bolder styles became in vogue in all walks of life, and jewelry and watches followed suit. Simple square, rectangular, oval, and round watches emerged~adorned with stronger, more daring link and meshbracelets. Simplicity also became popular around this time, with sleek designs, classic dials, and color-coordinated straps.

Ever conscious of the haute couture woman, the great jewelry houses constantly catered to this clientele, offering the finest, most eye-catch-

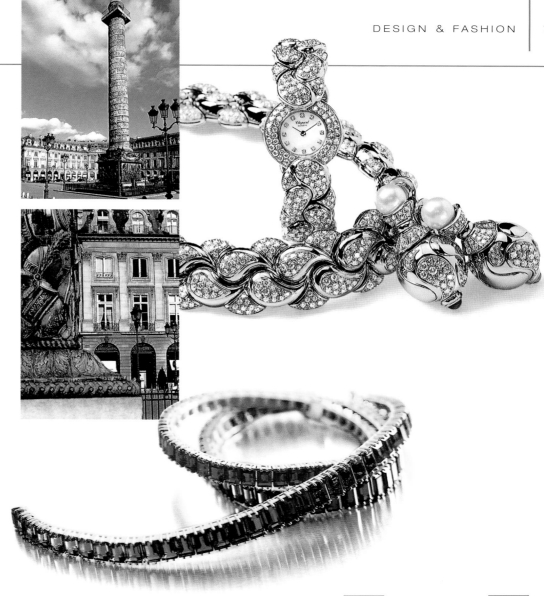

ing finishing touches that would allow women to define their own personal style. By the last few decades of the twentieth century, these great jewelry and watch houses had come full circle: They had created tiny timepieces, large timepieces, watches with a hint of diamonds, and watches ensconced in diamonds, all so that the wearer could choose the type of watch that suited her best.

On the cusp of the new millennium, these great houses were steeped in a reputation rich with pride and confidence. They were renowned for always being on the cutting edge, being able to coordinate their jewelry lines with their watch lines, and offering discriminating, singular looks. As the century turned, they had secured their inevitable position as leaders in the world of jewelry and watch design.

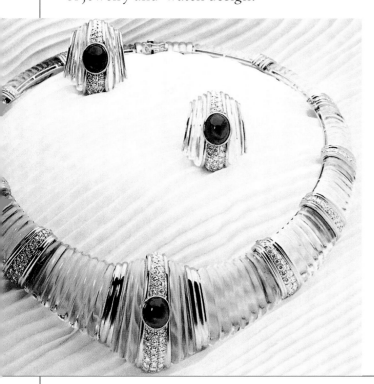

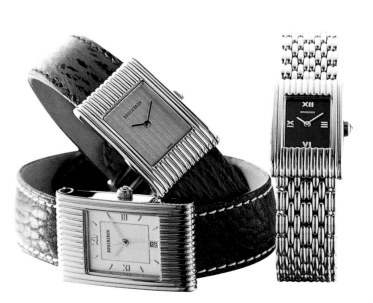

Designer Watches

While the great jewelry houses were driven by art and design to create scintillating watches, the fashion houses were also drawn to timepieces—but generally not until the final quarter of the twentieth century. While some top designers such as Hermes and Chanel had dabbled with an individual watch design here or there as early as the 1920s, it was decades before the concept of designer watches took hold. ■ The burgeoning growth of watches created by clothing and fashion designers was experienced around the world nearly fifty years later and was spurred by two critical spokes. One factor was the advent of the quartz watch, which made its firm and popular appearance on the scene in the late 1970s and enabled smaller, thinner, and more affordable watches. The other important influence was the shift in attitude about timepieces that came about with the more decadent lifestyle of the 1980s. As the hectic pace of business picked up, so too did the desire for personal satisfaction in sports and recreation. Along with this came an affirmation to be oneself—a desire to make a personal statement and impression.

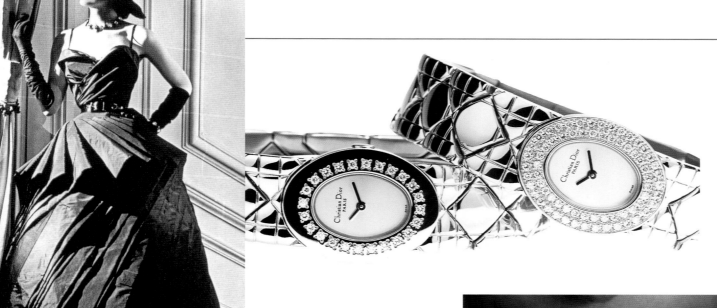

FACING PAGE

CENTER

A portrait of Coco Chanel.

THIS PAGE

TOP RIGHT

The Lady Dior offers modern design and balance for a softly feminine appeal indicative of Christian Dior's designs.

CENTER

The newest watches from Fred mimic the brand's dramatic style and image.

BOTTOM

The Morgan by Coach is a modern interpretation of a traditional tonneau-shaped timepiece. This chronograph offers classic, sophisticated design that is in keeping with the Coach products.

Watches became a part of this self-expression and individualism and were considered accessories that could tell all about the wearer.

It was a natural step, then, that fashion designers—who were popular for their signature looks and definitive statements—would be looked to by consumers to provide necessary direction in accessories. By the last decade of the twentieth century, the movers and shakers in the design world had introduced their own lines of watches and were enjoying an unparalleled heyday.

Perhaps more than ever before, the love affair between women and fashion was in bloom. Brand and designer names had a special place in the world of fashion, and consumers

TOP

From the Matelassee collection by Chanel, this watch offers an elegantly quilted bracelet pattern reminiscent of Chanel.

CENTER LEFT

The Premiere watch from le Temps Chanel reflects the Chanel style in its purest form. The sapphire crystal with beveled edges is inspired by the stopper of the Chanel No. 5 bottle, and the chain bracelet, interlaced with leather, echoes the chains on the quilted handbags designed by Coco Chanel.

CENTER RIGHT

From Hermes, this Montres Espace watch features bold yellow digital readout in addition to the analog timekeeping function.

BOTTOM

In an effort to offer versatility—a key issue in designer watches—Hermes createds the Montre Belt watch, with interchangeable straps.

had an almost built-in predilection toward obtaining designer jewelry and watches—especially at the luxury level.

What's more, many designers believed that while the great watchmaking houses provided important timepieces, and the jewelry houses provided haute joaillerie watches, there was a void when it came to more fashionable styling. These designers set out to create their own signature in wristwatches — one that would belie the self-expression of their dreams and fulfill the demands of their customers.

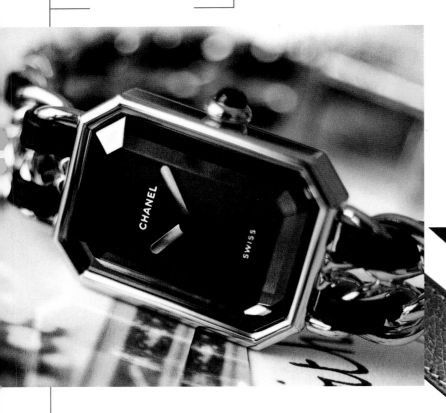

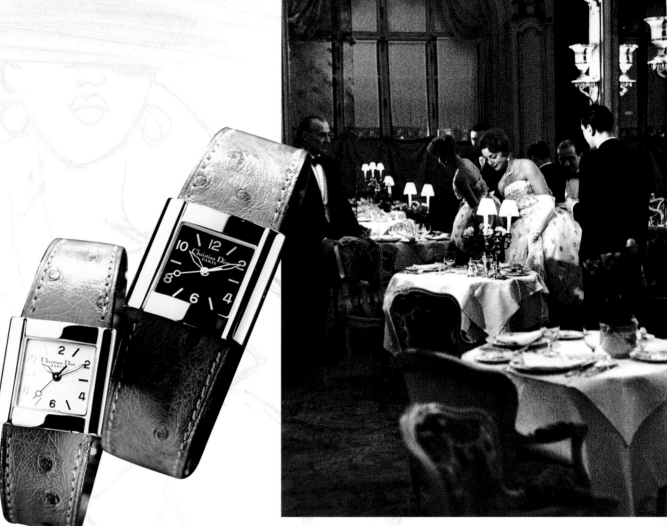

Among the first to initiate its own fashion watch line was Gucci, beginning in the early 1970s with a moderately priced timepiece collection. Similarly, Hermes, which had been making watches since the 1920s via outside watch houses, broadened its scope in the late 1970s when it developed its own watch manufacturing plant in Switzerland. The time was ripe for the firm to make this bold step, as the future of designer watches seemed exceptionally bright.

The Hermes watches emulate the brand,s distinctive "H" logo in both case shape and dial design. The back of each Hermes watch is engraved with the famous logo. The timepieces are crafted in eighteen-karat gold, sterling silver,

CENTER
The Riva by Christian Dior pays homage to the 1950s in the classically elegant, yet bold design.

BOTTOM
Calvin Klein's strikingly clean chronograph offers the simplicity and sporty elegance the fashion house is known for.

and stainless steel, and are often adorned with diamonds.

Later, other exclusive designers jumped on board the watchmaking bandwagon with watches that captured their signature style. Chanel, for instance, introduced wristwatches inspired by the company's clothing motifs. Chanel link chains that had been designed by Coco Chanel and had become famous on its handbags became the watch bracelets, and the watchcases were shaped after the stoppers of the famous Chanel No. 5 perfume bottle. Other designs offered either classic, sophisticated styling indicative of Chanel—such as pearl bracelets or black dials—or the more innovative, freer

TOP
Versace Madison men's model features Matt black dial and black cross-grained goatskin strap. It is water-resistant to 30 metres and has Swiss Made quartz ETA movement.

BOTTOM LEFT
With engraved Greca decoration, the Versace Fifth comes in men's and ladies' models, black or silver dials, and black or brown cross-grained goatskin straps.

BOTTOM RIGHT
The Versace Automatic Chrono Gent.

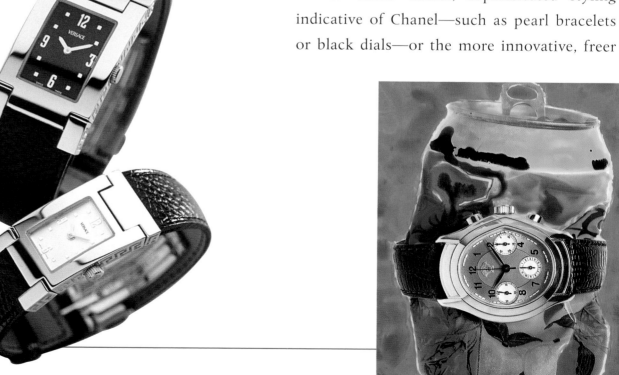

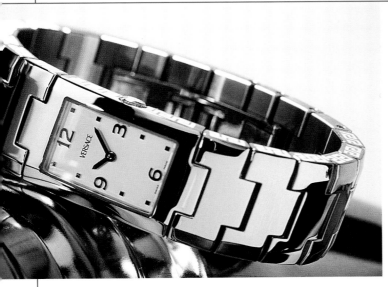

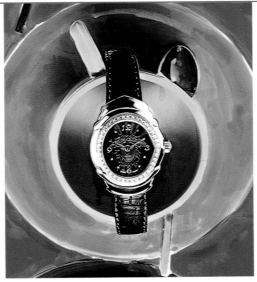

TOP LEFT
Versace Greca ladie's model with
Matt silver dial in cambered steel case
with steel bracelet.

TOP RIGHT
The Medusa line of watches by
Versace features the Medusa
emblem engraved on the dial. This
watch is accented with a black dial
and adorned with a diamond bezel.

BOTTOM
Featuring bold blue face and strap,
this Versace Automatic Chrono Gent
also has the Medusa head; inset in
crown position.

spirit that has also characterized the brand over the years. Such a mood is embodied in bold, open-linked bracelets and solid bracelets that emulate the quilting of Chanel handbags.

In the 1990s, designers such as Versace and Calvin Klein actively joined in the timepiece craze—offering designer watches that ran the gamut from fancy to sporty to avant-garde. Versace, a name synonymous with strong personality, confidence, and distinction, offered a certain purity and modernity in its watches that complied with the Versace philosophy. Strong geometric and unusual shapes were the mark of Versace watchcases. Dials were striking in their clean lines and subtle elegance, and sometimes were adorned with diamonds.

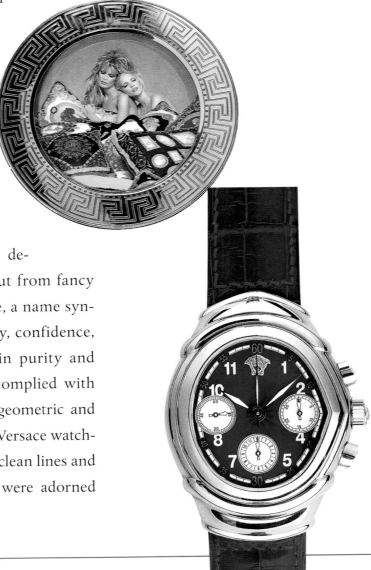

TOP RIGHT
Shakespeare watch by Swatch.

FAR RIGHT
Christian Dior and the model Sylvie.

CENTER
These dynamic Alfred Dunhill CityScape sports watches offer updated style yet reflect the bold appeal of Dunhill fashions and accessories.

BOTTOM LEFT
Raquel Welch with a Breitling Co-Pilot in the film *Fathom*.

BOTTOM RIGHT
Aptly named the Legacy, this Coach watch is designed in the unique buckle-shaped case that is the hallmark of Coach's philosophy and workmanship on its leather goods. This signature style is created on a strap or a bracelet.

FACING PAGE
CENTER
In the tradition of Coco Chanel, who had a passion for pearls, this distinctive watch features four rows of lustrous pearls for sublime elegance.

Whether it is the brand name, the designer appeal, or a combination of both, designer watches remain a strong niche in the world of watchmaking. As the world of fashion gears up for the individuality that the millennium holds, designers continue to create watches that mimic their own designs and meet their consumers' lifestyle needs.

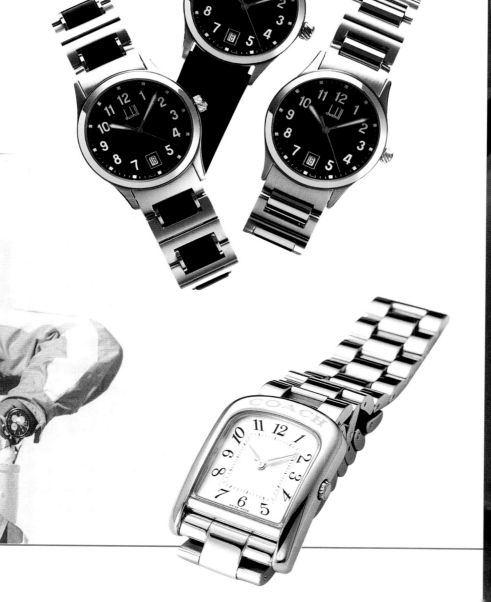

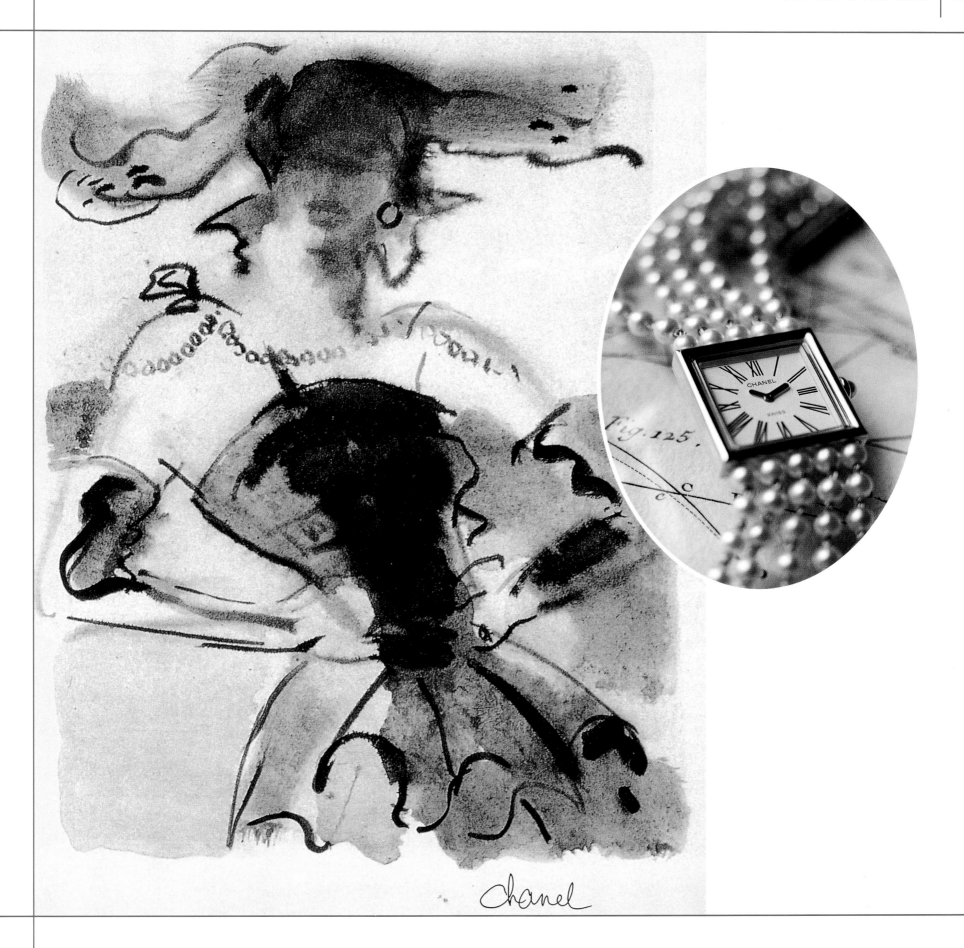

Chanel

FUTURE MASTERPIECES

The twentieth century brought with it advanced technology and a heightened quest for exploration that lead to new frontiers. Man navigated the depths of the ocean and explored the moon — and vital to their missions were top-of-the-line precision timepieces, instruments geared especially for diving and aeronautics. ■ Aside from these rugged yet elegant pieces of equipment, a wave of new timepieces made their way into the new millennium. During the 1990s, the race was on among top watchmakers to develop new technologies and utilize all kinds of materials. The finest watchmaking houses turned to natural fancy-colored diamonds such as pink, yellow, blue, and even black to accent their timepieces; others developed and implemented the methods required to set diamonds into steel—giving way to another important watch category. Platinum became all important, as did gold in its rainbow of available colors. ■ Similarly, with cutting-edge technology abounding in all fields, watchmakers took note of alloys and materials used in other applications and integrated those materials into their timepieces. Aeronautical titanium, aluminum, cermaic, rubber, and carbon fiber are among the high-tech materials gracing fine watches of the future.

Deeper Depths

The twentieth century was filled with people and companies intent on exploration—including those with the desire to reach new depths. From the first quest, watches accompanied explorers and professional divers on their adventures. Indeed, diving—for both professional and recreational purposes—requires highly technical precision instruments, and watchmakers understand this. Over the years, top watchmakers have developed timepieces to withstand this watery arena. ■ In fact, by the first decade of the twentieth century, watchmakers had already recognized the usefulness of strong, rugged wristwatches, as witnessed by the military acquisition of such timepieces during the Boer War of 1899 to 1902. However, more than just durability was needed; in the first quarter of the twentieth century, watch manufacturers made a concerted effort to create even more versatile instruments for military and sports uses—and the race was on to create a true water-resistant watch. ■ It was Rolex that made world headlines in 1926 on the wrist of Mercedes Gleitze, who swam the English Channel that year wearing the Rolex Oyster. The watch performed as well as the swimmer, and Rolex was

recognized as creating the first waterproof watch. Thirty-four years later, a specially made Rolex watch was strapped on the hull of the bathyscaphe Trieste for its venture to the deepest point of the earth yet visited, the Mariana Trench. Having achieved a depth of 35,798 feet, the Rolex watch still worked like a charm.

In the last quarter of the twentieth century, free-lake diver Roland Specker, world-record holder in the "no-limits" category of lake diving (diving to eighty meters—approximately 240 feet—without oxygen support, using a cable and a cast-iron weight, and resurfacing with an ascending parachute), set a new world record in the "variable weights" category—resurfacing assisted only by flippers. Specker used an Omega Seamaster 300-Meter Chrono

CENTER

This special limited-edition Seamster Skeleton watch from Omega offers a see-through dial to view the exquisite inner workings. It features a unidirectional turning bezel.

BOTTOM

The Vir Diver's Watch from Bertolucci has a self-winding movement and is water-resistant to three hundred meters This model is crafted in eighteen-karat white gold.

FACING PAGE

TOP

The Automatic Super Professional from TAG Heuer is water-resistant to one thousand meters and features luminescent hands and markers.

CENTER

This Porsche Design chronograph from Eterna features a stainless steel case and bracelet with a matte black chrome plating. It is water-resistant to fifty meters.

BOTTOM

The Tutima Pacific Automatic timepiece features a unidirectional rotating bezel with ratchet and is crafted in stainless steel.

Diver watch to time his one-minute-and-forty-five-second round trip to sixty meters.

Today, many of the finest watch companies create "dive" watches; these are all defined by certain characteristics. Such features typically include chronometer certification, durability, extreme water resistance, anti-glare crystals, luminous hands and markers, and case and bracelet materials that can withstand the elements of salt, water, and temperature change.

Of course, depending on the depths one wishes to reach, the water-resistance feature may well be the key one in a dive watch. Watchmakers are careful to equip their specific

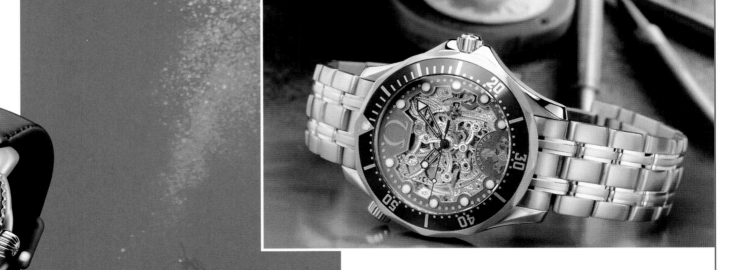

timepieces with a variety of features, many of which are patented. Such features include double- or triple-locked winding crowns, additional gaskets for water resistance, helium escape valves, silicone "o" rings, extra-large crowns, graduated one-way rotating bezels that click into place, and double-locked bracelet clasps. Watchmakers offer timepieces that are water-resistant to depths anywhere from 50 feet to thousands of feet—all in an effort to please each individual sports enthusiast.

To ensure durability under extreme conditions, most watchmakers turn to cutting-edge materials for the cases and bracelets of

TOP RIGHT

The GST Deep One from IWC combines a mechanical and automatic movement and features a dive timer, a depth gauge, and a maximum depth indicator. Crafted in titanium, it is also supplied with a Velcro strap that can be fitted without special tools so the watch can be worn over a dive suit.

TOP CENTER

Aptly named the Hammerhead, this Krieger chronometer is water-resistant to almost one thousand feet. It features a skeleton back, unidirectional bezel, and tritium markers and hands.

BOTTOM RIGHT

Breitling's Colt Oceane is water-resistant to five hundred meters and, like all Breitling timepieces, is a certified chronometer.

BOTTOM LEFT

A master of craftsmanship, Oris creates only mechanical timepieces, as with this Full Steel dive watch.

these timepieces. For dive watches today, surgical grade stainless steel and titanium are most often the metals of choice for cases and bracelets, but some watchmakers also use high-tech composites such as engineering ceramic for cases and either sharkskin or rubber for straps.

Watchmakers are also careful to take into consideration the special needs of divers, often equipping these durable watches with functions and amenities that divers may desire. Some dive watches indicate bottom time, measure elapsed time, have an alarm function that can be sensed under water, and even come with interchangeable bracelets or straps with extensions so that the watch can be worn over the wet suit. However, no matter what the added feature may be, watchmakers are always cognizant of the need to provide underwater adventurers with durable, reliable, precise timepieces—and strive to that end.

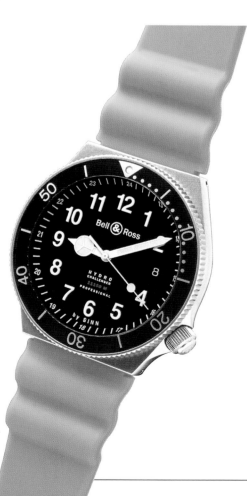

TOP
The Luminor Submersible from Panerai features an automatic movement and a special patented lock to protect the crown. The date window is magnified, and hands and markers are luminous for better underwater visibility.

BOTTOM LEFT
The Sportwave Chronograph from Ebel is water-resistant to fifty meters and has a titanium bezel and steel case.

BOTTOM RIGHT
The Hydro Challenger from Bell & Ross is water-resistant to the deepest part of the ocean, but its dial only reads 11,100 meters. It is fully injected with silicon, which has a density superior to water and is pressure positive.

New Heights

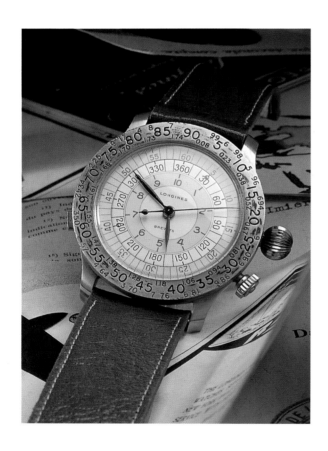

I n March 1999, just on the cusp of the new millennium, the century's last aeronautical record was made. Interestingly, it was achieved in a balloon. While the sport of ballooning is several hundred years old, no one had ever before gone around the world in a balloon. ■ On March 21, however, Swiss pilot Bertrand Piccard and copilot Brian Jones completed their successful circumnavigation of the globe; it took them nineteen days, twenty-one hours, and forty-seven minutes. The trip was made possible thanks to many factors, including a pressurized cabin (so they could fly at altitudes as high as thirty-six thousand feet) and the support of the Breitling Watch Company. Breitling, known for its avid aeronautical involvement, sponsored the Orbiter 3 balloon and its crew, equipping the pilots with Breitling Emergency watches that would send out emergency signals to search-and-rescue teams should the balloon go down.

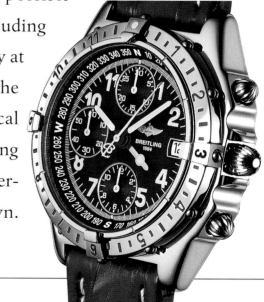

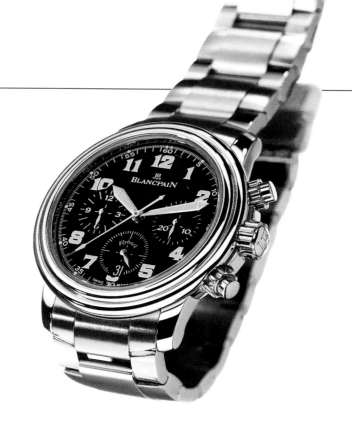

While this momentous flight will have a place in history, other incredible frontiers of height were also accomplished in the twentieth century. Once again, timepieces played an important role in most of these conquests. Longines entered aviation history in 1923, the year of its first exploit with an aviation pioneer. (Eventually, the number would be a grand thirty-four.) After Charles Lindbergh made his solo transatlantic flight in 1927, he designed the Hour-Angle watch and sent the proposal to Longines for development. (The company still creates the Hour-Angle watch in updated versions.)

Omega took a giant step in 1965 when NASA, after blind-testing chronographs from several different watchmakers, selected the Omega Speedmaster as the official watch of the American-manned space flights. When Neil Armstrong stepped onto the moon's dusty Sea of Tranquility on July 21, 1969, he was wearing an Omega Speedmaster. Later, in 1970, the Speedmaster Professional contributed to saving the lives of the astronauts aboard the doomed Apollo 13 shuttle (Commander James Lovell used his Speedmaster to time to one-tenth of a second the firing of secondary rockets, taking the ship out of lunar

FACING PAGE

CENTER

Longines continues to create the Hour Angle timepiece—one of the most popular pilot watches for the brand. It was designed by Charles Lindberg following his cross-Atlantic flight.

BOTTOM RIGHT

The Chronomat Longitude chronometer watch by Breitling not only features

THIS PAGE

TOP

From Blancpain's Land, Air, Sea trilogy, the Flyback Chronograph features an automatic movement and is crafted in steel.

BOTTOM LEFT

Fortis, the supplier of the Official Cosmonauts Chronograph to cosmonauts trained at the Training Center Star City, has created a limited edition of three hundred pieces of the Fortis Space Edition.

BOTTOM RIGHT

From Revue Thommen, this Airspeed Altimeter mechanical watch features an altimeter to measure altitude and barometric pressure.

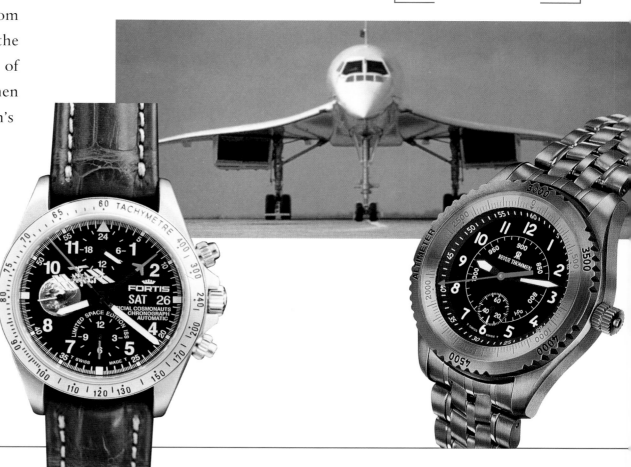

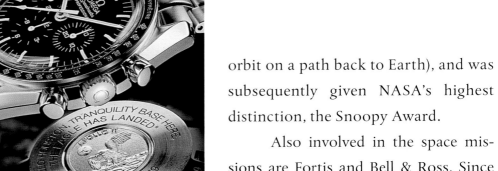

orbit on a path back to Earth), and was subsequently given NASA's highest distinction, the Snoopy Award.

Also involved in the space missions are Fortis and Bell & Ross. Since the beginning of the European-Russian space mission Euromir '94, Fortis chronographs have been part of the official equipment of the cosmonauts and were on the wrists of two cosmonauts in free space during the Soyuz TM 19 mission. Bell & Ross launched into space exploration in 1983, when its Space One watch with automatic movement was worn by Reinhart Furrer of the Spacelab mission. Also venturing into space was a Breitling Cosmonaute watch, which went on a trip on the wrist of Lieutenant Commander Scott Carpenter in 1962 during the Mercury program.

For a watch to be deemed an aeronautical instrument, it must meet certain criteria. Perhaps a cardinal rule in creating a pilot's watch is making sure it is a chronometer, as precision is crucial. Another key factor is anti-magnetism. Magnetism can affect the precision of watches. A magnetic field, often encountered in flight, has two properties: attraction and repulsion. These can throw the average mechanical watch completely off balance. Watch movements (particularly the escape wheel, balance ring, spring, and plate) become

confused by magnetic fields and do unpredictable things, resulting in total inaccuracy. Of course, this was more detrimental in the early days of flying, when pilots relied on their watches as a key instrument.

Master watchmakers at IWC developed a way to outwit magnetism more than sixty years ago. The then-revolutionary idea was to divert the magnetic fields by housing the watch movement in a jacket made of a special alloy that conducts magnetic fields, virtually eliminating the formation of magnetic fields inside the jacket. Today, many watchmakers get around the anti-magnetism issue by either installing a similar system or utilizing a titanium case, which also makes it impervious to corrosion and magnetic fields.

There are a wealth of other functions that various watch houses build into their pilot watches in an effort to be all-inclusive for the wearer. Such functions include slide rule bezels, a compass, telemeter scale (to measure distance) and tachometer scale (to measure speed), multiple-time-zone readouts, and a chronograph function. Some pilot timepieces also protect against temperature extremes and offer the adventurer a pulsimeter—an interesting function to have as we venture through a new century.

FACING PAGE

TOP

The Speedmaster Professional Apollo 11 chronograph celebrates the thirtieth anniversary of the first moon landing. The case back of this Omega watch is stamped with the mission emblem and is surrounded by an engraving of Neil Armstrong's first words on the moon.

CENTER

The Space 1 by Bell & Ross contains all of the key features and functions typical of this flight instrument, with luminous hands and oversized markers.

BOTTOM

The Aero-Compax 24H from Universal Geneve is equipped with a hand-wound movement. Its features a chronograph and a unidirectional rotating bezel with twenty-four-hour for second time zone reading.

THIS PAGE

TOP

The Oris Big Crown Original watch, created for pilots, features an oversized crown for easy turning on the wrist.

CENTER

The Military Flieger Chronograph from Tutima, developed for the German Air Force, features a mechanical movement, a double-sealed crown, and a convex sapphire crystal with luminous hands and markers.

Precious Materials

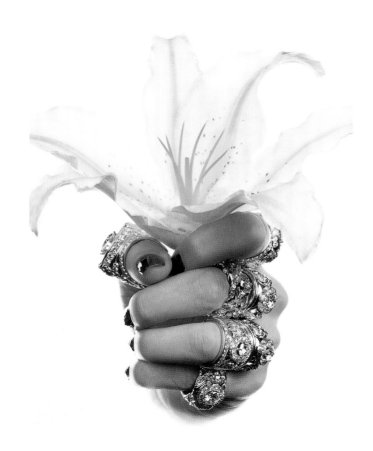

There is perhaps nothing on earth as precious as diamonds. These captivating stones have been mesmerizing men and women for centuries, and watchmakers have been using them in their watch designs almost equally as long. However, it is only in the last few years of the twentieth century that watchmakers turned their attention to natural fancy-colored diamonds. ■ This new foray offers incredible luxury and rarity in the world of fine timepieces. While clear or colorless diamonds have always been the most sought after, it is natural colored diamonds—referred to as fancy—that are truly the most rare and exciting stones. In fact, half of the world's greatest diamonds are natural fancies, including the deep blue Hope diamond and the bright yellow Tiffany diamond. It is estimated that for every ten thousand colorless diamonds, there is just one fancy colored diamond. ■ Interestingly, colored diamonds have a particular hue because of some flaw or imperfection in their makeup. These diamonds are not pure carbon, as colorless diamonds are. Blue diamonds,

for instance, are the result of boron within the structure, whereas yellow diamonds are linked to nitrogen traces. Other factors that can influence color in diamonds are hydrogen and fluorescence. And in some instances, such as with red, pink, purple, and violet, the deformation at the center of the diamond is unknown.

Fancy-colored diamonds have been mined and made into jewelry in small amounts for centuries, but now these scintillating stones have caught the eye of only the most discerning watchmakers. From vivid yellow to pale blue, pink, and even black, colored diamonds are being snapped up by the finest watchmakers in the world—who are turning out spectacular masterpieces with them.

Primarily, watchmakers turn to pavé diamond setting—where tiny diamonds are set one next to the other to offer a shimmering "paved" effect—for these watches. Often these pavé creations are color coordinated, with pink diamonds set in pink gold, yellow diamonds set in yellow gold, and white diamonds in white gold.

Because of all of the inclusions in black diamonds, it is very difficult to polish them, so they rarely have the shimmering appearance of other diamonds. Not considered by most to be fine, collectible diamonds, black diamonds nevertheless are diamonds, and make interesting, captivating watches.

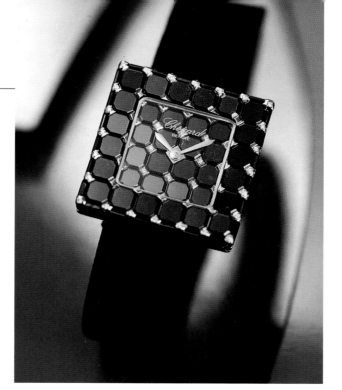

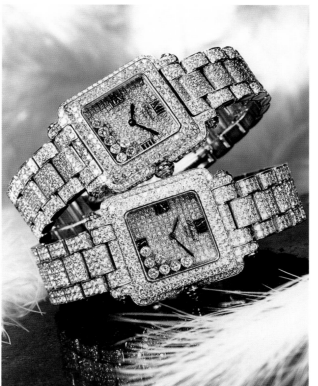

FACING PAGE
CENTER
D-Flawless rings from the Gianni Versace Collection.

THIS PAGE
TOP
Created by the astute jeweler de Grisogono, this stunning black and white diamond Ice Cube watch is created by Chopard.

CENTER
The Happy Sport Collection from Chopard is crafted in eighteen-karat pink and white gold color-coordinated with just over six carats each of pink and white diamonds.

BOTTOM
This Cartier Pasha watch in eighteen-karat gold features a grid set with shimmering yellow diamonds for added appeal.

Another of the Earth's most precious materials is platinum—a material watchmakers love to use in their finest creations. This incredibly rare metal was considered an annoyance in the middle of the eighteenth century to Spanish conquistadors who were searching for silver in what is today Colombia. Not recognizing the value of the metal they consistently came upon, they coined for it the term platina (little silver)—a diminutive name given in contempt.

However, platinum is today considered the world's most precious metal—making it highly desirable for luxury watches. One of the most difficult metals to obtain, it is estimated that to secure enough platinum for the case of a single watch, approximately ten tons of plati-

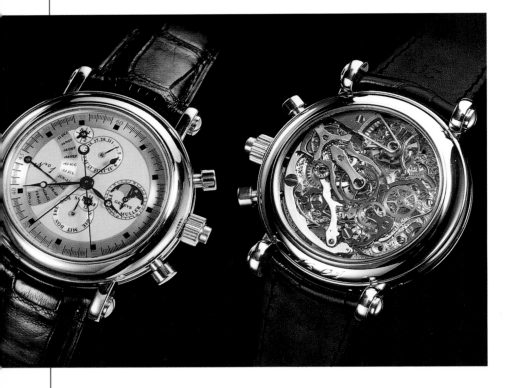

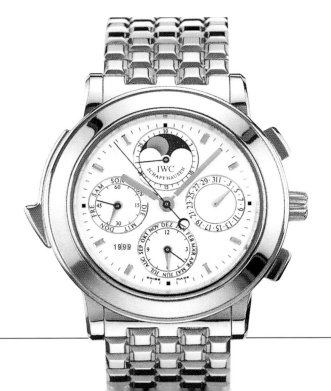

nous rock from a depth of three thousand to five thousand meters would have to be extracted. With the exception of a few instances at various points during the twentieth century, it was really not until the 1990s that platinum became popular in the world of watchmaking. In fact, the luxury Swiss watch industry is one of the largest procurers and users of platinum. Because of platinum's inescapable beauty and allure, the metal is typically reserved by these luxury producers for special timepieces that are introduced as celebration models or limited editions.

Interestingly, despite the fact that platinum is extremely rare and very difficult to work with in jewelry making (the metal is soft when pure and must be alloyed with a tiny amount of copper to attain the flexibility and strength required for crafting the final piece of jewelry or watchcase), luxury platinum watches can be obtained at prices ranging from approximately twenty thousand dollars to well over a hundred thousand dollars, depending on the movement housed within.

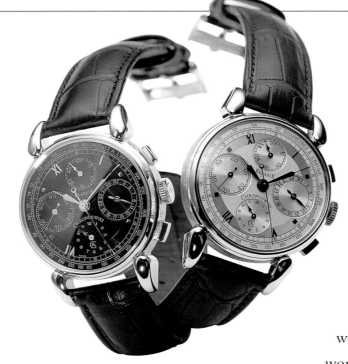

The glitter of gold holds a special place in history, civilization, and jewelry and watchmaking. This incredible metal was worshipped by early cultures and has been prized as the metal of the elite for centuries.

Thus, it comes as no surprise that this shimmering metal, so everlasting, would be the material most often utilized by the finest watchmakers of the world. Gold—perhaps the only metal in the world with such a long and impactful heritage—surely remains the metal of the new millennium.

Watchmakers have taken the legacy of this metal and modernized it for tomorrow's timepieces. Eighteen-karat yellow gold has typically been the metal of choice for watchcases and bracelets, but as the twentieth century gave way to the twenty-first, watchmakers were turning more and more attention to alternative shades of gold—particularly rose and white. Pure gold is too soft for ordinary jewelry making and watchmaking. To strengthen it, gold is alloyed with other base metals. Depending on the metal added to gold, it takes on different colors and properties.

Yellow gold is usually alloyed with silver and copper so it retains its yellow color. Rose gold is achieved by adding six

karats of copper to eighteen karats of gold. This color played a starring role in men's and women's watches of the last few years of the twentieth century. Often, these rose gold beauties are accented with copper-colored dials or, in the case of chronographs, with white dials and pink-hued subdials.

White gold is attained by adding nickel or silver to pure gold. As the "white hot" craze of 1999 and 2000 picked up speed, so too did the use of the shimmering white. Often, these white gold watches were high-polished designs, but some companies broadened their selections with combinations of matte-and-polish finishes to achieve texture and depth. Other variations of color hues—including red, green, and peach—also exist, though they are much less frequently used. It is primarily the rose or pink gold, white gold, and the tried-and-true yellow gold that emerge as the shining stars of the early twenty-first century.

TOP
Perrelet crafts its fine watches in eighteen-karat white or yellow gold to more attractively coordinate with the dumortierite dials.

CENTER
This Technicum from Paul Picot is crafted in eighteen-karat pink gold for added elegance to this automatic chronograph calendar watch.

BOTTOM RIGHT
Jacquet Droz works wonders with eighteen-karat white gold, typically accenting it with striking colors as in the blue engraved dial seen here.

High Tech Materials

As technology improves by leaps and bounds in all walks of life, many savvy watch companies look to the materials used in other fields to inspire new and different approaches in watchmaking. ■ Constantly searching for new materials that will enrich their designs, top watchmakers have turned to materials used in space exploration, surgery, automobile racing, and other arenas. One of the most prominent new materials in watchmaking comes from space exploration: Titanium, an alloy that is ultra strong and ultra light, has been used on space shuttles and jets and in surgical instruments. ■ Most recently, watchmakers have turned to it for their sports watches. Because of its durability and impervious nature, titanium does not succumb to corrosion or elements of nature. Its light weight makes it ideal not just for watchcases, but for bracelets as well. Prime users of titanium include IWC, Porsche Design by Eterna, TAG Heuer, and Omega—each

of which has introduced important sports models made with this durable, lightweight metal. Some watchmakers have even turned to titanium for their signature timepieces, such as Audemars Piguet, who produces a titanium Royal Oak chronograph watch.

Another important material newly used by watchmakers is rubber. This synthetic material has been around for years, as is evidenced by tires; however, its use in watchmaking is relatively recent. Perhaps the only exception is in the case of Hublot, the first watch company to introduce its entire watch collection with rubber straps. Other than Hublot, most companies began utilizing rubber in the last five years of the twentieth century—billing it as a material for the millennium.

Rubber is primarily used for straps, often embossed or designed with great detail. Chopard, for instance, mimics automobile tire treads on its Mille Miglia rubber strap. Similarly, Patek

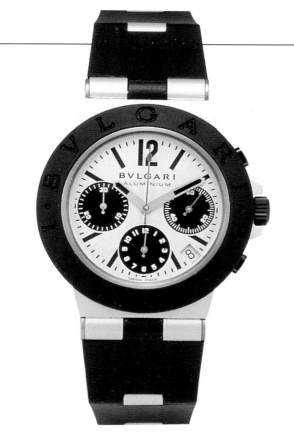

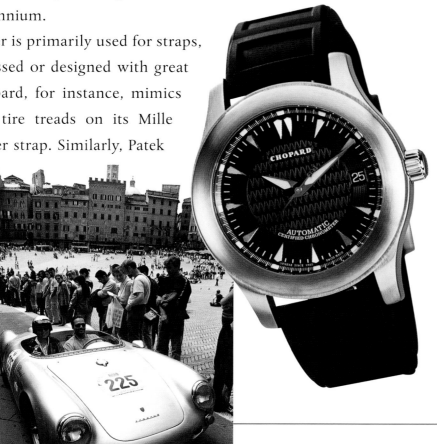

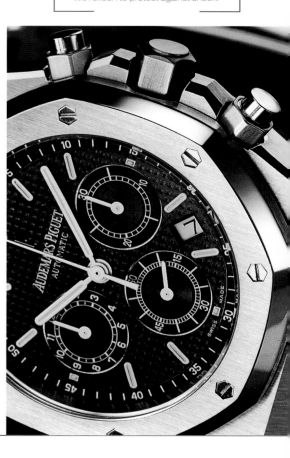

FACING PAGE
CENTER
The Ti5 from TAG Heuer is crafted in a polished alloy of titanium and aluminum called Grade 5 Titanium.

BOTTOM RIGHT
Baume & Mercier adeptly combines rubber and steel for a high-tech, high-fashion look in this Catwalk watch.

THIS PAGE
TOP
Bulgari crafts this sharp chronograph in an aluminum case with an aluminum and rubber bracelet.

BOTTOM CENTER
Chopard utilizes rubber for straps on certain of its sports watches, as with this L.U.C. Sport 2000.

BOTTOM LEFT
Mille Miglia 1999. The Chopard team. Porsche 550A 1955.

BELOW
The Royal Oak Offshore Chronograph is crafted in titanium and finished in matte gray. Audemars Piguet selected this lightweight, durable material to complement its functions. The crown and pushers are layered with silicon to protect against shock.

TOP

Focusing on futuristic design and high-tech materials, Rado creates the Cerix watch in scratch-proof high-tech ceramics. The upper surface of the watch is further protected by scratchproof sapphire crystal, meticulously ground and polished. The folding clasp is titanium.

CENTER

Even in luxury watches, high-tech materials play a role. Boucheron uses steel and a high-quality, stitched, and finished black rubber strap for its elegant watch line.

BOTTOM RIGHT

The Breitling Blackbird owes it name and look to the U.S. high-altitude reconnaissance aircraft built largely of titanium alloy. The Blackbird watch, crafted in titanium, features a sturdy Diver Pro rubber strap.

BOTTOM LEFT

"Elapse, Eclipse, Ellipse." Movado watch with three dials, each with its own mechanical movement, appear almost to be melting into one another, suggesting a triview of the from distant space.

Philippe and Chaumet emblazon specific designs on their straps. Some of the more savvy watch companies are even introducing various colored rubber straps, primarily for sports models. However, some avant-garde designers such as Hysek and Ikepod utilize top-quality, leather-like rubber for straps on its timepieces simply for the overall futuristic look it achieves.

In addition to rubber, other top-notch, high-tech materials never before seen in watchmaking include engineered ceramic, aluminum, and carbon fiber from the automobile racing industry. Carbon fiber is primarily used on the watch dials of sleek, fashion-forward sports

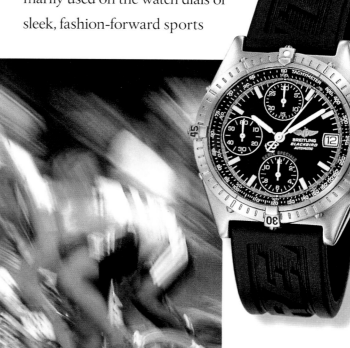

watches. Girard-Perregaux, for instance, is a great user of this material for its Ferrari line of timepieces.

While steel and diamonds have always been important in the world of watch- making, until recent years the two were never combined. The hardness of steel made milling it into cases quite difficult, even more so when one considered setting gemstones into it. However, new technology that was developed by other industries made the technique possible, resulting in a wealth of

TOP
In its For Ferrari line, Girard-Perregaux consistently utilizes cutting-edge materials. This chronograph, produced in a limited edition of one thousand pieces, consists of a titanium case, carbon fiber dial, and a rubber strap.

BOTTOM RIGHT
From Eterna, this Porsche Design chronograph is crafted in a solid titanium case and bracelet with a matte black titanium nitride finish (PVD technology) for sleek appearance and ultimate function.

BOTTOM LEFT
Xemex turned to rubber for the strap of this compass watch, adding durability and sleekness.

TOP

Few things in life are as luxurious as diamonds, here mixed with steel. Bedat is a master at this technology, as evidenced by this No. 3 steel watch set with 594 diamonds.

CENTER RIGHT

By Chaumet, this steel dual-time watch is engraved "Chaumet Paris" on the back, with an individual serial number

CENTER LEFT

The Eliro by Movado sleekly brings together steel with a diamond bezel.

BOTTOM

This Boucheron steel watch with a patented interchangeable strap system features a diamond bezel.

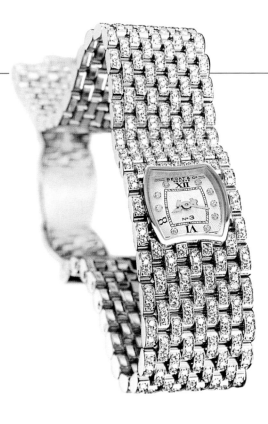

diamond-and-steel timepieces emerging just in time for turn-of-the-century celebrations.

In fact, these watches were offered by what might be otherwise considered unlikely sources, including ultra luxury firms such as Patek Philippe, Bedat, and Boucheron. Of course, the cutting-edge technology is the carrot dan-

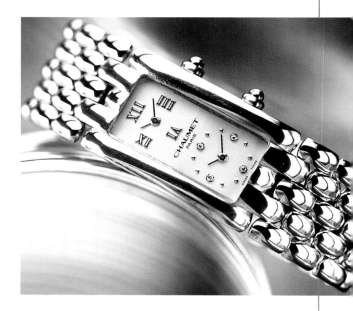

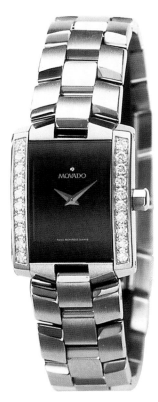

gled in front of the faces of these companies, which otherwise might not consider using steel in their timepieces. Fortunately, it was a carrot they could not resist, as steel and diamond watches offer a wonderful price alternative while still keeping the wearer's secret. Most people cannot distinguish between steel or white gold when seen from a distance and not touched or held.

All of these high-tech materials have offered new visions and extensions for watches, making them more durable, stylish, and futuristic. Watchmakers will certainly not confine themselves to these materials. In watchmaking, their are few limits other than imagination.

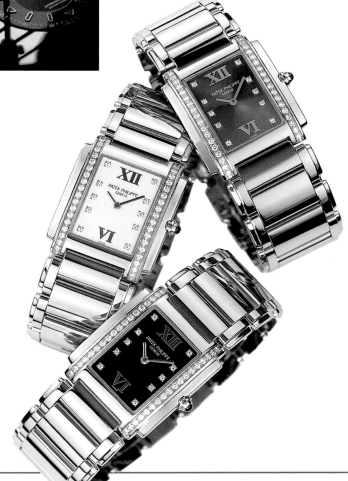

Ultimate Designs

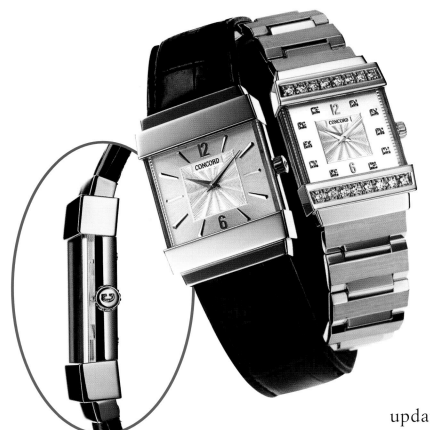

F or watchmakers, design has always been important—but never more so as when some of these centuries-old houses try to make their mark on new generations. The same is true of young watchmakers trying to carve a niche in an already full market. As a result, watch design and direction has never been so scintillating. ■ Watchmakers are turning in a wealth of different directions as they strive to embody individuality. From big and bold to classically elegant, and from sleek avant-garde to updated retro styling, watches offer more personal choice than ever before. The great watchmaking houses have gone above and beyond the call of duty when it comes to creating watches that captivate. ■ As the century turned, several important emerging design directions clearly dominated the scene. Top among them were unusual case shapes, an abundant use of color, ultra big or ultra thin, updated retro styling, and a futuristic appeal. ■ While round is the traditional case shape, there has been an incredibly exciting foray into new and different shapes, offering unparalleled versatility. The square and rectangle are particularly important in updated designs. Rectangles are frequently found with

cushioned edges or curved or indented sides to add flair and form. Squares also abound, often with stepped cases to bring depth and height to the watch, or with integrated case-to-bracelet attachments so that the case flows as part of the bracelet for a uniformed look. The tonneau, or barrel-shaped case—favored in the past—has been updated and ergonomically redesigned to curve with the wrist.

Among the newest shapes taking hold in watches are asymmetrical designs and elongated ovals crafted both vertically and hori-

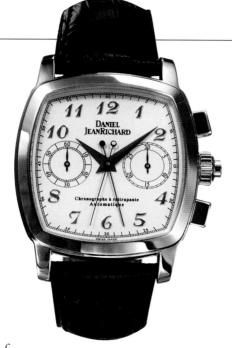

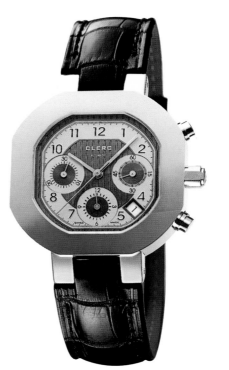

FACING PAGE

CENTER

Concord's Crystale exemplifies an unusual approach to shape and dimension. The square watchcase is transparent on the sides, creating a prismatic effect that allows light to shine in on the dial. The elegant, gray engraved dial is framed by a north-and-south double-tiered bezel for architectural appeal.

THIS PAGE

TOP LEFT

Daniel Jean Richard's TV Screen Split-Seconds chronograph features a cushion-shaped case that emulates the look of old television screens. It is crafted in a limited edition of five yellow and five pink gold models and fifty steel pieces.

TOP RIGHT

The distinctive boldness of Clerc's octagonal case shape makes a lasting impression. This chronograph is crafted in eighteen-karat white gold.

BOTTOM CENTER

The Starmaster from DeLaneau offers a unique case shape. Crafted in eighteen-karat white or yellow gold, it emulates a rounded triangle.

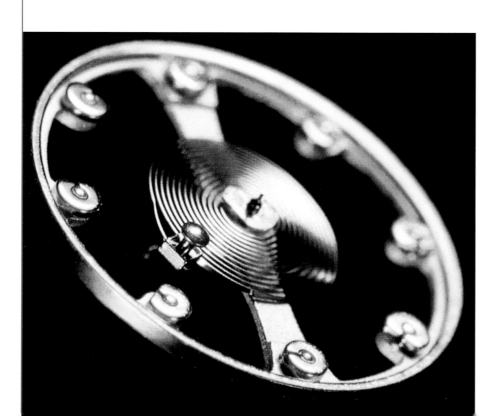

TOP
Vacheron Constantin's Asymmetrical case watch, crafted in eighteen-karat pink or yellow gold, is an unusual shape that was inspired by a design found in the company's archives and revived in 1999. The watch features an asymmetrical deployment clasp in eighteen-karat gold.

BOTTOM LEFT
The return to retro styling is often the cause of different case shapes emerging, as with the La Nouvelle Sport watch from Movado. This curved, elongated rectangular watch conforms to the contours of the wrist for contemporary flair.

RIGHT
Philippe Charriol's curved tonneau timepiece is a bold statement of design and beauty.

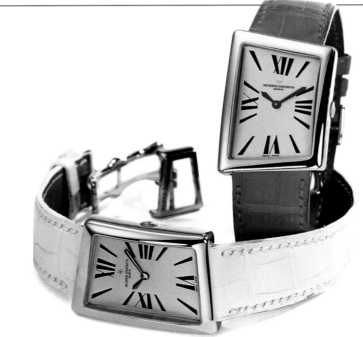

zontally. For women, floral-motif cases, marquise-shaped cases, and even teardrops emerge—all for a very fluid, sensual appeal.

Color also plays a new and exciting role in time-pieces—reflecting the daring boldness of the new millennium personality. Women's watches are predominantly offered with either bright- or pastel-colored straps of patent leather, silk, or calfskin. Most often, these timepieces are adorned with color-coordinated dials that offer an additional dash of fashion savvy. Simultaneously, men's

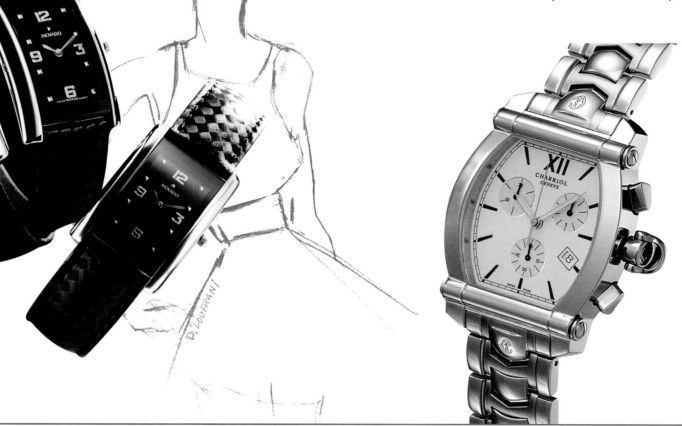

watches emerged bold and brazen, primarily in vibrant red, green, blue, yellow, and orange. Because colorful timepieces are a statement of self-expression, vibrant colors are often found on men's sport and casual watches.

Along with the excitement of a new century and a new millennium, also sometimes comes a bit of fear and nostalgia. That may be why so many watchmakers have turned to the past and are introducing redesigns from decades gone by. Some watch companies have searched their

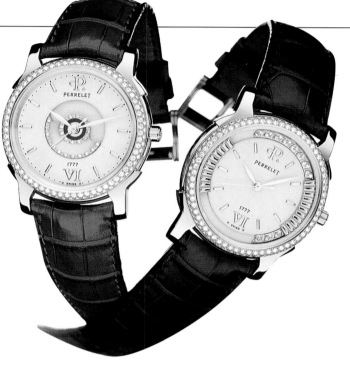

TOP

Color plays an important role in twenty-first century timepieces. Perrelet chooses bold green and burgundy to accent these horological feats.

BOTTOM LEFT

Jean d'Eve favors seductive, unusual designs, as with this horizontal rectangular case, curved to fit the wrist. The crown is at twelve o'clock so as not to distract from the overall design.

TOP

This Moonphase timepiece from A. Lange & Sohne, although inspired by the past, is one of the more futuristic-looking moonphase watches on the market. Crafted in eighteen-karat pink gold or in platinum, the manually wound watch features a moonphase display computed for a period of one thousand years.

BOTTOM LEFT

From designer Jorg Hysek, this curved steel timepiece with rubber strap is also available with diamonds and emulates the signature look of his pen rest.

archives for designs that, when reinterpreted, offer a flavor for the future.

Though today's designers sometimes look to yesterday's styles for inspiration, the new designs possess a strong presence of cleaner, larger dials, often in copper, silver, or white. With the updated retro stylings also come oversized timepieces and incredibly classical watches. By contrast, some of these timepieces are ultra thin or subtly smaller and more demure, offering a quiet elegance.

In contrast to the styles of yesterday are the needs of today. Faster paces seem to cry out for sleeker looks. Watchmakers endeavor to answer this call with slim-

mer watches, smaller watches, and more futuristic watches.

Curved timepieces that hug the wrist are indicative of this direction, as are more fully integrated overall designs. This is typically achieved through the use of bracelets that fit more snugly to the case and that emulate either the case or dial design of the timepiece.

Versatility is another key theme, as several watchmakers offer other uses for their watches by making them convertible. In some cases, wristwatches can be stood up outside of their cases to act as bedside table clocks; in other cases, wristwatches convert to pocket watches.

TOP
This bold Xemex timepieces is a COSC-certified automatic chronometer chronograph that offers the date between the four o'clock and five o'clock positions. It is bold and striking, particularly in its case and lug design.

BOTOM LEFT
The newest edition to Chanel's horlogerie collection features an updated, fashion-forward circular design that offers bold appeal.

BOTOMRIGHT
From Ikepod, these high-tech titanium timepieces feature a futuristic pod design with curved crystals and unusual shaped rubber straps.

And, of course, many watchmakers created special, limited-edition timepieces especially for the new millennium that are destined to be collectibles. For instance, Harry Winston commemorated the millennium in style with the Semi-Ramis 2000. Only five of these exquisite timepieces were created. Crafted in platinum, they feature a channel-set diamond bezel and case-to-bracelet attachment, and an invisibly-set diamond dial. Gerald Genta's Backtimer had a special function built in that counted the

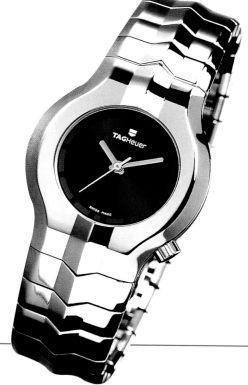

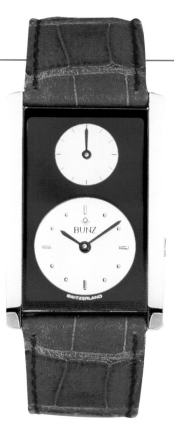

number of days left until the new millennium. After that, the feature could be set to an important personal date in the wearer's life.

Still, whether a watch is designated as a millennium timepiece or not is inconsequential. In the world of watchmaking, the future masterpieces will lie with the companies that follow their distinct design philosophy in all that they create, seeing the future as a whole new realm of exploration and innovation.

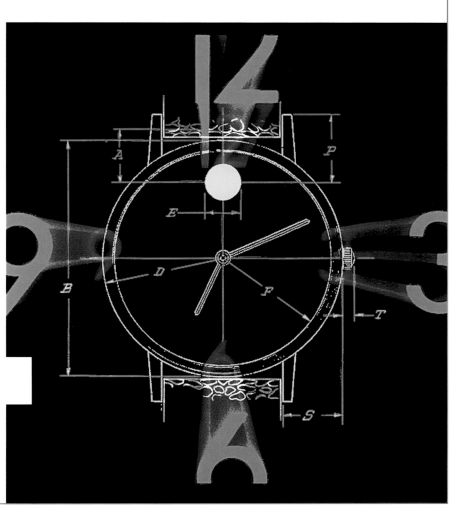

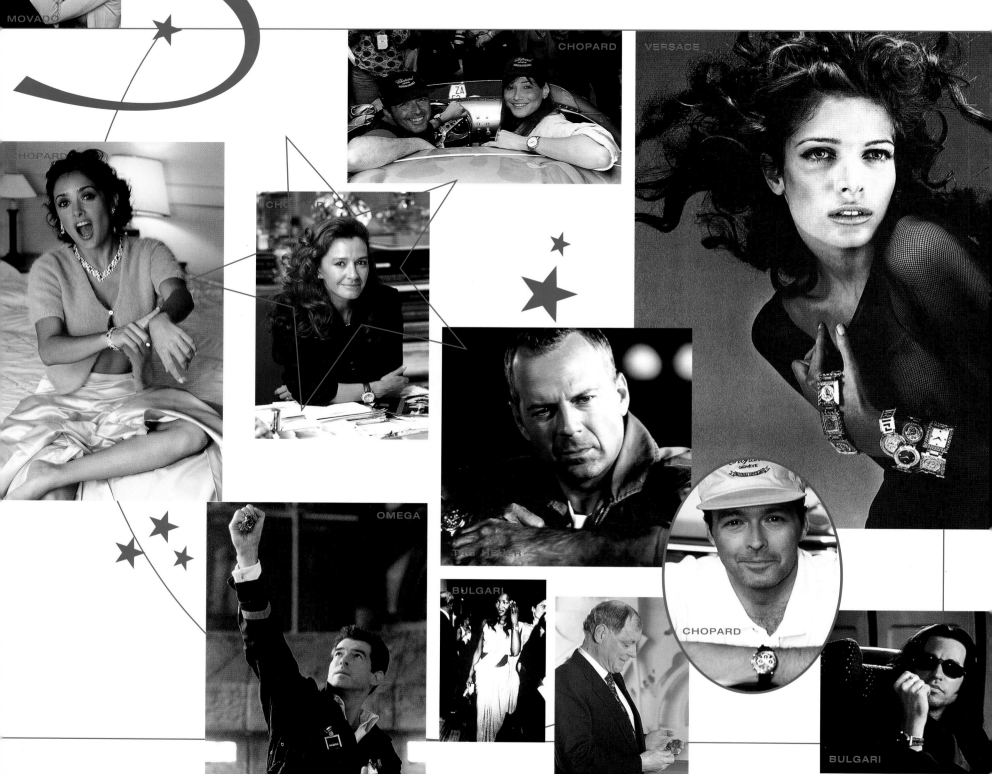

STAR STRUCK

MOVADO

CHOPARD

VERSACE

OMEGA

BULGARI

CHOPARD

PATEK PHILLIPE

BULGARI

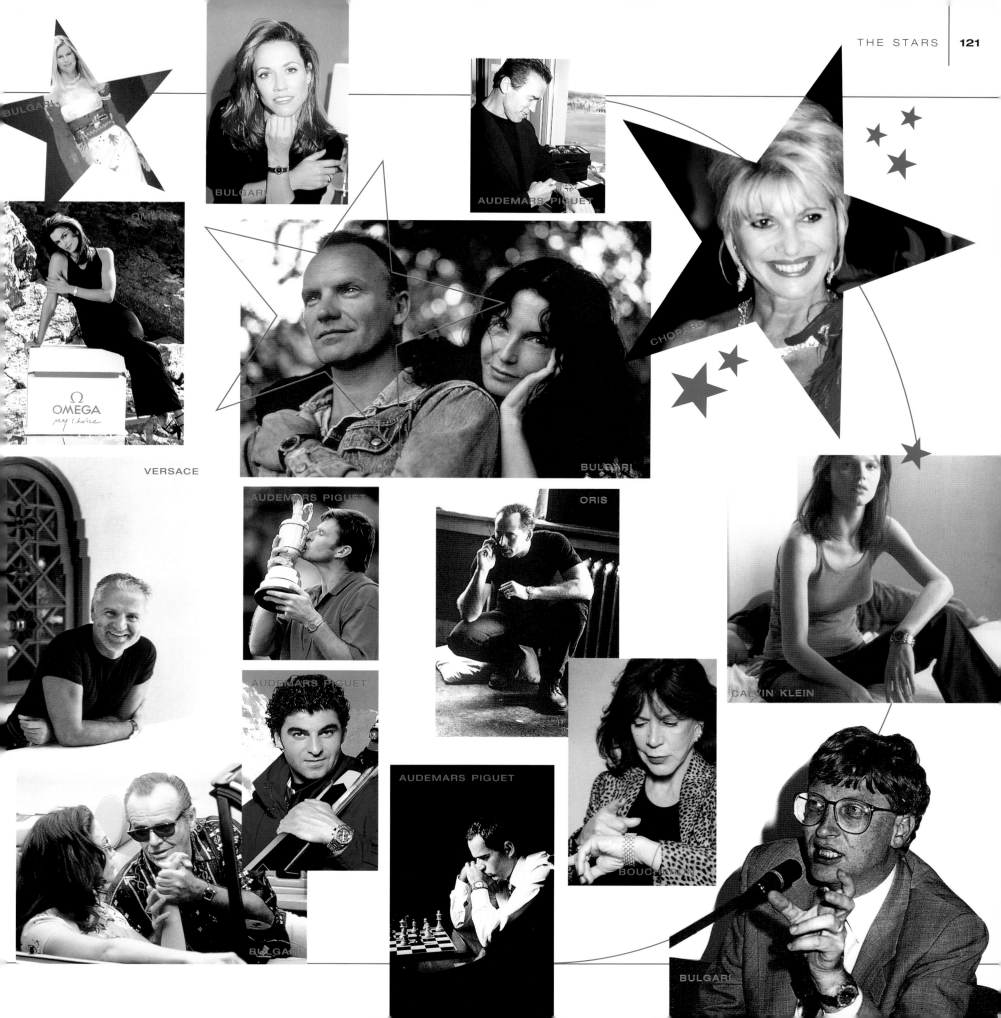

BULGARI

BULGARI

AUDEMARS PIGUET

OMEGA
my choice

CHOPARD

VERSACE

AUDEMARS PIGUET

ORIS

AUDEMARS PIGUET

CALVIN KLEIN

AUDEMARS PIGUET

BOUCHERON

BULGARI

BULGARI

AUDEMARS PIGUET

One of the finest legendary names in watchmaking, Audemars Piguet has upheld the tradition of excellence and innovation for which its founding fathers stood to such an exacting degree that today it is one of the most successful luxury brands in the world. ■ Long known as a creator of complicated watches, Audemars Piguet continues in this vein with a sophisticated superiority. Some of its newest one-of-a-kind and limited edition introductions deftly combine the old-world tradition of watchmaking with updated styling and design. Audemars Piguet also transcends into the realm of high-tech sports watches, classical beauties, and incredibly elegant bejeweled watches for men and women. The brand's diverse product collections are each distinctive and exciting in design and craftsmanship. ■ In fact, it is craftsmanship that reigns supreme at Audemars Piguet. Quietly nestled in the famed Vallée de Joux watchmaking center, Audemars Piguet hand crafts and assembles all of its timepieces, producing just about 20,000 watches a year for worldwide distribution. Its creed of high performance and perfection is based on the examples and demands set by its founding fathers.

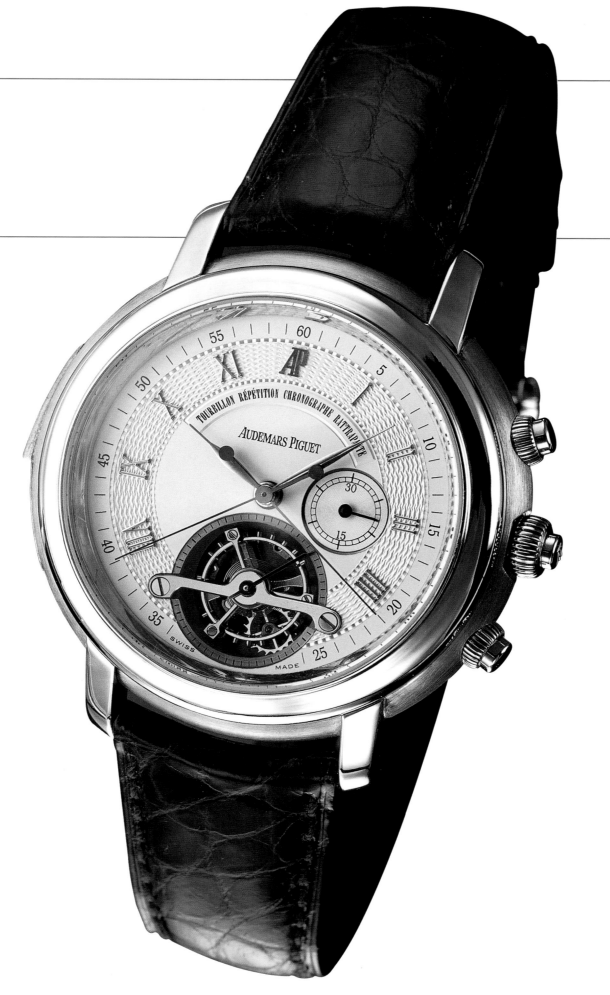

The firm known today as Audemars Piguet had two separate and distinct watchmaking founders — each of whom were third generation watchmakers.

In the mid-1800s when the Industrial Revolution took hold in Switzerland, many skilled artisans traded the workbench for a factory job and machine tools took over for human hands. It was a time when only the finest watchmakers could survive on their own. Jules Audemars was one of them.

In 1875 he created a tiny workshop in his parents' farmhouse. His high-quality work and creative thinking was rewarded quickly, with orders for

watchmaking pouring in from outside factories. Audemars was particularly known for his chronographs, minute repeaters and calendar watches. He was immensely interested in creating new movements and functions, and was obsessed with a desire to manufacture his own timepieces. It was this goal that led him to Edward Auguste Piguet.

The Piguets, probably the oldest family still established in the Vallée de Joux, had also turned to watchmaking nearly a century earlier. Third-generation watchmaker Edward Auguste Piguet had a passion

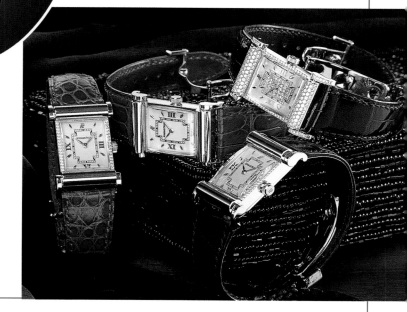

AP
AUDEMARS PIGUET
Le maître de l'horlogerie depuis 1875

for horology and spent long hours studying watchmaking before joining the aristocrats of this fine art.

These two horological masters met in 1875 and over the years they worked together, they regularly discussed creating their own timepieces — thereby laying the foundation for the their own company. Their premise was consistent high-quality watchmaking that could only be achieved if every operation was done in house. It was in 1891 that the formation of the company known as Audemars, Piguet & Compaignie was legally formed to manufacture and market high-end timepieces built to exacting standards.

Even today the spirit of these founders lives on in their direct descendants. Generation after generation, members of each family have held positions as members of the board of directors of Audemars Piguet. The strength of this family tradition and the important link between the families' names and history promotes a deep sense of responsibility for quality and prestige.

LEFT
The ultra-thin watch (1946).

BOTTOM LEFT
A remarkable feat of accomplishment, this Grande Sonnerie Minute Repeater Carillon movement.

BELOW
The new manual wind movement housed within this timepiece is based on nearly a century and a half of technical expertise. It features a power reserve of more than 48 hours, and is dedicated to Jules-Louis Audemars, co-founder of the company.

It is that sense of pride that governs all new product introductions. Each watchmaker employed by the firm is responsible personally for the quality of his work. While traditional watchmaking still remains indispensable, especially in executing the production of complicated watches, Audemars Piguet has also brought the most cutting-edge technologies to the drawing board for design purposes. Computers simulate the functional interaction of components, calculating shapes, materials and tolerances, so that the end result of high-technology and meticulous craftsmanship yields accurate, elegant heirlooms.

Such heirlooms typically are introduced in what the company calls its Jules Audemars line of very complicated watches. One such timepiece is the recently unveiled Grande Sonnerie Minute Repeater Carillon. This incredible watch strikes the hours, quarter hours and minutes in

different combinations either automatically or upon the push of a lever. A new triumph in Audemars Piguet's haute horlogerie, the watch has several options of operation: in the grande sonnerie position, the hours and quarter hours are struck automatically; in the petite sonnerie position only the hours are struck automatically; finally, by the push of a lever, the hours, quarters and minutes strike at the wearer's command.

Other important timepieces in the Jules Audemars series include tourbillons, perpetual calendars and moonphase watches, all meticulously crafted and detailed. Of course, Audemars Piguet — built on the strength of char-

acter of two watchmakers — also has an Edward Piguet line of perpetual calendars and chronographs.

In fact, one of the most classically elegant chronographs in the Audemars Piguet line is the Edward Piguet rectangular Chronograph. The watch features a black face, with a center oval dial for regular timekeeping, within which are the subdials of the chronograph. Pushpieces are curved rectangulars that emulate the curved case design and caseback. Crafted in 18-karat gold this elegant execution is indicative of Audemars Piguet's appeal and stature.

Of course, many collectors and connoisseurs in the know also equate Audemars Piguet with the very distinctive Royal Oak. First introduced in the 1970s, the Royal Oak has fast become a standard of excellence and a signal of power and wealth internationally. It is one of the few watches launched in the last century that

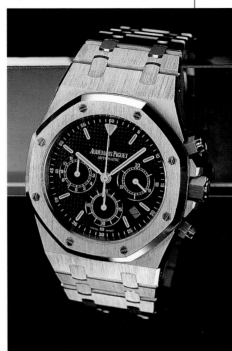

maintains its firmament in the new millennium.

This unique, trailblazing watch has been so successful that Audemars Piguet has had to regularly add extensions to the line. Recently it introduced the Royal Oak Chronograph with an entirely new mechanical movement with automatic winding and streamlined slenderness. This high performance luxury sport watch also features a perpetual calendar.

Bringing this much-demanded series to an even higher plateau, Audemars Piguet also recently unveiled the Royal Oak Grande Complication, combining ten complications into a single movement. The case alone is an assembly of 70 different parts, into which fits a movement finely crafted of 700 components.

The fruit of many years of labor, the Royal Oak Grande complication is a triumph of technology that offers the date, day, week and month, the year in leap year cycle, and a lunar calendar. Additionally it is a minute repeater that strikes the hours, quarter hours and minutes on demand and it features a split-second chronograph — bearing witness to the fact that this is unmistak-

ably a watch for sportsmen and connoisseurs alike. This incredible feat of technical prowess offers a power reserve capability of more than 50 hours.

With such a wealth of highly regarded timepieces, it's hard to believe that there is more — but with Audemars Piguet there is always more. Other significant collections include the horizontal elliptical Millenary — acclaimed by many as one of the most important watches as the millennium turns. From diamonds to gemstones, Audemars Piguet has always been on the cutting edge of design and fashion in women's watches presenting a dazzling array of jeweled masterpieces.

Thus it is no wonder that as this great watchmaking house traverses yet another century of technical and design innovation, it stands firm in its position as one of Switzerland's leading brands.

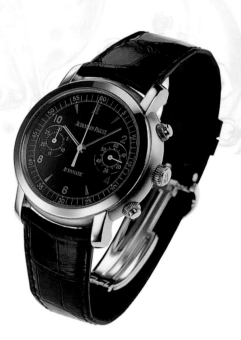

BEDAT & C°

Innovation seamlessly melding with tradition — that is the hallmark of Bedat & Co., Switzerland's seasoned watchmakers who produce one of the youngest lines. Run by the mother and son team of Simone Bedat & Christian Bedat, the two are becoming a powerful force in the Swiss watchmaking industry with their line of contemporary, stylish timepieces. As testament, Bedat & Co.'s newest timepiece turns history upside down, just in time for the millennium, by giving an old timepiece a brand new look in the ChronoPocket, a chronograph wristwatch that is also a pocket watch, and a table clock, perfect for travelers. Christian Bedat calls the timepiece the first contemporary pocket watch. "For me, I have always liked pocket watches. I think the pocket watch is beautiful. But when other companies develop pocket watches they strive to recreate the look of old pocket watches rather than creating contemporary ones," says Bedat. When considering whether to launch either a chronograph or a pocket watch, it struck Bedat that he could offer one timepiece that combined both features. "It's important to propose something to the consumer that they appreciate and

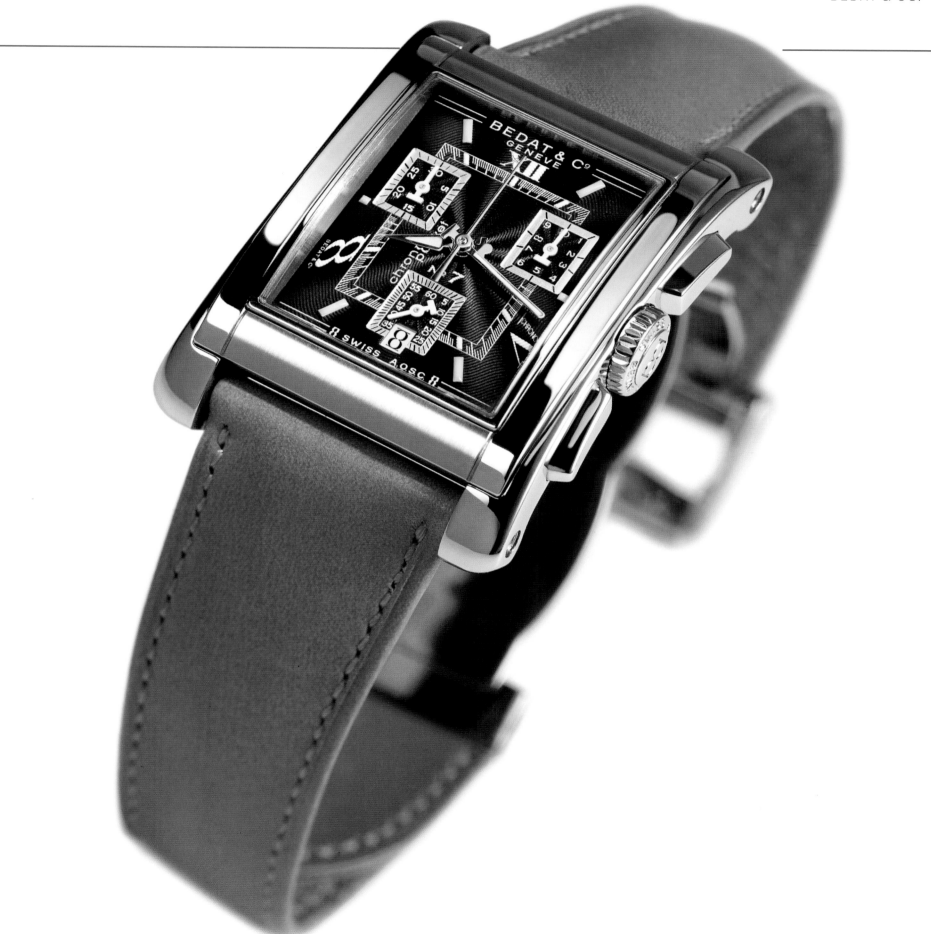

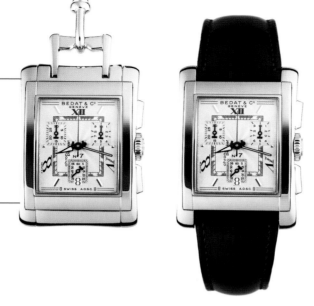

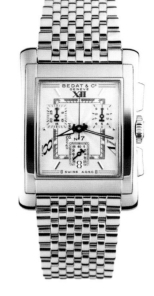

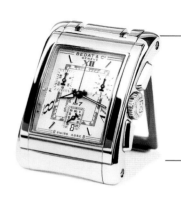

something they don't already have," says Christian Bedat. "We are creating an image by being innovative."

The ChronoPocket is housed in an elegant leather box lined with grey flannel, and contains up to three straps and the tool to convert the timepiece from wristwatch to pocket watch. Its sleek, rectangular face has three unusual rectangular windows to reveal the chronograph features, and it is available in steel, yellow and rose gold, white gold, or in platinum. "The name ChronoPocket refers 100 percent to the product. Few watch names define the product and that's one thing that gives the product the strength to become a classic." It is important to Bedat that his watches survive for generations. For this reason, the design of a Bedat & Co. timepiece is steeped in classic styling inspired by the work of artisans in the 1930s, yet updated with modern details.

The style of Bedat & Co. watches are suited to a particular niche of sophisticated watch wearers recognized by both Simone Bedat and Christian Bedat when the two decided to launch

their own brand in 1997. The first collection drew remarkable acclaim from within the industry, where the Bedat's are well-known after committing several decades of experience to watchmaking. With the launch of their first collection of 52 pieces, it was evident that Bedat & Co. would not waver on standards. First, Bedat & Co. developed their own set of guidelines called the A.O.S.C, the "Certificate of Swiss Origin." "The A.O.S.C. guidelines were developed to instill confidence with the consumer," Bedat explains. The guidelines certify that each watch is made of only Swiss parts, and also guarantee the life of the watch for five years. The Bedat's also carefully defined the style consistency of the Bedat & Co. collection. Each dial is always comprised of the same Bedat & Co. details, from the exclusive Bedat watch hands, to the placement of the Bedat logo at the 8, to the appearance of the Bedat & Co name above the 12 and the A.O.S.C. insignia below the 6.

With the same precise detailing, Bedat & Co. also established firm rules on how each collection would be named and chose to refer to

ABOVE
The elegant leather and grey flannel box housing the ChronoPocket and its tools.

BELOW
"The name ChronoPocket refers 100 percent to the product." Here featured in 18K yellow and rose gold.
Ref. 778.310.320

each collection by number, symbols of time itself. When determining which numbers would be selected, the Bedat's understood they must appeal across continents, and chose the numbers with deep significance for many cultures. The ladies' collection is named No. 3, for the symbol of perfection; the Trinity, Buddhism's three jew-

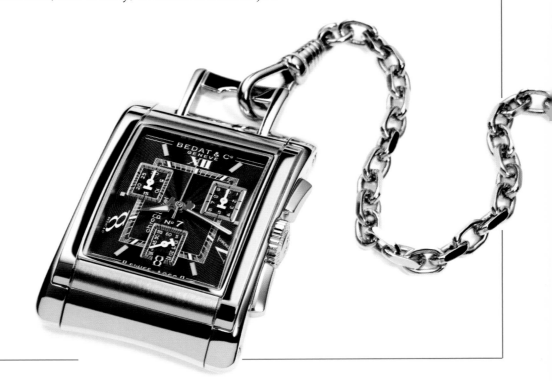

els and the three phases of existence, while the men's collection is called No.7, the symbol of eternal life; seven degrees of perfection and the seven heads of naja at AngkorWat, while the No.8 collection is represented by the symbol of infinity.

Although each watch boasts the trademark Bedat & Co. features, each collection has its own distinctive look. With its sensuously curved, rectangular face, the ChronoPocket is an obvious extension of the No.7 collection, which includes square, rectangular, and a slightly rounded rectangular shaped watch faces. While the No. 7 collection was developed for men, in 1999 Bedat adorned the symmetry of the square shape with diamonds, added a satin strap and created an irresistible evening timepiece. "We've

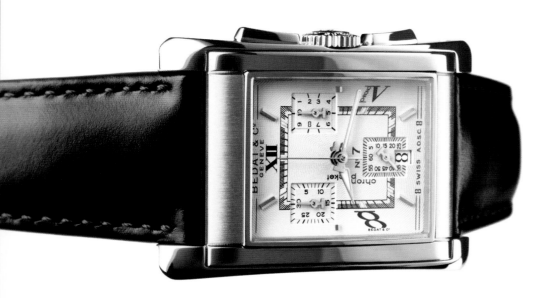

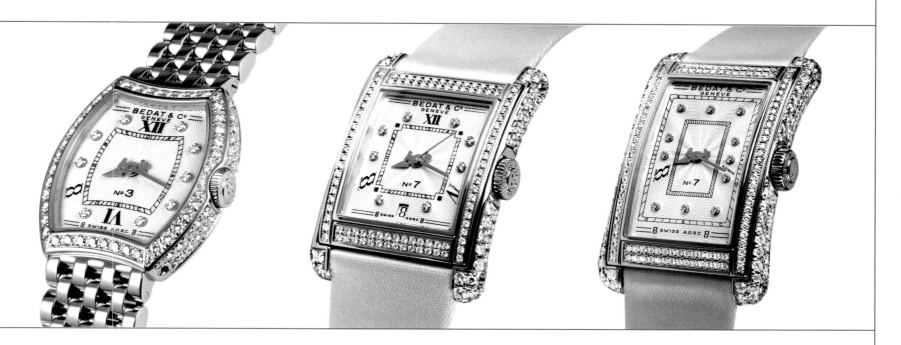

come further with setting our watches with diamonds, using more diamonds than ever before," says Bedat. Consumers can decide between the more refined diamond setting alongside the bezel, or a magnificent diamond watch whose bezel is completely set with diamonds.

The ladies No. 7 timepieces also come with colored stones and accent color strap, with one row of stones at the top and bottom of the bezel. Each reflects the sensational appeal now familiar from the Jeweler in Steel. "The use of color is comforting, reassuring," says Bedat. The jeweled No. 7 watches are the cosmopolitan counterpart to the extraordinary No. 3 collection which includes the bracelet watch with knitted steel links. Delicate and demure, the bracelet style looks like a family heirloom, or an item that would have been worn by your grandmother. Whether completely covered in diamond pave or delicately set with diamonds on the bezel, the timepiece evokes nostalgia for days gone by. A

bracelet design may have as many as 592 diamonds accenting supple beauty.

From the sinuous barrel, manchette and hexagonal shapes of No. 3 to the smooth curved lines of each timepiece in No. 7 and the sporty round shape of No. 8, Bedat & Co. strives to offer elegance that transcends generations. "Whatever we create should be a contemporary classic today and tomorrow," says Bedat.

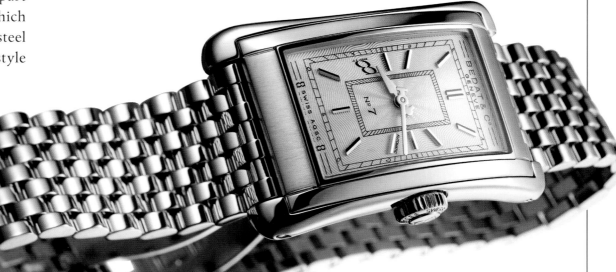

BEDAT & C° JEWELLER OF STEEL

BELOW

Automatic N°7 steel set with
princess cut blue topaze,
pink tourmaline, yellow citrine
or diamonds.
Ref. 728.810.109
Ref. 728.710.109
Ref. 728.610.109
Ref. 728.510.109

The watch brand is attracting the attention of leading fashion magazines in the U.S., a development that has not gone unnoticed by Bedat, who oversees the development of the U.S market. "We are new and when people support us, I really appreciate it." His well-planned, yet subtle branding may be a part of the draw. Advertisements for Bedat & Co. products are captivating for what they don't say. Images of charismatic people in unidentifiable settings beg the viewer to ask, 'Where are they? Who are they? What are they thinking?.' Bedat explains that the ad targets the people who will buy his watch, those who will identify with the person in the ad and recognize that the ad demonstrates that a person has a choice which watch to wear, that they are not obligated to wear a Bedat & Co. or any other brand.

A watch lover himself, Bedat recognizes that there are many prestigious watches to own and is most pleased when the consumer chooses a Bedat & Co. watch because of an appreciation for the design, not because of a feeling of obligation. As a new watchmaker, Bedat says his goal is to develop Bedat & Co. into a "small institutional brand." Already, the watchmaker is stealing a great deal of limelight with its inspiring innovations, including the ChronoPocket, that are helping pave the way for the future of watchmaking.

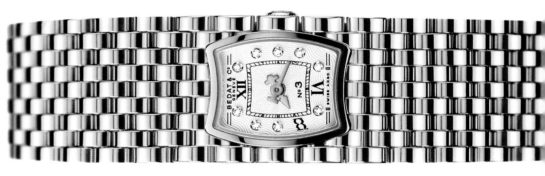

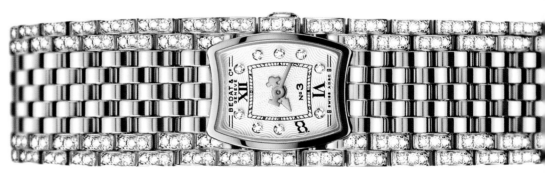

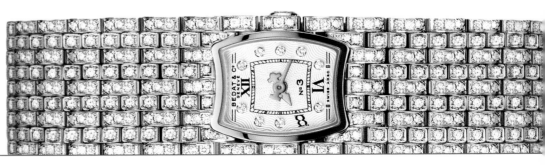

BOUCHERON

The great house of Boucheron boasts a prestigious place among the greatest jewelers of the world, not to mention its physical location at the heart of the haute-joaillerie world — Place Vendôme. This venerable jeweler has been creating immediately recognizable objects of art and sensational pleasures for well over a century. The title jeweler to imperial courts, shahs and maharajahs, Boucheron caters to international royalty, celebrities, corporate magnates and women of distinctly fine taste and spirit. ■ Today, under the creative direction of fourth-generation Alain Boucheron, the company continues to follow the path of its founder: conveying emotion and passion in all of its creations — but with an enviable edge toward the future. In the past few years Alain Boucheron has brought the company to new heights, introducing incredible new jewelry and watches that reflect the company's artful eye, elegant past and well-poised future. ■ It was Alain Boucheron's great grandfather, Frederic Boucheron, who opened his atelier in Paris in 1858 and immediately began creating high-jeweled celebrations of life, as well as opulent pendant, brooch

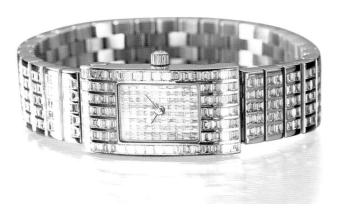

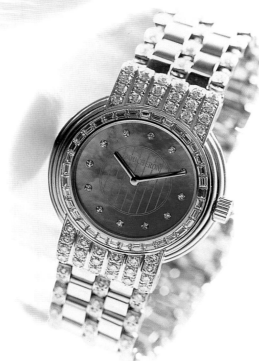

and pocket time-pieces. His penchant for the finest of gemstones made his jewelry and timepieces coveted prizes of beauty. With his creations, the name of Boucheron was sealed — forever synonymous with elegance, innovation, and excitement.

Well ahead of his time, Boucheron opened his now famous boutique in Place Vendôme in 1893 — and adorned his windows with magnificent jewelry and watches. It may well have been his forward-thinking about timepieces that made the name Boucheron such a desirable and well-rounded company in its day. In an era when jewelers primarily offered jewelry and watchmakers offered watches — Boucheron offered both — masterfully — earning its reputation as the Jeweler of Time.

Throughout the next generations of Boucheron, the family continued to hold time-pieces as the most appealing and useful of jewels, and embarked on new ways to depict beauty in

OPENING PAGE
Limited Edition platinum UNESCO watch with skeleton back featuring the Everglades World Heritage Site.

PREVIOUS PAGE
18K white gold automatic "Diamant" watch.

TOP LEFT
18K white gold "Reflet" watch, set with 400 baguette diamonds.

TOP RIGHT
18K white gold and diamond "Solis" watch with pavé diamond dial.

CENTER
18K white gold and diamond "Solis" watch with mother of pearl and diamond dial.

BOTTOM
18K yellow gold and diamond "Reflet" watch on a cultured pearl bracelet.

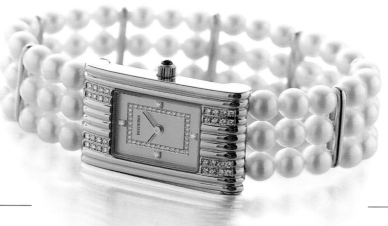

its watches. The design and innovations that epitomize the history of Boucheron watches defies time. From the first jewelry wristwatch to spherical watches, ring watches, and rock-crystal watches, Boucheron has always been a master at offering the unexpected.

In 1948 Boucheron created and patented an interchangeable invisible-clasp bracelet that set a new standard of excellence. The interchangeable straps and bracelets are slipped into an invisible clasp that is integrated into the watch case. The clasp closes once the watch strap is put into place. This unique system allows quick and easy interchanging of bracelets. It also features the BEST (Boucheron Easy System Technology) buckle system that allows the length of the bracelet to be perfectly adjusted to fit the wearer's wrist. Composing a world of harmony and emotion out of gemstones, pearls, platinum, gold and steel is a Boucheron passion that has remained intact for its more than 140 years. Even to this day, Boucheron continues in its ability to delight and surprise — a characteristic that Alain Boucheron has been careful to bring to Boucheron's objects d' art. While the timepieces created under Boucheron's attentive eye convey

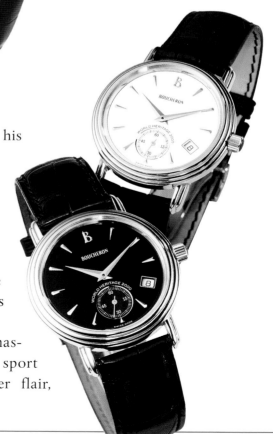

the same elegance and high style that his great-grandfather coined, they also offer a futuristic element of beauty and versatility.

"Today, Boucheron creates for the woman of the third millennium," says Alain Boucheron. "It imagines for her jewelry that will be the classics of tomorrow, and gives birth to a timeless value of emotion."

Indeed, from the high-jeweled masterpieces to the simply elegant sport watches, Boucheron timepieces offer flair,

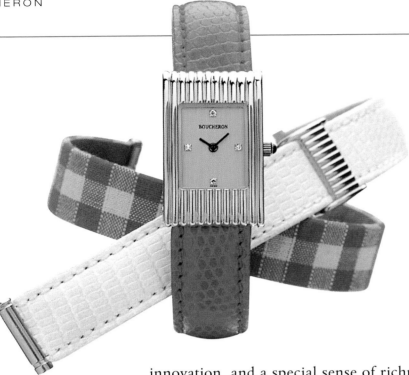

innovation and a special sense of richness. Precious stones, pearls, and ornamental features grace Boucheron's timepieces — expressing personality, technique and sensitivity.

Artfully capturing the French spirit, Boucheron's timepieces embody a Swiss soul. All of the watches are designed and developed at Boucheron's workshops in Paris and are produced in the heart of the preeminent watchmaking country of Switzerland, where the time-honored tradition is world-renown.

Immediately recognizable for its striking lines and detailed craftsmanship, the Boucheron Montres Collection is at once complex, precise and elegant. It is focused, simply, around two design directions, one rectangular and the other circular. But that is where simplicity ends. Boucheron's rectangular design, Reflet, has been

part of the company's collection since 1948. The round design, called Solis, was conceived of two years ago. Its contemporary style offers sporty, technical inspirations — and from it was born the Diver, Chronograph and Chronogolf — a unique timepiece that tracks golf scores.

Each timepiece collection features signature "godrons" — indented consecutive parallel

BOUCHERON

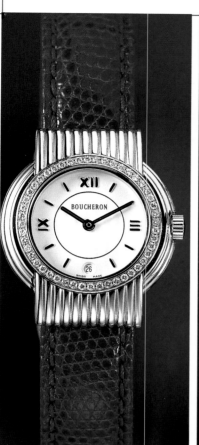
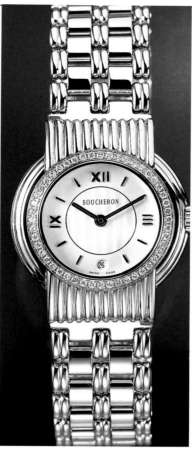

TOP LEFT
Stainless steel "Solis" watch with diamond bezel featured on a steel bracelet and interchangeable leather strap.

CENTER
Stainless steel chronograph on interchangeable steel bracelet.

BOTTOM RIGHT
Stainless steel "Solis" watch on blue leather strap with strap and bracelet accessories.

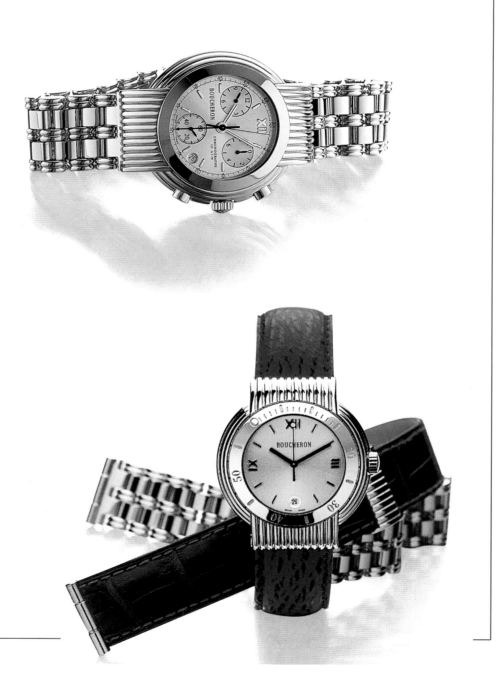

lines that offer depth and dimension, emulating the female. Each, of course, incorporates the same patented interchangeable strap, invisible-clasp design from 1948 — offering today's watch wearer incredible versatility. The choices of bracelets range from the elegance of pearls, to the subtleness of satin, the allure of metal, and the casual comfort of denim. Twice a year, Boucheron introduces an array of metal bracelets and fabric straps that reflect the most up-to-date fashions and trends.

Finally, these elegant timepieces are adorned in varying degrees with diamonds and gemstones. Some are simply adorned with diamond markers, while others offer bezels and cases of sparkle. Still others are totally dripped in diamonds from bracelet to case to dial — offering the ultimate jewelry emotion — which is, of course, Boucheron's hallmark.

BREITLING

*W*hile the words "jets" and "planes" certainly are synonymous with the world of aviation, next in line is probably Breitling. One would be hard-pressed to find a pilot or aeronautical engineer who hasn't heard of this significant watch brand. ■ With more than a century of technical prowess and cutting-edge product development, Breitling charges into the new millennium with what may well be the most technically advanced wrist instruments in the world. Along with this product niche, Breitling has a keen interaction in the world of aviation and aeronautics through its grass-roots sponsorships and flying involvements — which are about as vast as the sky. ■ In many ways Breitling's growth in the world of aviation parallels the field itself. It was in the early years of the 1900s that the dream of flight became a reality — first with balloons and later with planes. Breitling had already made incredible headway in the world of chronographs and wristwatches earlier in the century, and the ingenuous third-generation of the family firm, Willy Breitling, immediately recognized the fascination flight would hold and began producing on-board chronographs. Focusing on technical

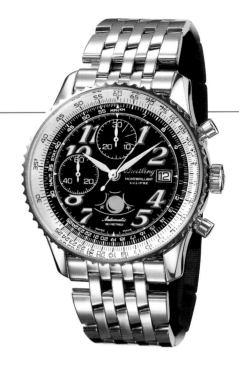

precision, reliability and the desire to be different, Breitling developed cockpit and wrist chronographs that commanded attention. "Breitling" had become a pilot's household word. In 1939, Breitling signed a contract with the British Air Ministry to make flight chronographs for the Royal Air Force — forever sealing its association with aircraft navigation and invention.

Even on the threshold of this new century, Breitling was making history in this field. On March 21, 1999, the Breitling Orbiter 3 balloon successfully circumnavigated the globe in 19 days, 21 hours and 47 minutes — breaking the last aeronautical record of the century.

Dedicated to the field of aviation, Breitling quickly rose to the challenge of sponsoring the first nonstop balloon to fly around the world. This was the third time Breitling had sponsored the balloon, which was piloted by Swiss Captain, Dr. Bertrand Piccard and English co-pilot, Brian Jones. Following the failed flight of the Breitling Orbiter 2, Breitling formed a team of experts to examine scientific and technological concerns and make the according modifications. The Orbiter 3 had a new envelop design to enhance flight conditions, the cabin was pressurized to

permit normal breathing at elevation over 36,000 feet, and the capsule carried propane gas instead of kerosene in 32 titanium containers.

Breitling remained in constant vigilance of the Orbiter 3 on its incredible journey, as the crew of two withstood extreme temperatures, zigzagged around mountains, unruly winds and hostile airspace, and contended with issues such as the limited fuel supply. Breitling technology and the Orbiter 3 crew made international head-

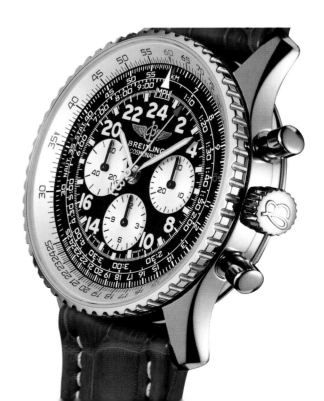

lines when the balloon landed in southeast Egypt. Making another significant contribution to history and time, Breitling donated the Orbiter 3 balloon capsule to the Smithsonian National Air and Space Museum, where it will hold the honored place in aeronautical achievement beside Lindbergh's plane.

Piccard and Jones had been equipped for the flight with Breitling's outstanding technical innovation, the Emergency watch. Licensed in Europe (and awaiting U.S. licensing), the Emergency is an instrument-watch with a built-in micro-transmitter broadcasting on the 121.5 MHz aircraft emergency frequency. Several years of research and development went into this unprecedented technical breakthrough. Designed for pilots and flight crews, the watch becomes a personal survival wrist instrument. Following a plane crash or forced landing, it will broadcast a signal enabling search and rescue units to

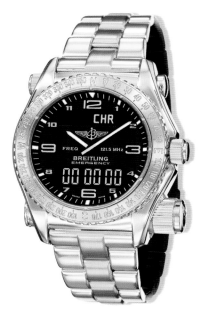
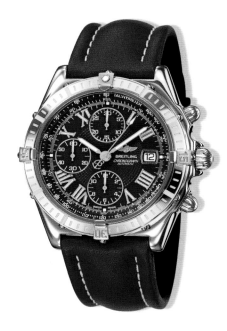
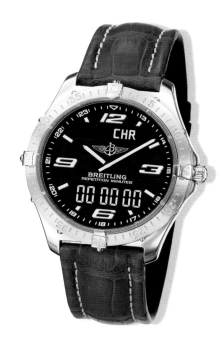

home in on the wearer's location. It serves as a complement to the aircraft's own distress signals. The transmitter is activated by unscrewing a protective cap and pulling its antenna out to proper length. The transmitter will broadcast nonstop for 48 hours.

The Emergency is one watch in Breitling's extensive array of instruments for professionals. While it was many years ago that Breitling initiated its link with aviation, most of its key timepieces introduced over the years in this field remain in the line today. The Navitimer, which was first launched in 1952, provided pilots with a chronograph designed specifically for air navigation purposes thanks to its "navigation computer" capable of effecting the calculations a flight plan requires. Its slide rule bezel also enables flight crew to convert miles into kilome-

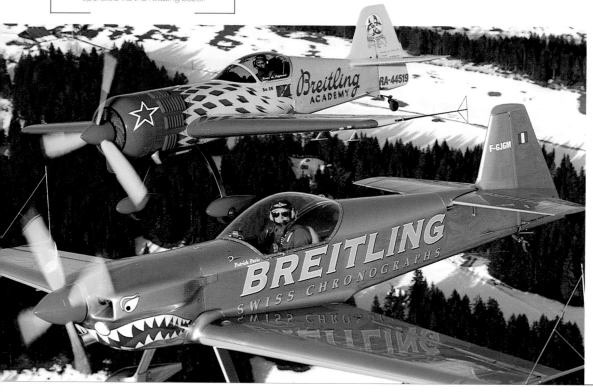

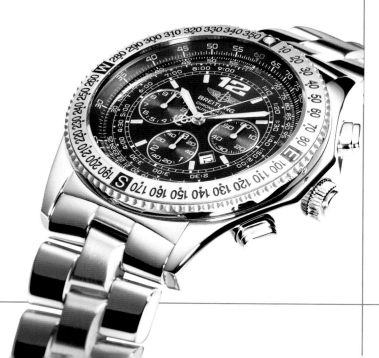

ters and vice versa. The first Navitimer design became the official watch of the globe-spanning AOPA pilot's association. Today's Navitimers are updated, but the design's unique spirit has remained intact and still features the same precision and usefulness as a professional instrument has in the past.

The Cosmonaute, which dates from that thrilling period of space exploration, was first introduced in 1962. In fact, on May 24, 1962, Scott Carpenter, aboard the Aurora 7 space capsule, was the second American to experience orbital flight. Strapped to his wrist was the Breitling Cosmonaute chronograph. Today the Cosmonaute is the only Breitling chronograph fitted with a hand-wound mechanical movement exactly like the original 1962 design.

Other key Breitling watch families include Chronoliner and Professional. Chronoliner series are sport watches with a stopwatch function, and a variety of other functions. The Professional series incorporates state of the art micro electronic developments that provide nuances such as back lighting, alarms, perpetual calendars, and multiple time zones. This series includes the B-1, the B-2, Aerospace, Colt Superocean and Chrono Colts. Indeed the Breitling line is extensive.

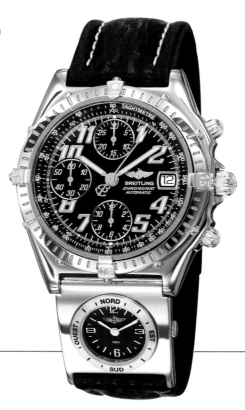

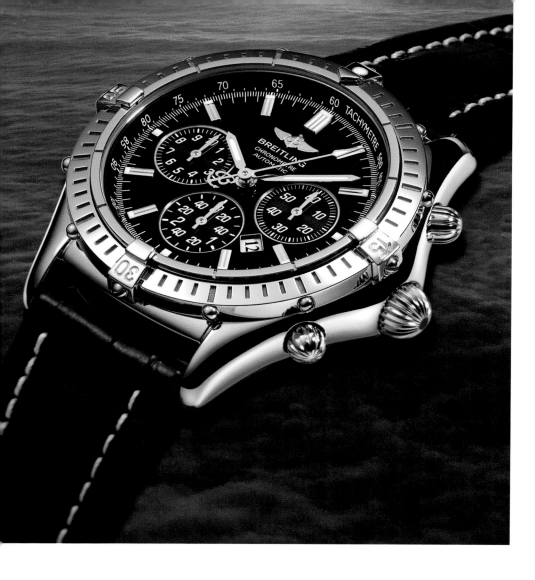

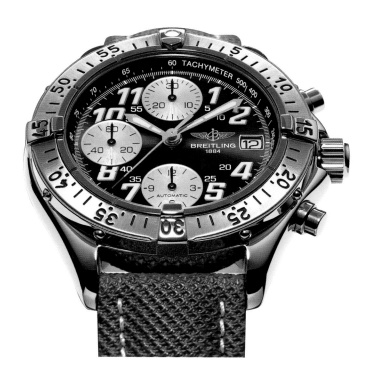

Because the Breitling name is synonymous with performance, each timepiece is made to adhere to the strictest codes of reliability and durability. Every watch Breitling produces is a certified Chronometer, attesting to the fact that its movement has been tested by the COSC, the top Swiss observatory, under the most stringent conditions of gravity, pressure and a variety of other conditions, and has passed. Breitling is the only major watch brand, whose entire watch production is COSC certified. In addition to the technical superiority of the COSC certification, every Breitling timepiece is crafted from top quality titanium, steel, 18-karat gold or the most precious of metals — platinum. Every watch is water resistant to varying depths, depending on the use of that particular instrument, and features the according additional functions such as slide rule bezels, multiple time zones, alarms, tachometers, and the like.

Because of Breitling's intimate relationship with the world of aviation, the company

TOP

The Shadow Flyback is elegance and mechanical refinement at its best. It is the newest addition to the Chrono-liner range, and conceals a sophisticated "flyback" mechanism that makes it possible to start a new timing operation by a single press on the push piece. A press on the second push piece returns the hands to zero and starts them off again, enabling the pilot to easily monitor flight times.

TOP RIGHT

The Chrono Colt Automatic chronometer chronograph also offers tachometer inner ring to measure speed.

RIGHT

The Old Navitimer chronometer chronograph with slide rule bezel is based on the company's original Navitimer design, introduced in 1952.

LEFT
The Montbrillant Eclipse, an important chronometer in Breitling's line, is available in 18-karat gold as well as in stainless steel.

BOTTOM LEFT
Always catering to the female pilot as well as the male, Breitling offers the Emergency technical instrument with diamonds accents for beauty and efficiency.

BELOW
The Breitling B-Class offers sophisticated elegance for women. From the highly prized Nightflight collection, this newcomer is a sporty chronometer that is water resistant to 100 meters and features three-gasket crown and glare-proof sapphire crystal.

also produces some of the most coveted special edition watches in honor of international flight teams. Among those honored by Breitling are the USAF Thunderbirds, the US Navy Blue Angels and Top-Gun, Britain's Royal Air Force, France's Patrouille de France, Italy's Frecce Tricolori, Sweden's Team 60, Japan's Blue Impulse and Switzerland's Patrouille Suisse. Breitling also is involved in air shows around the world and dedicates much effort to the Breitling Academy — an academy set up and structured to provide highly advanced flight training to some of the world's most promising young aerobatics pilots.

A company rich in history and steeped in technology, Breitling is well poised for the future. With today's fast-paced, high-tech lifestyles — today's drive for hobbies of passion and watches of distinction — Breitling answers the demand for innovative product that keeps pace and anticipates what's next — in all fields of sport and profession.

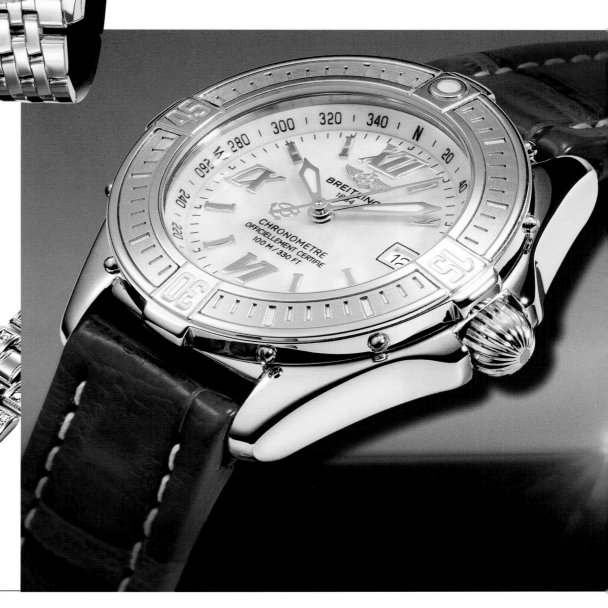

CHOPARD

The world of Chopard is rich with history, technique, elegance and beauty. One of the most perfectly well-rounded watch and jewelry houses on the globe, Chopard's success story weaves myth, mystery, passion and allure. This legendary firm produces some of the world's most exquisite jewelry and timepieces—catering to men and women alike. Since its inception 140 years ago, Chopard's craftsmen have managed a symbiosis of tradition, technology, design and elegance that is unparalleled. The talent and desire for perfection that Karl Scheufele, his wife Karin and their two children, Karl-Friedrich Scheufele and Caroline Gruosi-Scheufele have put into Chopard is what has propelled it to the forefront of the luxury jewelry and watch industry. The astute business acumen of Karl-Friedrich Scheufele, Chopard's vice president, and the exacting eye of Caroline Gruosi-Scheufele, vice president and creator of Chopard's most beautiful watches, come together in a brilliant mix of refreshing innovation. As this family-owned business waltzes into the new millennium, it offers a wonderful array of exciting complicated timepieces, lush high-jeweled masterpieces, and invigorating sports marvels.

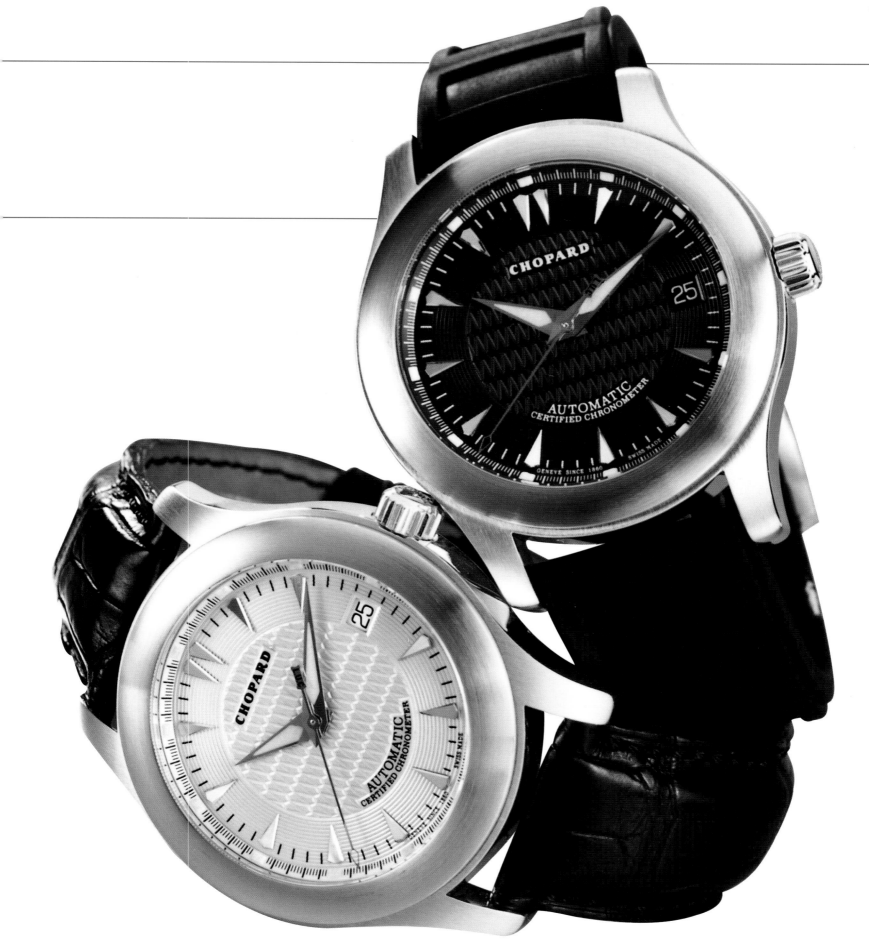

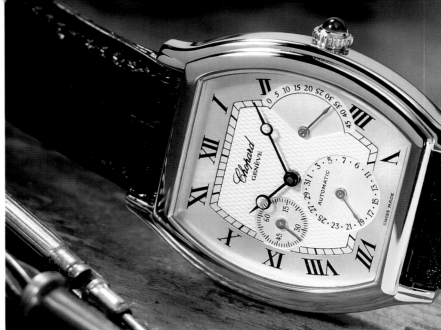

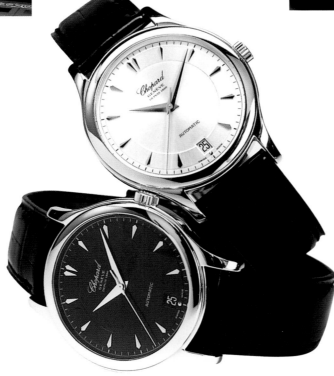

lowed in his footsteps, keeping the company rooted in its heritage and building a worldwide reputation for its chronometers until 1963 when Karl Scheufele bought the firm from Chopard's grandson.

One of the finest jewelers of his time, Scheufele was a master goldsmith, innovative in gem setting and exquisite jewelry designs. His jewelry workshops were located near the great jewelry-making city of Pforzheim, Germany. It was his goal to bring his jewelry collection full circle, and to create elegantly jeweled wristwatches. The family firm had already been creating

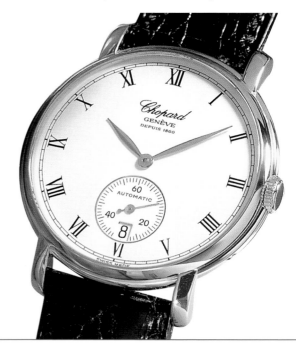

The genius that is Chopard today has its roots in 1860 when Louis-Ulysse Chopard founded his watchmaking company in a small village in the Jura Mountains of Switzerland. Even from the start, his timepieces were incredible works of art, elegantly designed with filigree, offering the finest enamel dials. Deeply dedicated to precision and quality, Chopard created wonderful pocket chronometers and exquisitely decorated watches for women. His family fol-

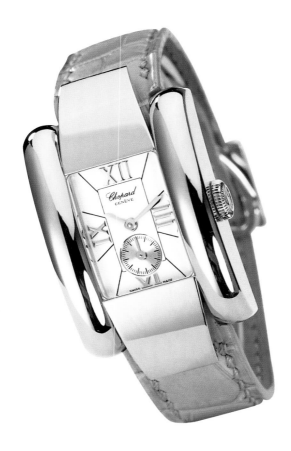

own parts, builds up the basic movements it purchases, and assembles them all together in the Geneva workshops. It has even created its own superior watch movements.

Through regular family meetings, the Scheufeles determined that their watches, like their jewelry, should be hand made to the utmost standards of quality and craftsmanship. Today, Chopard embodies the epitome of technical prowess, hand-craftsmanship and tradition.

With this legendary reputation around the world, the newest generation of Scheufeles—Karl-Friedrich and Caroline—has spent the past years taking the company to new heights in terms of product.

It stands to reason, given the background, that Chopard should excel at haute joaillerie (high-jewelry) watchmaking. And it is precisely in this arena that Chopard shines with stunning creations of luster and femininity. Passionate about her work, Caroline Scheufele travels the world looking for the finest precious stones and answers their call to her with vivid, striking designs. Inspired by the fascination of the stones, Scheufele's designs are distinctly modern and classic at the same time.

watchcases, table clocks and pocket watches with the name Eszeha on them. His purchase of "Le Petit Fils de L.U. Chopard"—now located in Geneva—gave him independence in the watch industry and the ability to produce whatever he chose. He spent several years streamlining his new possession, and relaunched Chopard as a top-of-the-line luxury hallmark.

Thanks to Scheufele's foresight and ingenious design, Chopard has grown to over 900 employees. Today the firm has a work force of more than 500 varied artisans, including goldsmiths, watchmakers, gem setters and mechanics. The Scheufele family took the fine firm one very important step further—making it a fully integrated, complete manufacturer.

Chopard today is one of the few luxury watch companies left that creates many of its

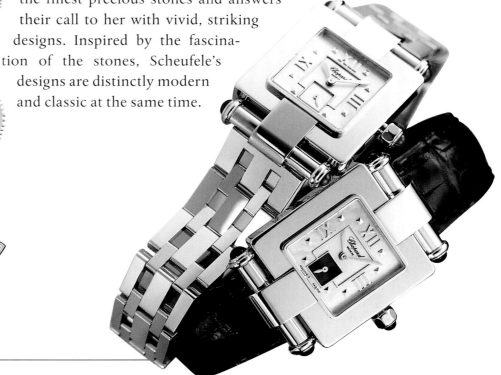

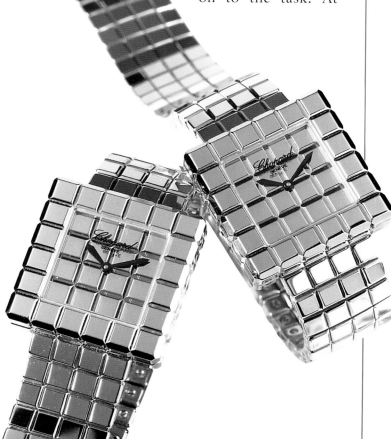

watch in which diamond brilliants would reveal their full beauty and glitter roaming free on the watch dial. Inspired by a waterfall, the design was chosen by a panel of leading jewelers as the "most interesting watch of the year."

Great in concept, the execution of this design was a puzzle to accomplish—one that required incredible technical knowledge and open mindedness. Karl-Friedrich Scheufele rose to the challenge and set his Geneva craftsmen on to the task. At

Each piece, once sketched and planned, is handmade—sometimes taking hundreds of hours at the most detailed work. Goldsmiths must solder together anywhere from 3,000 to 4,000 points to provide the settings for these pieces of art. These pieces, too, often command the highest prices—reaching well into the multiple thousands and even hundreds of thousands depending upon their intricacy.

In the world of diamond watches Chopard also excels when it comes to uniqueness. Aside from its incredible haute joaillerie pieces, Chopard corners the market on inventive diamond-setting with its signature Happy Diamonds collection. It was 23 years ago that one of Chopard's top designers conceived of a

every step, new issues arose, including where to find a top and bottom glass that the diamonds, when set between, would not scratch. The solution was to create a conical shaped sheath that ensconced the base of each diamond, so that with the lightest tap of the watchcase, the diamonds would rotate.

Borne of whim, the design won the 1976 Golden Rose of Baden-Baden competition. A year later, it was one of the most-demanded watches the firm created, and today, it is a legend. Chopard creates the Happy Diamonds watches either with full gemstone-adorned cases and bracelets, or as simply elegant 18K gold watches with dancing diamonds within.

What's more, the company has introduced new evolutions of the concept, from the Happy Diamonds perfume, with free-floating diamonds in the bottle to the Happy Diamonds

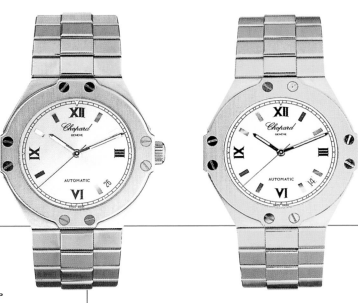

TOP

The St. Moritz offers sporty elegance
in its nautically inspired design.

RIGHT

Mille Miglia Chronograph in steel, special
Jacky ICKX edition. Case-back in
sapphire crystal to admire the automatic
movement, black dial, water-resistant
up to 50 meters, date indicator,
tachometer, hour counter, limited
edition signed by Jacky Ickx.

BELOW

From the Imperiale collection, this lady's
chronograph watch in steel with a blue
dial are set with cabochon-cut sap-
phires (1.76ct), water-resistant.

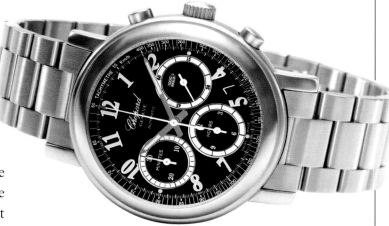

watches collection with rubies, emeralds or sapphires merrily spinning on the dial, to the Happy Sport collection. In this series, intended to contrast with the Happy Diamonds, the diamonds roll elegantly around the dial, and the stones roll freely across the watchcase.

But for the Scheufele family, diamonds and gemstones simply are not enough. In tribute to its forefathers—of both its own and the Chopard family—precision and quality nagged at them. While the diamond pieces were perfectly set and exquisitely executed, their penchant for complexity drove them forward. Today, Chopard's great Geneva watchmakers also excel at the intricate art of classical, complicated watchmaking.

Among its myriad timepieces of technical excellence are perpetual calendars, chronographs, dual time zones, skeletons and moonphase watches.

Symbolizing the company's return to its origins, fourth generation Karl-Friedrich Scheufele, on the threshold of the new millennium, initiated research into the creation of a

Chopard movement, and set up factory in Fleurier—a top Swiss watchmaking region. Here it was that the Chopard automatic movement, named L.U.C. in tribute to Louis-Ulysse Chopard, was born. After three years of research and development, the L.U.C. brings the house of Chopard full circle making it a true "manufacture" in the strict Swiss sense of the term.

Of course, also behind this intriguing company is a boundless creative spirit that yields refreshing innovation in classical and sport watches. Chopard's watch collections range the

full gamut, from Art Deco inspired watches, to the sophisticated Tonneau, to the beveled, hand-engraved Skeleton. Sportier lines include the Gstaad and St. Moritz collections, and the Mille Miglia—produced in tribute to the legendary Mille Miglia vintage car rally that was held annually from 1927 to 1957. The Mille Miglia was revived in 1977 as a three-day show-case rally for vintage cars. Within years, Chopard became the sponsor of the race, and each year creates a watch in tribute to it and its drivers. Mille Miglia was another perfect match for Chopard—not only because cars and watches have always held true to the same ideals of high performance and elegance, but also because both Karl and Karl-Friedrich join in the race with their vintage automobiles.

So, by carefully keeping an eye on the traditions of the past, and by blending in the passion and drive of the present, Chopard is one of the most gracefully poised personalities in the luxury watch and jewelry business for the millennium.

LEFT
La Strada Collection pair of ladies' watches in steel, steel bracelet with blue or white dial.

BOTTOM RIGHT
Karl-Friedrich Scheufele and his wife participating in the Mille Miglia race in 1999 with a Porsche 550A Spider of 1955.

BOTTOM LEFT
The 1999 Mille Miglia chronograph features a rubber strap with the Dunlop racing tire design, engine-turned silver dial, automatic movement and tachometer bezel.

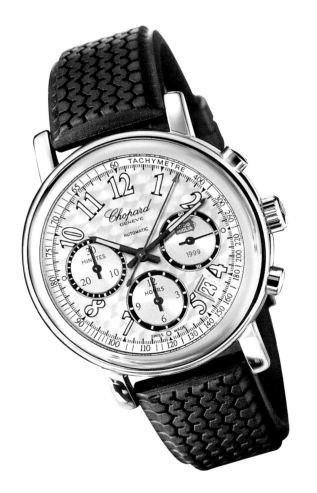

CLERC

There is a new breed of watch on the market — one marked by ingenuity in technology and design. The brand is Clerc, and the uniqueness of the timepieces it unveiled on the cusp of the new millennium lies in the fact that for the first time, a watch company has developed a method for setting precious gemstones such as rubies and sapphires into steel. ■ The art of gemsetting in timepieces and jewelry requires incredible expertise, dexterity, patience and technical prowess. An arduous and painstaking process, gemsetting into relatively soft 18-karat gold or platinum, nonetheless, is an art that has been mastered for more than a century. It has only been in the past few years that the world's finest watchmakers have mastered the art of setting diamonds — the world's hardest stones — into the hard metal of steel. Until Clerc recently revealed its newest jeweled collection, none had mastered the technical challenges of setting precious gems with a lower level of hardness than diamonds into steel. ■ The process is laborious, with a multitude of steps involved that require long hours of painstaking craftsmanship on behalf of some of the finest, most experienced

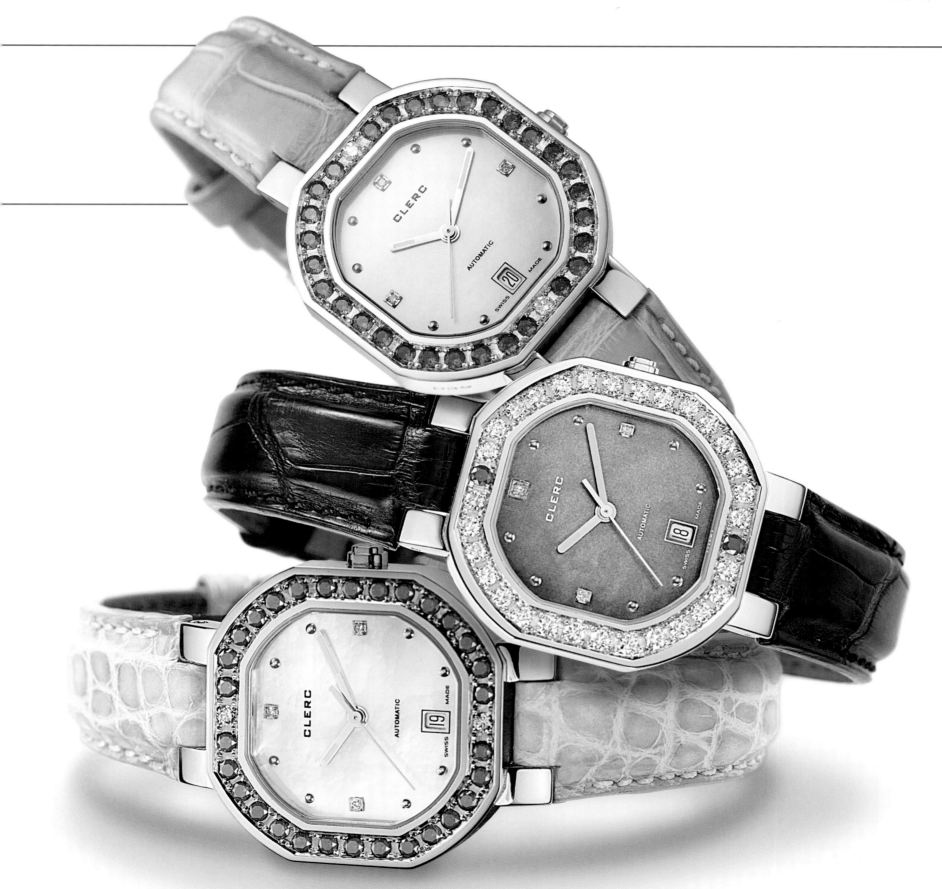

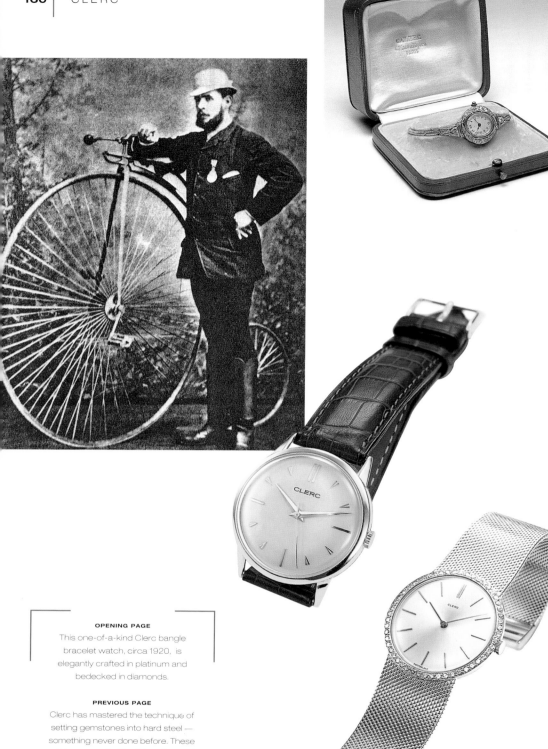

gem setters in the world. Once the watch is designed and the number of gemstones that will adorn it is set, the steel case is precisely marked off in order to prepare for their positioning on the bezel. Eleven successive millings are required to fashion each individual "seat" that will hold the gemstone. Then the gemsetter must finely and precisely cut out the metal surrounding each cavity to the exact dimension of the stone so that it will slip right into place.

Even then the process is not complete. The physical gemstones must be properly graded and prepared so that the surface, once set, of the entire gemstone bezel is smooth to the most discerning touch. The slightest irregularity to the touch, or the tiniest variation in uniformity of the setting, diminishes the strength of the stones and the intensity of the facets. Unlike many other finished pieces of jewelry, Clerc's steel and gemstone watches must be polished after the stones are set. If the degree of strength

OPENING PAGE

This one-of-a-kind Clerc bangle bracelet watch, circa 1920, is elegantly crafted in platinum and bedecked in diamonds.

PREVIOUS PAGE

Clerc has mastered the technique of setting gemstones into hard steel — something never done before. These watches are set with rubies, diamonds and sapphires for stunning appeal.

CENTER

This classic men's watch, circa 1950, is crafted in 18-karat yellow gold.

RIGHT

Created in 1960, this 18-karat white gold watch, with mesh gold bracelet, is an example of Clerc's meticulous craftsmanship.

used in this process is not completely controlled, the stones are likely to be scratched. It takes more than three days of delicate hand craftsmanship to ready a steel watch, which, when finished is a work of art and supreme elegance.

"Clerc watches display a keen desire to go a step further," says Gerald Clerc. "Always in pursuit of perfection, Clerc combines rigorous stylistic work with a determination to craft a product to the most stringent quality requirements — yielding a unique and modern collection."

While Clerc's newest invention of steel and gemstone watches is definitely cutting edge,

the company also continues to create in 18-karat gold — wherever possible, with a technical or aesthetic twist or nuance. Such is the case with Clerc's self-winding chronograph. This large watch is crafted in 18-karat gold and features another new jewelry approach. Whereas most watch companies choose to adorn the cases, and bezels with diamonds, Clerc goes a step further in this watch, adorning not only the bezel, but also the caseband and lugs — with 588 diamonds.

Ingenuity and innovation in product design and technology are hallmarks of the Clerc

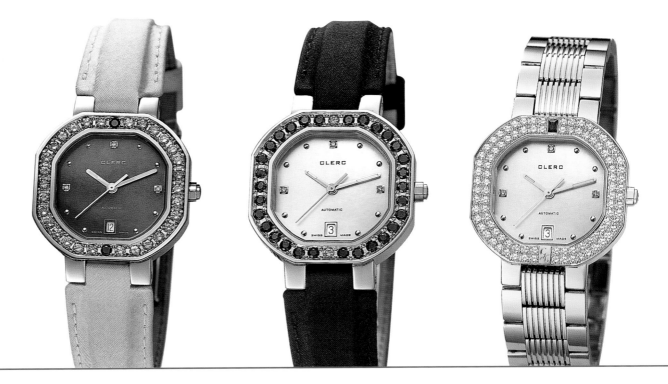

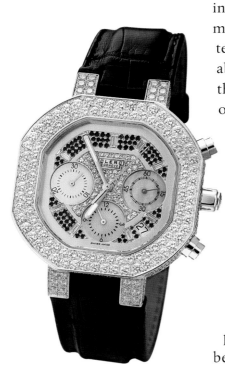

brand. At a time when fine watches are in demand, Clerc embraced the idea of introducing a new line, recognizing that it must be different in look and style. Indeed, the strength and modernity of Clerc watches is gained from the technical prowess and immediately recognizable design. Every Clerc timepiece is crafted in the softly cushioned definable lines of an octagonal case — belying its dynamic strength of character.

"This collection arose from a shape, a perfect square in a perfect circle," says Gerald Clerc, who designed the distinctive line. The bold lines of the case shape, coupled with the incredibly beautiful dials and bracelets, make the Clerc brand identifiable at a glance — the mark of a true designer.

Heir to a longstanding family tradition, Gerald Clerc's watchmaking passion has been perpetuated for generations. In fact, Clerc has been creating watches for over 125 years. The family firm was founded in 1874, and the timepieces it has created have always been recognized for their avant garde design and exception

quality. Today's collection, designed by Gerald Clerc, exemplifies the same standard of excellence and innovation that stamped the watches of Clerc's history — but with a definitive spark for the new millennium.

A definitive perfectionist, Gerald Clerc insists that every detail of his the timepieces that bear his family name be finished to his exacting standards. The shape of the push pieces, for example echo the case shape, the combed effect of the dial is achieved by hand guilloche only, and the supple bracelet links are the result of detailed and extremely sophisticated levels of craftsmanship and hand polishing. Its links curve beautifully around the wrist and are fashioned by milling rather than stamping. The central part of the bracelet features perfectly regular grooves that emulate the guilloche pattern on the dial.

All Clerc watches, made in Geneva, are fashioned and sculpted from solid blocks of either 18-karat gold or 316L steel — one of the top qualities available on the market. Clerc adheres to the finest craftsmanship and heritage

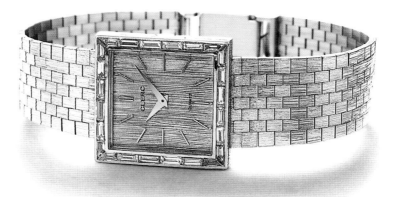

— housing only mechanical movements in its timepieces. Transparent sapphire casebacks, date window, screw-locked winding crown and glare proof sapphire crystals are the norm for Clerc.

The collection, which includes calendar models and chronographs, is available in three sizes and offers an entire palette of options. From simple to jeweled, bracelet or hand-stitched strap, one metal or bicolor metal — Clerc's versatility and styling is perfect for the new millennium. Confident in its product, Clerc stands behind its watches with a three-year international guarantee.

In 1999, Clerc entered the United States market under the direction of watch executive veteran Herman Plotnik. As president, Plotnik plans a limited, selective distribution of this bold and beautiful brand that is destined to be a fabulous success.

TOP
This Clerc Chronograph features a double row of diamonds on the bezel and case to bracelet attachment for overall beauty.

BOTTOM
Circa 1970, this platinum watch features a hand-guilloché dial and a bezel of baguette diamonds.

CONCORD

Since its inception, Concord has proven to be a master of time design and elegance. In an age when time is the ultimate luxury, a truth captured by the company's new advertising campaign, Concord continues joining technological excellence with superbly beautiful design and enjoys appreciation by those who understand the invaluable freedom to be late. Concord enters the twenty-first century with fine watchmaking that brings time, and therefore all the best of living, into one's own hands. ■ The company was formed 1908, in Bienne, Switzerland, when two young watchmakers sought to develop extremely thin movements and revolutionize the proportions of timepieces. Among their early achievements was the popularization of the petite ladies watch, which captured the fashion sense of the times. And their success in engineering and design brought them commissions to create luxury watch lines from leaders in haute joaillerie, including Tiffany, Cartier and Van Cleef & Arpels. ■ Concord's eminence in the area of wrist-worn timepieces held a steady pace throughout the following fifty years. Then in 1979, Concord capitalized on the advent of quartz

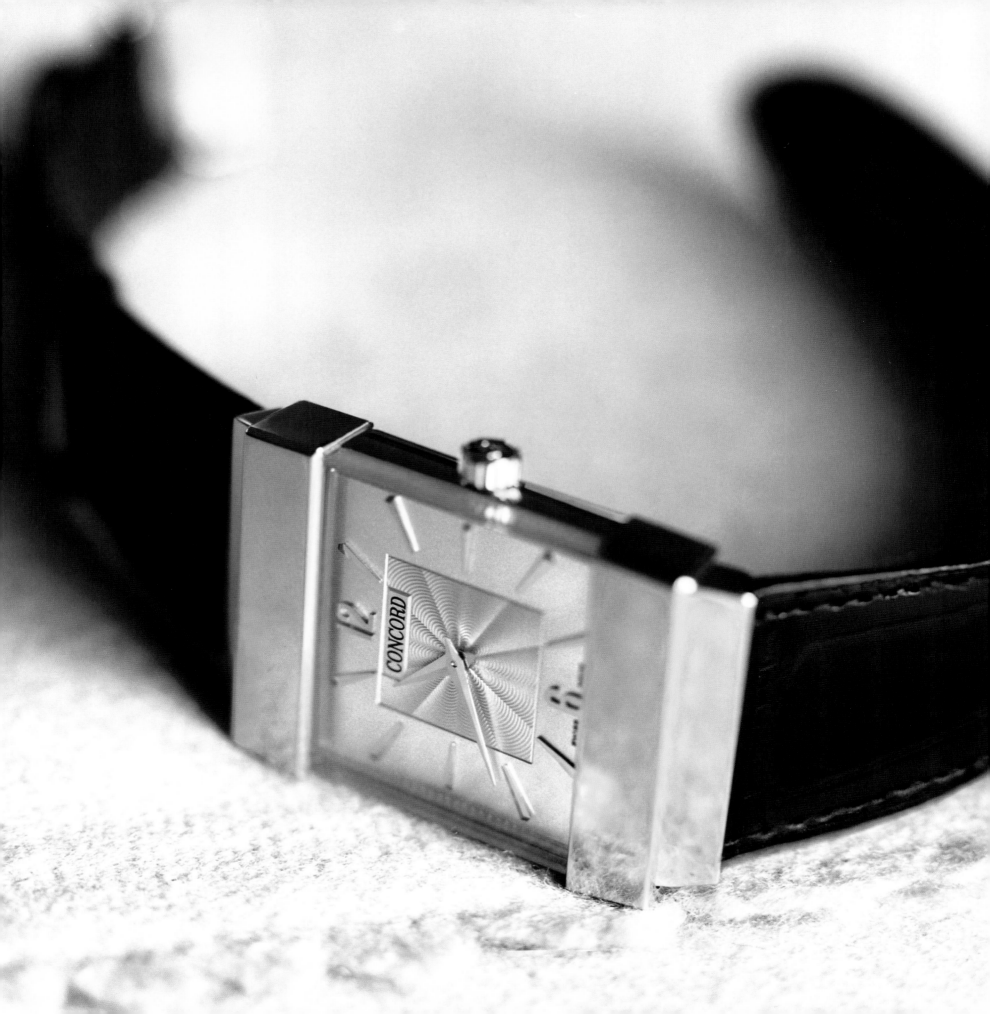

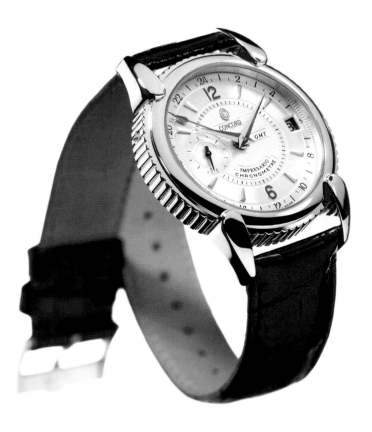

movements and the design advantages such technology affords by creating Delirium, the "thinnest watch in the world." In a case measuring just 1.98 millimeters, the first generation Delirium quite lived up to its claim. This amazing proportion was achieved by incorporating the movement into the case back itself. But the momentum at Concord did not abate and Delirium II was issued in the same year. The second Delirium broke the 1.5-millimeter barrier; within two years the barrier had been brought down to the almost inconceivable 0.98 millimeters. Twenty years after its initial introduction, current Delirium models are still unsurpassed in thinness and elegance, in their trademark rectangular cases of 18 karat gold, stainless steel, or gold and steel.

For the connoisseur of fine, traditional Swiss movements, Concord created the gentlemen's Impresario Mechanique Collection, a family of watches distinguished by its masterful harmony of form and function.

Unique tear-shaped lugs and meticulous coin-edge detailing on the case, bracelet and crown mark the collection with elegant sophistication. Included in the collection are the Impresario Chronographe and the Impresario GMT. The first automatic chronograph movement in the world able to measure time to tenths of a second, the

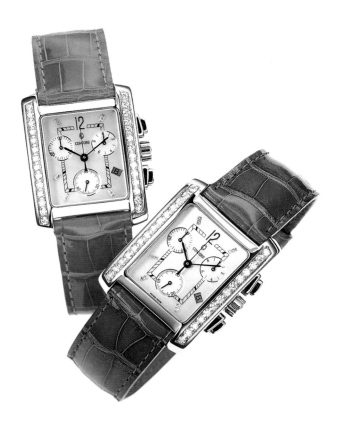

Impresario Chronographe is a precise time-keeper that also makes a bold style statement. And the cosmopolitan Impresario GMT is internally complex to track time on two continents while maintaining external sophistication that transcends borders of style. At the pinnacle of the line are the one-of-a-kind, haute horlogerie tourbillons known as the Concord Impresario Maestro Masterpieces. Masterfully handcrafted of precious materials, these pieces combine beauty with highly intricate and complicated mechanisms prized for unsurpassed precision. The entire Impresario Mechanique Collection, first unveiled on the occasion of Concord's 90th anniversary, is an appropriate celebration of the company's commitment to excellence and innovation in design and the understated assertion of the luxury of time.

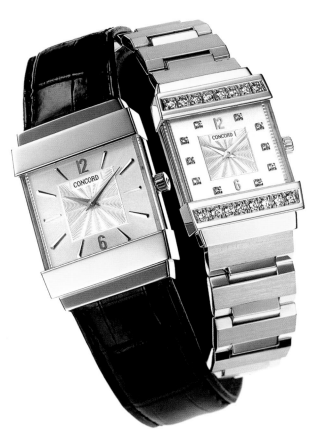

TOP LEFT
A sophisticated sport watch, the bold Concord Sportivo Chronograph successfully combines fashion and function. Crafted in high-polished stainless steel, the strap models feature elegant, mother-of-pearl dials with full set diamond bezels on fuchsia, blue or classic black alligator straps.

TOP CENTER
Concord's new advertising campaign, with the tagline "Time is a luxury," appeals to those who appreciate and can afford to savor life's important moments.

TOP RIGHT
The Crystale in profile, a remarkable achievement, is sleek, flat and transparent on the sides.

BOTTOM
The meticulously crafted Crystale showcases Concord's mastery of exceptional and sophisticated design.

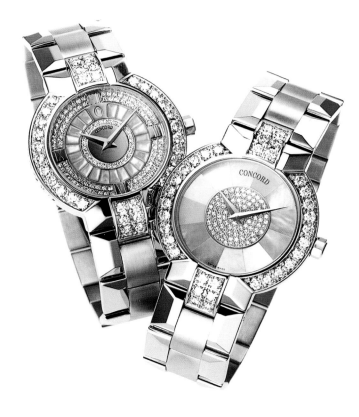

Honored by De Beers as one of the 50 most luxurious watches for the new millennium, the La Scala Grande provides an accurate portrait of Concord's continued success in rendering timepieces of unique and exceptional beauty. As in the La Scala line, which debuted in 1997, the geometric lines of the Grande are a contemporary take on Art Deco style and pay homage to the grandeur of the Milan Opera House. In the La Scala Grande, diamonds are mounted in an invisible setting, relying on natural tension and physics rather than the typical gold prongs to keep them in place. The effect is one of ultimate indulgence, made possible by assiduous craftsmanship. New for 1999, The La Scala line, which had featured only square cases, expanded the line with round case models and a chronograph timepiece.

With timepieces that exude the sensuality of the now, Concord celebrates the importance of time in our lives. Long beloved by the rich and famous, Concord made an impressive showing at

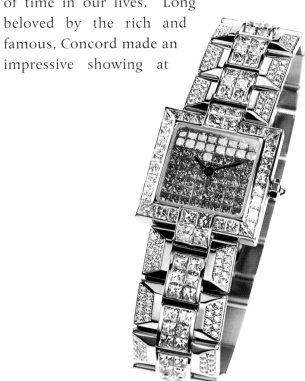

Concord's heritage is also rich with creativity. This innovative spirit is continually demonstrated, most recently in the spring of 1999 with the launching of the Concord Crystale. This timepiece is especially appealing to modern individuals who value understated elegance, yet demand exceptional design. Where traditionally a watch crystal is enveloped on all four sides by a bezel, the Crystale is quite novel in its utilization of the sapphire crystal as case—the crystal functions as the sides of the case. Transparent, the sapphire crystal creates a prismatic effect when light shines through. Executed in 18 karat yellow or white gold, the Crystale's square dial and graduated, double-tiered north/south bezel (with the first tier available set with diamonds or not) communicate confidence. Its architectural lines and bold inclusion of light make Crystale a modern classic.

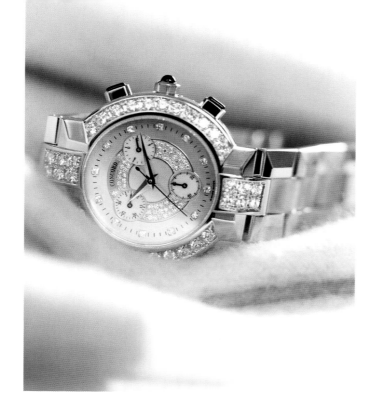

the 1999 Oscar Awards, walking down the red carpet on the wrists of Geena Davis, Jim Carrey and Ian McKellan, among others. And all eyes in the house, and around the world, were on hostess Whoopi Goldberg and her diamond encrusted Saratoga Signature.

The technical advances of Concord have kept stride with the twentieth century and continue to propel the company forward into the new millennium. The company's new advertising campaign, which debuted in fall of 1999, breaks ground within the watch industry. Whereas watch advertising has traditionally been product focused, Concord emphasizes the importance and value of time in our lives. Time is a luxury: Concord's simple, yet provocative statement that real luxury is to experience, savor and enjoy the fullness of the present moment. Concord succeeds in making the luxury tangible with its superlative craftsmanship, design, and twenty-first century technology.

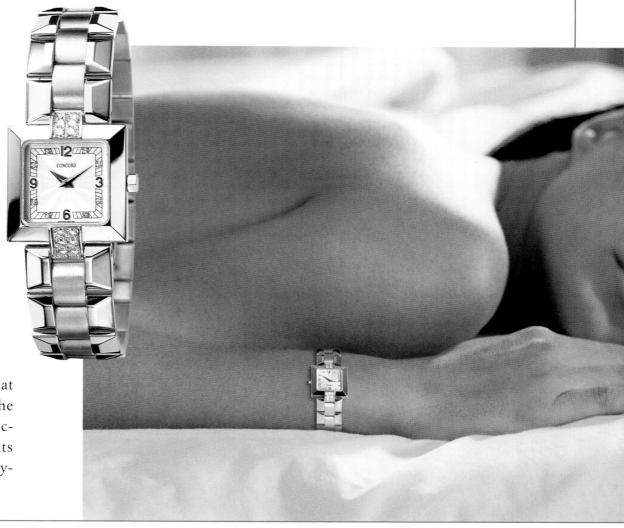

DANIEL JEANRICHARD

*F*irst revered more than one hundred years ago as the founder of watchmaking in Neuchâtel, Daniel JeanRichard's name is once again drawing great acclaim. Though a statue of JeanRichard has long loomed in the proud watchmaking town of Le Locle, and his name has graced the streets of many towns in the region, JeanRichard is re-emerging internationally through a new line of timepieces that carries with thecollection his spirit of fine technical wizardry, as well as his name. Within a year of launching its phoenix line, JeanRichard is offering exceptional mechanical and complicated watches boasting sleek design. In particular, the TV Screen split-seconds chronograph, with its expansive face and slightly curved bezel shape appears to crow the hour in a style that is undoubtedly the star of the collection. ■ Such extraordinary design coupled with fine craftsmanship is typical to the watch group responsible for bringing JeanRichard back to life, the Sowind Group, which also includes Girard-Perregaux and GP Manufacture. Under the direction of Sowinds CEO, Luigi Macaluso, Jean Richard is rising to its esteemed position as a master watchmaker.

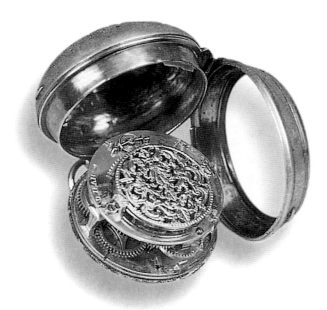

Possessing a celebrated history in watchmaking enables the seamless restoration to its solid foundations.

The son of a farmer, Daniel JeanRichard was highly skilled in working with machinery by the age of 18. As he began to seek out a means to express his love for mechanics, watchmaking caught his attention. At the time, only a few watchmakers existed in Geneva, and they were extremely guarded against the development of new competition. Yet by refusing to sell Jean-Richard any of their wheels, the watchmakers merely fueled his passion. JeanRichard began crafting his own watch parts, ultimately inventing what is known as a divisor, which produced both pinions and wheels. The year spent laboring at the development of the divisor established firmly in JeanRichard,s mind what would be required to run a thriving workshop. A remarkable insight, considering that when Daniel Jean-Richard installed his first workshop in 1705 in the town of Le Locle, it was merely the dawn of modern watchmaking. Timepieces were crude mechanical items that were frustrating because of their inability to keep time, and during Jean-

PREVIOUS PAGE

The Bressel Chronograph will catch the eye of all lovers of beautiful watches with its 51 ruby DJR 25 movement, with a frequency of 28,800v/h that is housed in a 316L steel case. It features a grained silver dial with vertical varnished blue hour markers and tone-on-tone counters. Produced in a limited, numbered series of 500 pieces.

LEFT

The retro style Cambered Rectangle, one of Daniel JeanRichard's new 1999 models, features dials of a classic yet contemporary design, and it is finely engine-turned under a layer of translucent lacquer that gives it extra depth.

FACING PAGE

TOP

To meet market demand, Daniel JeanRichard has manufactured a limited, numbered series of the classic TV Screen Chronograph in 25 yellow gold pieces and 25 pink gold pieces to mark the brandıs first participation at the prestigious Salon International de la Haute Horlogerie in Geneva.

CENTER

The center piece of the DJR range, the TV Screen Split-seconds Chronograph has been produced in three limited series of 5 yellow gold, 5 pink gold and 50 steel pieces. This exceptional timepiece has a 44-hour power reserve and is water-resistant to 50 meters.

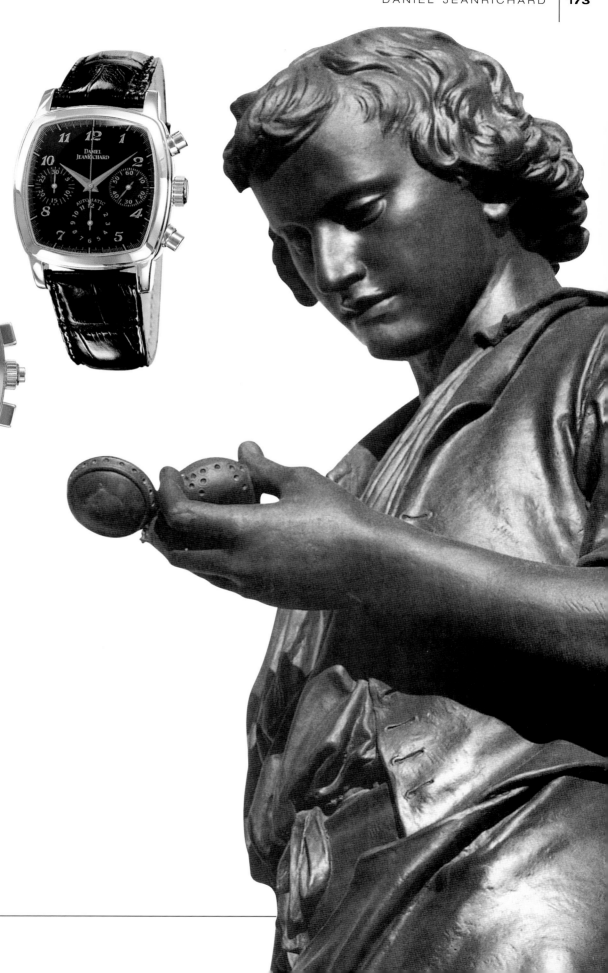

Richard,s first decade of business, astounding leaps would be made in watchkeeping. For his part, Jean-Richard,s skills and passion for his craft were recognized by peers and citizens of the region, and more than a decade after his death, inspired the sculptor Iguel to create a statue in his likeness in 1888. It is a tangible testament to a man who is considered to have given birth to one of the key places for Swiss precision horology.

This devotion to precision horology manifests itself in this new watch line, which first appeared in 1999. To celebrate its international launch, JeanRichard produced a special Gold TV Screen Chronograph in a limited series of 25 yellow gold and 25 pink gold pieces. At the same time, the company presented remarkable time-keeping pieces, such as the Bressel Chronograph and the Chronscope. Evident at a glance that the wristwatches are highly specialized, the face of the Bressel Chronograph is unusual with blue

hour markers reading the time and an outer perimeter of red numbered markings revealing its chronograph features.

The Chronoscope, the name is the correct term for chronograph, is similar in that the time is indicated at the center of the face, while the recording of the intervals of time are notched around the perimeter.

Considered a high-tech product, the Chronoscope features a rotating bi-directional bezel under the glass, activated by a second crown at 9 o,clock. Water-resistant to 100 meters, the watch is available with a choice of four different dials.

As this collection of timepieces may indicate, JeanRichard is intimately involved in the racing industry, a reflection of its commitment to~and passion for~mechanics. Much like Girard-Perregaux, JeanRichard produces timepieces for major sports car manufacturers, such as Alfa Romeo and Lancia. The watchmaker also counts three races in which it is involved, and of course, in which it excels. First, JeanRichard,s co-driver Luis Moya received the best co-driver award in the World Rally Championship in 1999. For more than a year, Daniel JeanRichard has been a part of the Italian Two-wheel-drive Championship, with the cars of Stefano and

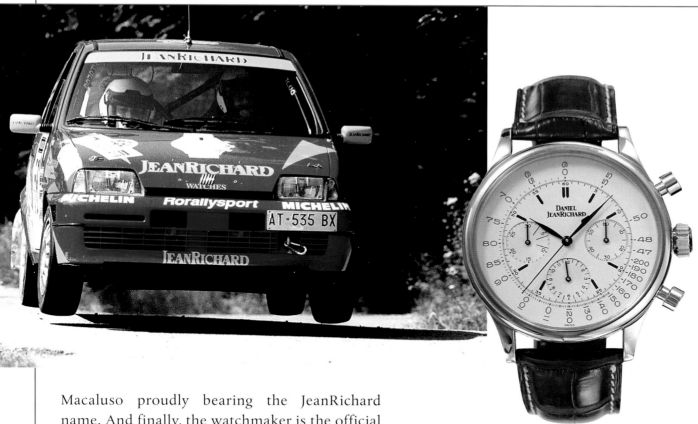

Macaluso proudly bearing the JeanRichard name. And finally, the watchmaker is the official sponsor of the Swiss Historic Racing Team.

Watchmaking, perhaps more than any other craft, involves a profound respect for the past and an innate ability to grasp the skills that have evolved for hundreds of years. With the revival of a leader in the industry from another century, Daniel JeanRichard is bound to return to its position of eminence, picking up where it left off, and once again paving the way for horological technology in the future.

deGRISOGONO

T he **"Instrumento N° Uno"** is the first watch to appear under the de Grisogono label. The world famous collection of black diamond jewellery is now accompanied by an original timepiece in keeping with the jeweller's taste for perfection and innovation. ■ "Instrumento N° Uno" is a watch of style, generously proportioned, perfectly balanced and refined in form. Created by Fawaz Gruosi himself, its different versions, whether steel, gold, platinum or encrusted with jewels, meet contemporary needs and tastes without any loss of culture and tradition. ■ The "Instrumento N° Uno" has a square and slightly arched case. The curve flows through into the opulent and functional attachments, giving the whole a stamp of allure and harmony. Inside the case nestles an automatic 28 800 A/h movement, with the unique feature of rhodium plating in black, de Grisogono's hallmark color. ■ The basic calibre comprises two additional modules: *The Dual Time Zone* module, specially created following the instructions of Fawaz Gruosi, permits simultaneous time-keeping in two different zones, which are permanently synchronized with each other. Pressing a button on the side of

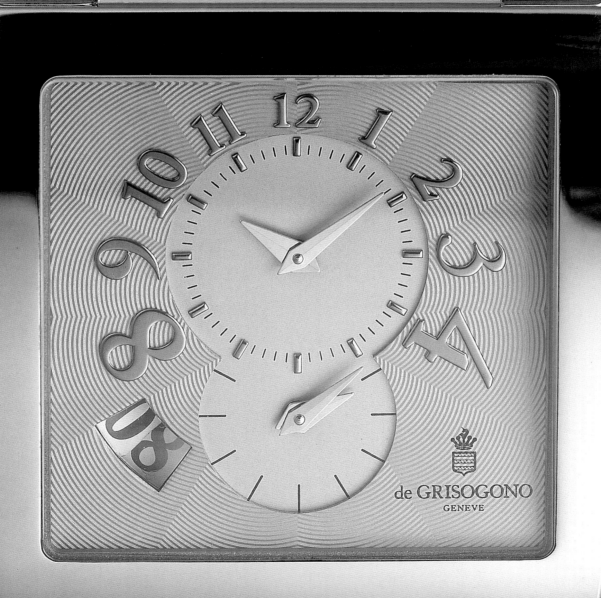

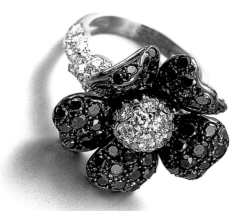

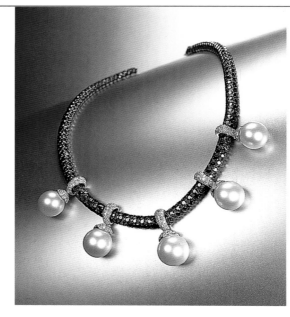

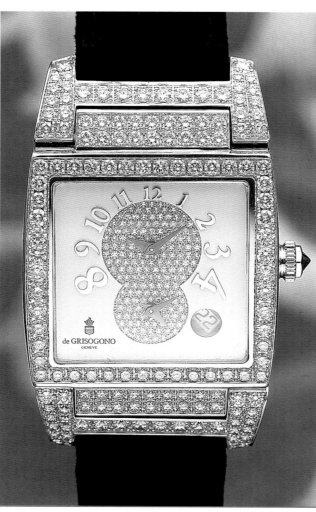

the case switches the time display to the second dial. The first dial itself is set with the exclusively designed crown, adorned with a cabochon black diamond. This system is an important feature, which ensures that the reference time is never lost.

The dial, either guilloché or set with diamonds, presents three functions: the main display at 12 o'clock, the secondary display at 6 o'clock and the extra-large date. The geometrical center of the dial does not serve as an axis, the two displays being separate and placed at different distances from the centre. This gives the impression that there are two watches in one, but with the "Instrumento Uno" there is in fact one single automatic movement. The large and exclusively designed figures sweep around the main display in a rising curve. The overall sense of precision is heightened by the sharply defined hands, which are superluminova coated to provide a luminous display.

The Extra-Large Date, the second module, is a remarkable feat of watchmaking, which is

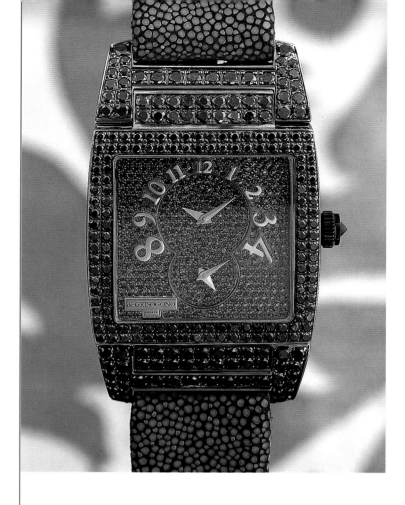

shown in a trapezium-shaped window situated at 7 o'clock. This unique but logical position is ideal for easy reading. And not only is the window twice the usual size but it is also fitted with a magnifying lens for even greater ease. The date is instantly set and reset from the crown.

The back of the watch, retained by four screws, is shaped to follow the curve of the case and to hug the wearer's wrist. It is covered with sapphire glass, so that it is possible to look inside and see the beating heart of the blackened automatic movement, with the escapement, spring, balance wheel and the oscillating weight engraved with the name "Instrumento N° Uno".

As always, de Grisogono blends originality with diversity. Thus, Fawaz Gruosi offers this unique model in a number of versions: steel, yellow gold, white gold, pink gold and platinum. In addition, there are ladies' models which come in the same size as the men's but are set with rubies,

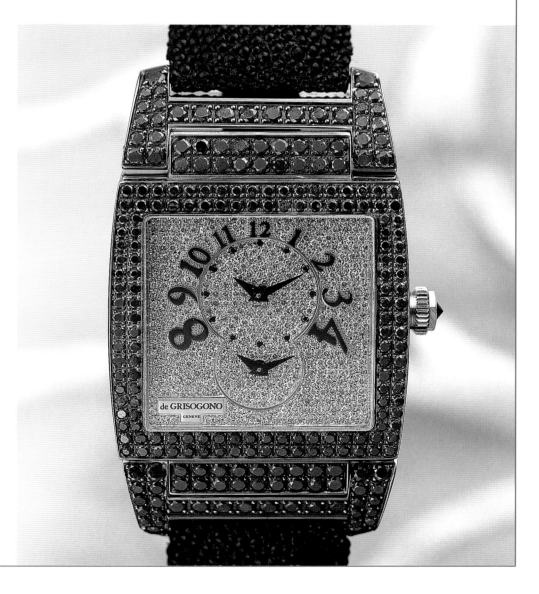

TOP RIGHT

Mrs. Caroline Gruosi-Scheufele
and Mr. Fawaz Gruosi.

TOP LEFT
White gold ring set with rubies with a
teardrop black diamond in the
center, circled by white diamonds.

BOTTOM RIGHT
"Instrumento N° Uno" white gold
watch with red "galuchat" strap.
Case, bezel and links set with black
diamonds. Dial set with rubies.
Dual time automatic movement and
crown set with a black diamond.

BOTTOM LEFT
Portable phones set with black
diamonds are one of a kind.
de Grisogono enhanced these
portable, compact Ericsson and
Motorola phones with black and
white diamonds weighing a total of 28
carats-a delicate task that took
about two months to complete.

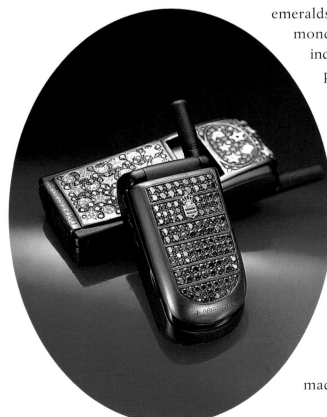

emeralds, white diamonds or black dia-
monds. Another original touch: the
index of the ladies' watches are incor-
porated directly in the setting.

The man's watch is worn
with a brown or black croco-
dile strap, while, as a unique
first, the lady's watch has a
"galuchat" strap, the perfect
accompaniment for watches
set with rubies, emeralds or
diamonds. This leather is
available in a range of
colors and textures. The
exclusively designed buckle
bears the distinctive de Griso-
gono logo.

"Instrumento N° Uno" is
made and assembled in Geneva, the

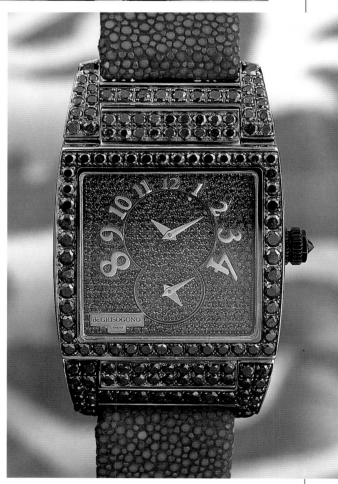

very cradle of Swiss watchmaking.

"Instrumento N° Uno" is a unique and personal creation from Fawaz Gruosi, developed with all the painstaking care associated with his name. A passionate believer in his art and profession, Fawaz is constantly on the move and this watch was originally designed for his own use. It incorporates his needs and his inclinations and the whole bears the characteristic stamp of his taste and style. In short, the watch is a joy to look at and a triumph of technical ingenuity.

Ease, facility and speed are all combined with sober elegance. A single glance suffices to take in the two time zones, with their allied and competing functions. The dial ticks away unforgettable hours and minutes, all flowing with the same rhythm and beat from a single "heart". "Instrumento N° Uno" marries the beauty and abundance of forms with the traditional watchmaker's art. A watch for travelers, for businessmen and for lovers of beauty and generosity.

de GRISOGONO

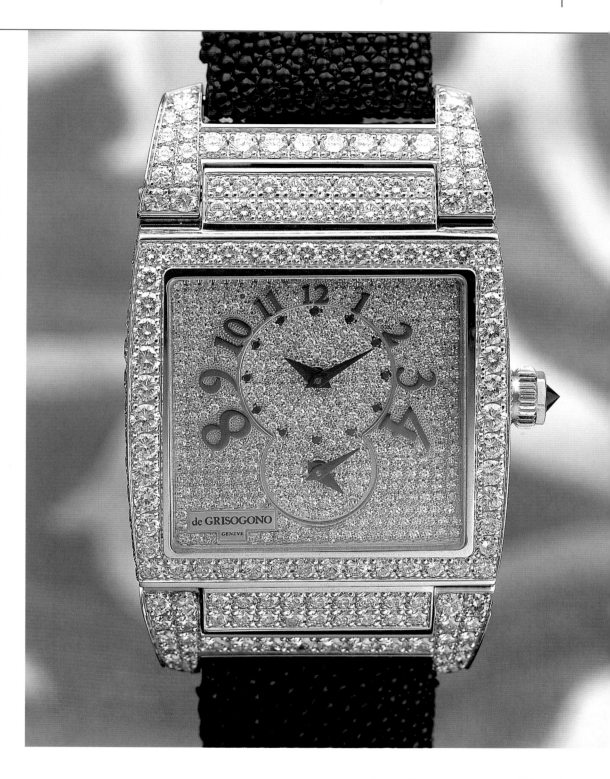

GIRARD PERREGAUX

With utmost reverence to time itself, Girard-Perregaux crafts remarkable timepieces in classic tradition while bringing together innovations brought by progress. For more than 200 years, the watchmaker has produced timepieces in this manner because at Girard-Perregaux, goals and objectives remain constant: there will never be a compromise in watchmaking. As the rest of the world fixes its attention on the year 2000, Girard-Perregaux looks beyond the millennium and focuses on its continual evolution as a watchmaker. The timepiece Girard-Perregaux chose to honor the end of the millennium is as exceptional, and as traditional, as every watch produced at the manufactory in La Chaux-de-Fonds, Switzerland. The Vintage 1999 is a chronograph whose tank-shaped case is based on a model that first appeared in 1945. What is noteworthy is that the watch features a new movement that required three years for development. It is an integrated chronograph movement, featuring a column wheel used to transfer the power to the chronograph features. Yet the size of the movement is small, giving watchmakers greater flexibility with case shapes and sizes.

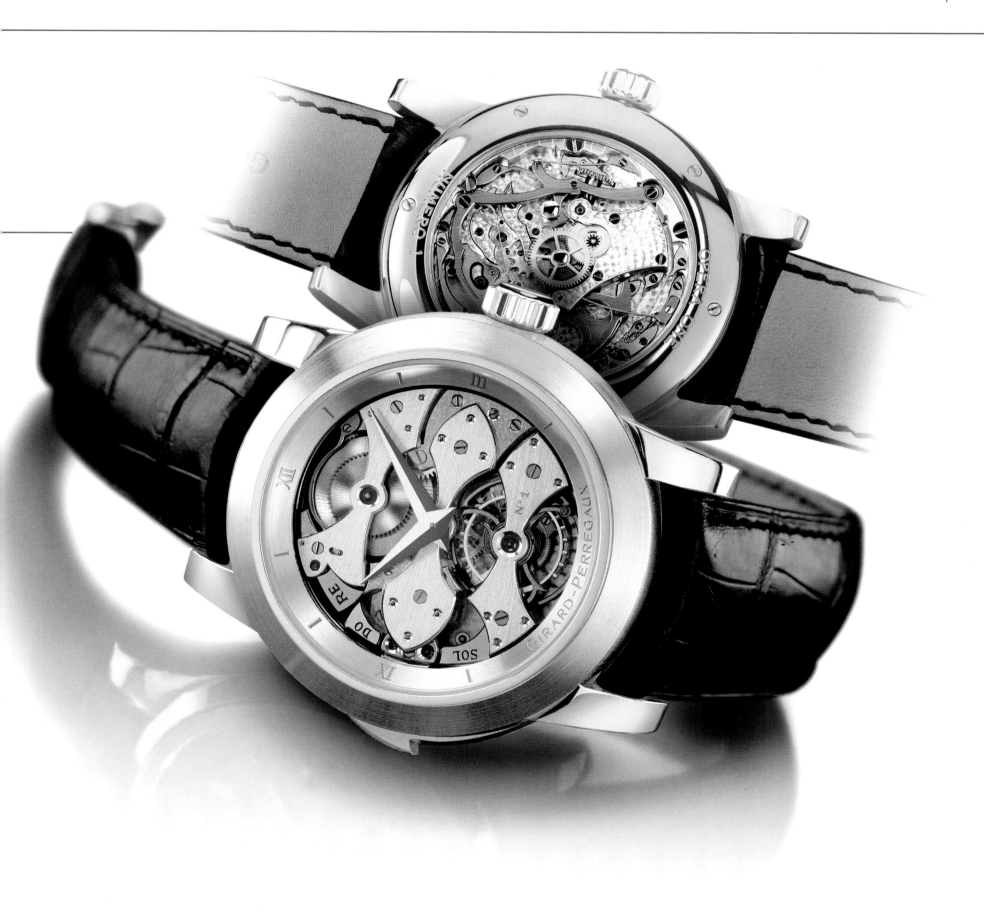

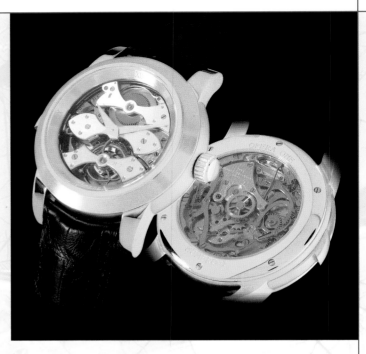

The Vintage 1999 is produced in a limited edition of 999 pieces in the workshops at Girard Perregaux, an achievement that is both rare and admirable in Swiss watchmaking.

With most companies today it's very rare to possess the skills and infrastructure to create anything from within, whether it is the development of a concept or the manufacturing of the product. For Girard Perregaux, all of the research, development and production is done in-house and it is accomplished by people employed within the infrastructure of the Girard-Perregaux company. It is this philosophy that served as the basis for watchmaking when J.F. Bautte founded the company in Geneva, Switzerland in 1791, and that continues to be embraced by owner Dr. Luigi "Gino" Macaluso. These principles enable the company to create its dynamic repertoire of watches today.

Indeed, perhaps the most difficult question ever asked of Girard-Perregaux is, "Which watch is most important?" The answer one is likely to receive takes some time. There are a number of important watches released every year. For example, at the same time that Girard-Perregaux presented the Vintage 1999, the watchmaker also offered an Opera One Tourbillon with Three Gold Bridges featuring a minute repeater with a Westminster chime, along with an Automatic

Tourbillon with Three Gold Bridges, an S.F. Fourdroyante split-seconds chronograph, the F1-047 and the F1-048.

Four gongs sound the first, second and third quarters and two gongs mark the hours and the minutes with a delicate warmth in the Opera One Tourbillon with Three Gold Bridges. The mechanical marvel is revealed through the face as a result of careful stylizing of the Three Gold Bridges.

The Three Gold Bridges architecture is held in special regard for its links to Girard Perregaux's namesake, Constant Girard. After assuming the company in the mid-1800s from founder

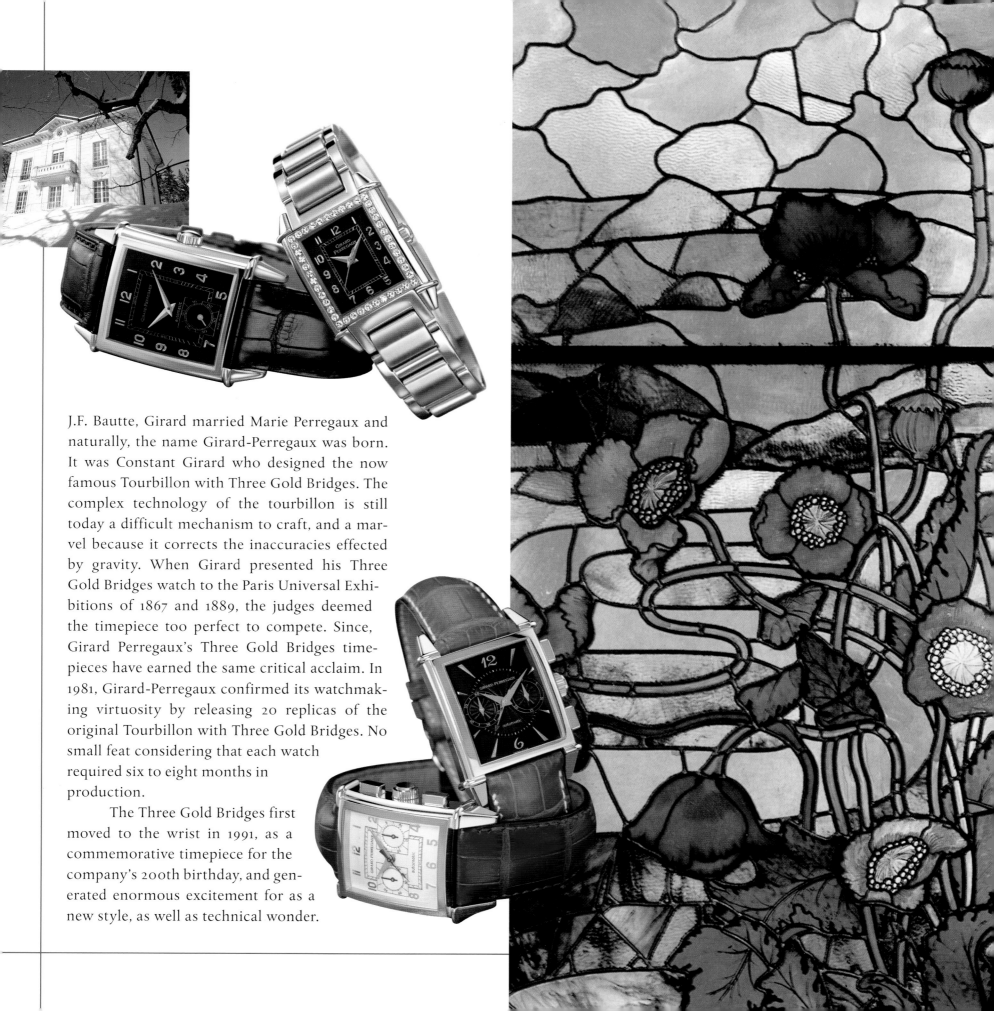

J.F. Bautte, Girard married Marie Perregaux and naturally, the name Girard-Perregaux was born. It was Constant Girard who designed the now famous Tourbillon with Three Gold Bridges. The complex technology of the tourbillon is still today a difficult mechanism to craft, and a marvel because it corrects the inaccuracies effected by gravity. When Girard presented his Three Gold Bridges watch to the Paris Universal Exhibitions of 1867 and 1889, the judges deemed the timepiece too perfect to compete. Since, Girard Perregaux's Three Gold Bridges timepieces have earned the same critical acclaim. In 1981, Girard-Perregaux confirmed its watchmaking virtuosity by releasing 20 replicas of the original Tourbillon with Three Gold Bridges. No small feat considering that each watch required six to eight months in production.

The Three Gold Bridges first moved to the wrist in 1991, as a commemorative timepiece for the company's 200th birthday, and generated enormous excitement for as a new style, as well as technical wonder.

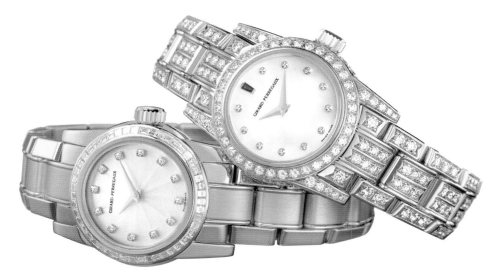

Once again, Girard-Perregaux delved into its rich history to develop the S.F. Fourdroyante. The limited edition split-seconds chronograph was produced in only 750 pieces and is based on a concept that dates to 1860. On the watchface is an 1/8-second subdial that relates fractions of seconds and a separate power reserve.

Girard-Perregaux, operating today under a unique co-branding arrangement with Ferrari, is one of the only watchmakers who is inextricably involved in the racing industry. This is traced to the company's leader, Macaluso, a former Fiat

It is testimony to Constant Girard's vision that the design dated to the turn of the century. The recent Tourbillon with Three Gold Bridges timepieces uphold the watchmaker's tradition while continuing to advance technology. In the Automatic Tourbillon with Three Gold Bridges, the rotor is fitted beneath the barrel, retaining the face of the watch as the focus of beauty: the Three Gold Bridges.

race car driver and President of Club Italia, a 50-member group devoted to the preservation of Italian cars and motorbikes. As a result, the watchmaker produces phenomenal chronographs, many specifically developed for the Italian car manufacturer, Ferrari. The "Tribute to Ferrari" series began in 1994 when Macaluso assumed leadership of Girard-Perregaux. He and the president of Ferrari were longtime friends, fortifying a natural union between watchmaking and car racing. The two also shared grand visions. "Because Ferrari is the dream car that is unique to the world, we decided to create something that was for the top collectors," Macaluso said.

Connoisseurs were delighted with the first pieces produced under the "Tribute to Ferrari" series. In 1995, Girard-Perregaux showcased a one-of-a-kind timepiece adorned with a Ferrari stallion insignia carved from a ruby. This exceptional collector's watch quickly sold for $150,000. Girard-Perregaux also created special timepieces to honor Ferrari's history.

In 1997, Girard-Perregaux joined forces with the Italian automotive legend and created the F50 wristwatch in honor of the 50th anniversary of a vehicle

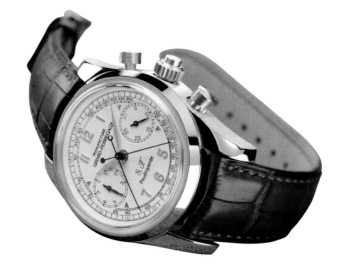

that could only exist twice in one lifetime, the F50. Girard-Perregaux chose gold, platinum or titanium for the watchcase, which contains the F50 watch's complex mechanism. The F50 timepiece is an exceptional technical accomplishment. It boasts an automatic chronograph with a perpetual calendar capable of correcting the date, even in leap years, until the dawn of the 22nd century.

Girard-Perregaux issued the Ferrari F50 watch in two very limited series. The first series of 349 watches was designed for the 349 owners of Ferrari F50 cars. Owners who acquired the F50 watch were cordially invited by Girard-Perregaux to have his name and serial number of his automobile engraved on the watch's case. A second series of 250 chronographs was then offered to distinguished collectors.

Drawing from its passion for racing, Girard-Perregaux recently launched the F1-047, which incorporates the innovative materials used in racing. The watch's alluminum case is created from an alloy that equals half the weight of titanium and was developed by Alcoa for the engine block of Ferrari F1 racing cars. Nearly weightless, the wearer only feels the weight of the mechanism inside the case. In the same spirit, Girard-Perregaux created the equally lightweight F1-048. The case is titanium, the dial is carbon, and the strap is rubber—resulting in a

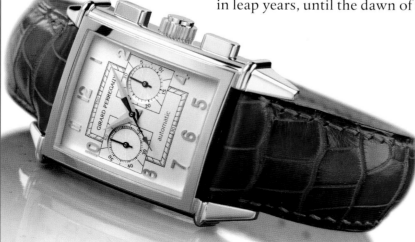

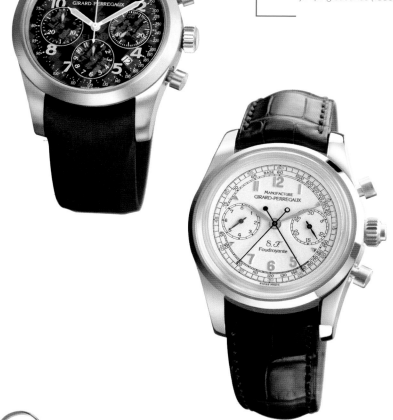

very light yet exceptional mechanical timepiece that can be worn racing, or while playing tennis and swimming.

Girard-Perregaux assures the quality of its watches by producing only 18,000 each year. The watchmaker's peerless reputation draws acclaim from other leading watchmakers, and Girard-Perregaux creates some 20,000 watch movements for other watchmakers. With careful mastery, Girard-Perregaux is leaving this century much as it entered; as an esteemed watchmaker that holds the crafting of timepieces as an honored art form.

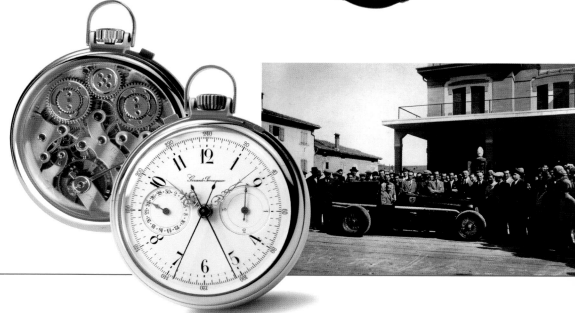

KELEK

*D*emonstrating its firm commitment to Swiss watchmaking tradition, Kelek is run by a master watchmaker who just happens to have an astute business sense, too. For three decades, Gabriel Feuvrier has been steering the centenarian watchmaker with one guiding principle: quality supercedes quantity. When he assumed control of the company in the 1970s, he decided that the watchmaker would focus only on producing mechanical timepieces. "Quartz, in my view, is not enough to make a watch," Feuvrier said. "It is a very reliable electronic timekeeper with a chip that is based on very sophisticated, state-of-the-art technology, but it is technology that can be bought as a completely assembled item. With the mechanical watch, you have a piece of precision engineering, a masterpiece." A seemingly risky decision during a time when quartz watches threatened to overwhelm the market, it has since proven sound. Today, connoisseurs and collectors seek out Kelek's timepieces, and the watchmaker is firmly established as a leading maker of self-winding mechanical chronographs. ■ Feuvrier's vision matches the spirit established by Ernest Gorgerat, the

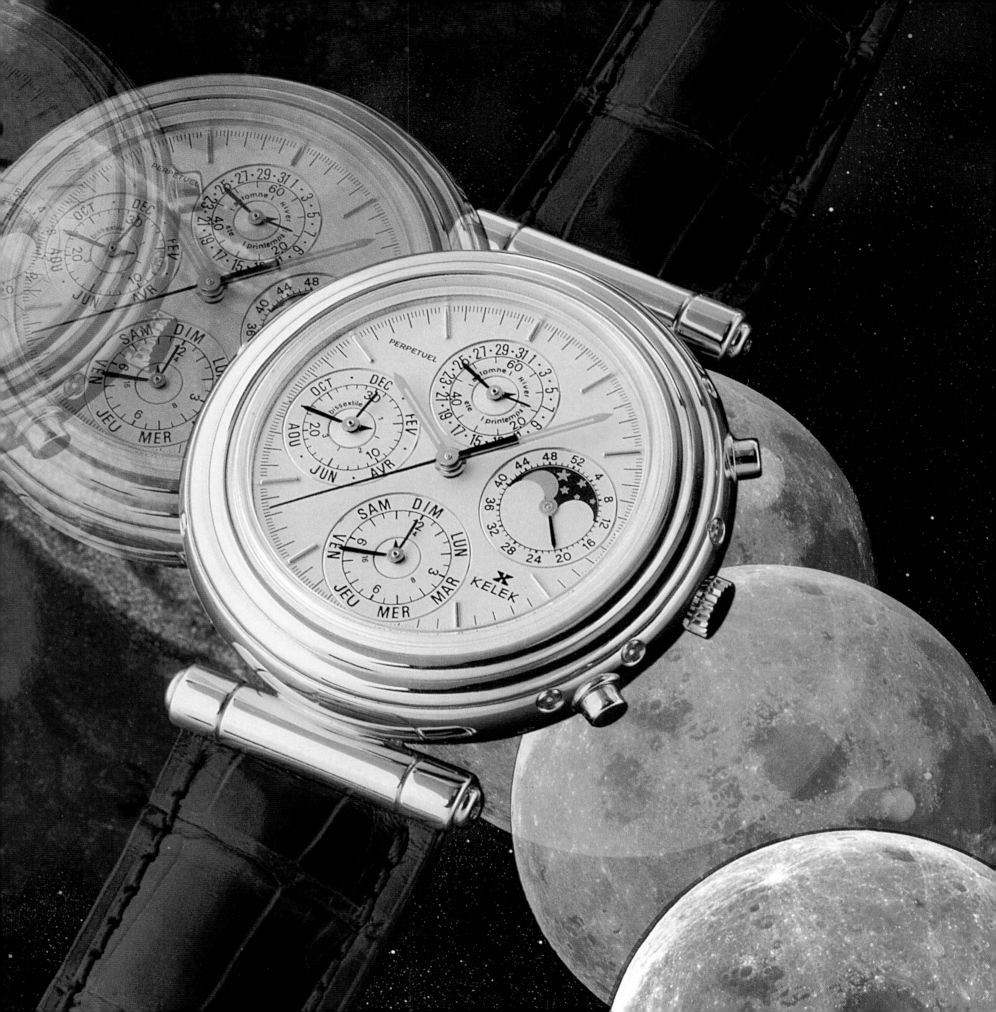

founder of the company that is known today as Kelek. A palindrome that evokes the swinging rhythm of a pendulum, the name Kelek is traced to the rafts of ancient Egypt that carried passengers to and fro across the Nile.

Kelek enjoys marking its progress with milestones of human achievement — the watchmaker shares a symbiosis with the world around it. When Gorgerat first set up shop in La Chaux-de-Fonds in 1896, he shared the date with the opening of the first modern Olympics, held in Athens. That same year, the third National Exhibition was held in Geneva, and many clockmakers showed their wares.

The city of La Chaux-de-Fonds enjoyed unusual prosperity for the time. During his first decade in business, the city grew from 13,000 to 31,000, fostering a thriving watchmaking industry. Such status as a business mecca merited La Chaux-de-Fonds connection to the largest of cities by rail lines and gained the bustling village all of the amenities of modern living, from running water to electric lights on the city streets. Gorgerat took advantage of the thriving economy and began developing in foreign markets.

In particular, he surmounted the difficult challenge of establishing business in Japan and formed a relationship with the Hattori Trading Co. Ltd., known today as Seiko.

OPENING PAGE
Hour and five-minute repeater Lépine pocket-watch with automaton and jacks. 18-carat gold case.

PREVIOUS PAGE
Grande complication bracelet. Automatic chronograph, 30-minute counter, 12-hour counter, small seconds-hand. Perpetual calendar, date, day, 52 weeks, month, year, season, 24 hours, moon phases, 18-carat gold case.

TOP
Kelek firm, in La Chaux-de-Fonds, Switzerland.

TOP LEFT
Mr Gabriel Feuvrier, CEO of Kelek.

RIGHT CENTER
One of the smallest automatic chronographs available at present. 10-minute counter, 3-hour counter, small seconds-hand, calendar. 18-carat gold case.

RIGHT
Automatic chronograph, 30-minute counter, 12-hour counter, small seconds-hand, 52 weeks, day, date-aperture. Stainless steel case.

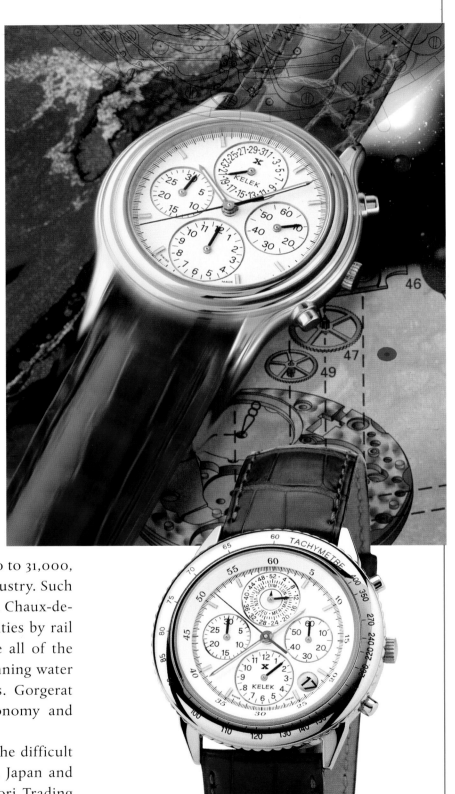

CENTER

Automatic hour and five-minute repeater wristwatch. 18-carat pink gold case.

BELOW

One of the smallest automatic rectangular chronographs in the world. 30-minute counter, 12-hour counter, small seconds-hand, date-aperture. Stainless steel case.

Nearing retirement in the 1950s, Gorgerat turned the business over to his grandson, Jean-Raoul Gorgerat, who gave the watchmaker its extraordinary name. Along with the new name Kelek, he expanded the business into a manufacturing business, producing up to 1,000,000 pieces a year. Perhaps because Kelek had lost a major client when Hattori began producing its own watches, the company understood early on that the company would have to institute dramatic changes. Still, Jean-Raoul Gorgerat never relinquished the craft of creating mechanical timepieces. So it was fitting that when he chose to step down, Jean-Raoul Gorgerat would tap the firm's leading horological engineer, Feuvrier, to guide the family business into the next era.

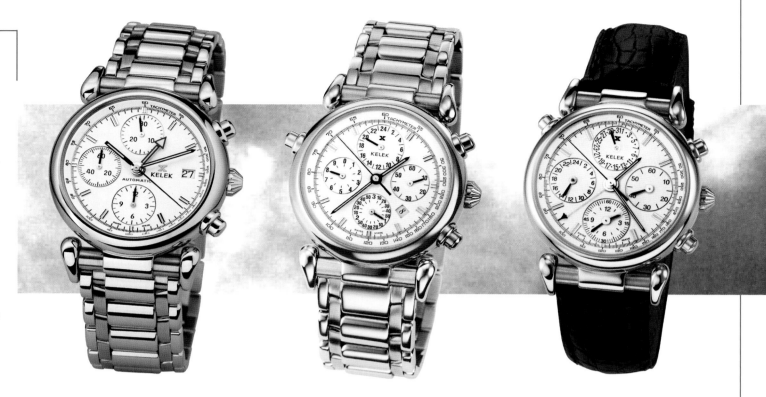

Feuvrier's first task was to tap the Dubois-Dépraz company to collaborate in the development of mechanical timepieces. The two began a partnership that continues today and follows his founding principle: "We can excel among the best — and this is what we want." With relentless dedication, Kelek began producing one mechanical marvel after another. During the 70s, to the delight of connoisseurs, Kelek released the world's smallest self-winding chronograph. Within two years, the watchmaker introduced an hour and 5-minute repeater wristwatch, followed by a musical pocket watch.

By the mid-80s, Kelek produced the full range of self-winding calendar watches, from the simple timepiece with day and date to the more complex perpetual calendar.

With every turn of success, Feuvrier returned the profits into the company, honing the expertise that would enchant watch lovers who returned to mechanical timepieces in the mid-80s. At this point, Kelek launched the first self-winding chronograph, caliber 2152-24S. This complex chronograph features 30-minute and 12-hour totalizers, plus a seconds subdial. It also boasts a perpetual calendar with phases of the moon. Then, Kelek released caliber 5152M-24S, a self-winding perpetual-calendar wristwatch that automatically displays the date, day, weeks, months, moonphases, seasons and year and includes a 24-hour readout.

Feuvrier holds a unique place in the world of watchmaking in that once he's made the executive decision choosing which timepieces will be produced, he possesses the ability to explain to watchmakers how the watch will be created. As a result, Kelek has assumed prestige as the creator of mechanical watches within decades of Feuvrier assuming the helm. Although he's taken the company many strides forward, all of the rewards come from developing the most exceptional timepieces.

Perhaps this is why, without ostentatious fanfare, the modest and proud watchmaker humbly celebrated its 100th anniversary in 1996 simply by offering an exceptional timepiece - the

Kelek Centenary watch — in 100 numbered pieces. Featuring an hour and quarter repeater, the timepiece is exceptional for numerous reasons, in particular its special repeater module, which can be removed from the watch independently for repair.

The array of complicated timepieces offered by Kelek include an entire range of calendar watches and an exceptionally sleek line of sports chronographs in steel and steel and gold.

Just as it did in the earliest hours of this century, Kelek is once again thriving amidst a booming economic climate. Now affiliated with Breitling, once a customer, Kelek is following the rhythm of its name, marking the passing of time as its watchmakers quietly handcraft mechanical timepieces with the single-minded pursuit of producing the best watches.

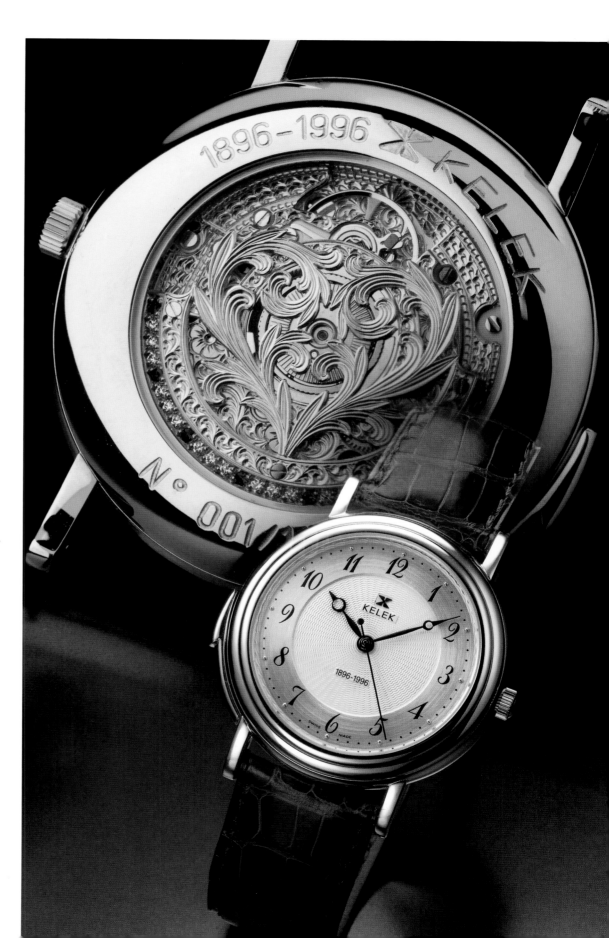

LONGINES

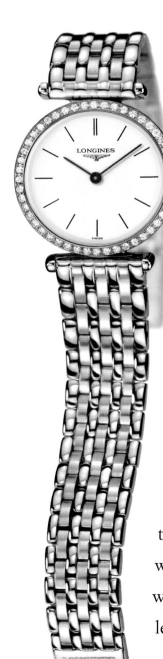

*W*hen the immediate ancestor of the present-day Longines company first saw the light of day in August 1832, its founders had no idea what the future held. Other, similar ventures had already come and gone. More would follow. ■ Why, then, should Longines have managed to flourish as it has for the better part of two centuries? Like some individuals, corporate births may well occur under a lucky star. But like the gods, stars are fickle. The answer, if any, must lie elsewhere, with the inborn qualities of its founders and their successors. Tenacity was surely among them, along with a less than modest measure of inspired ingenuity. ■ Very early in its history, by 1867 to be exact, Longines already stood apart from a growing band of watch-parts makers by turning out complete, cased-up pocket watches under its own name. It had of course unusual assets, not least the staying power, the grit, to press along where others faltered. ■ Along with the good sense to concentrate on ruggedly

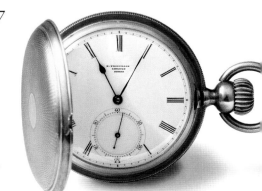

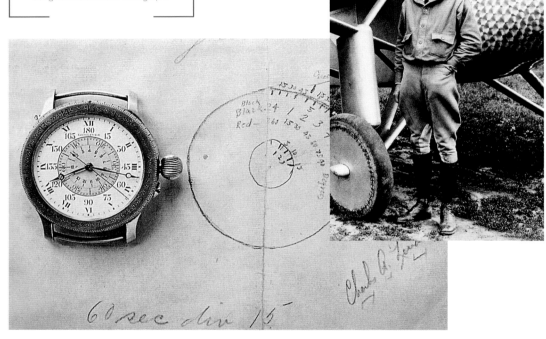

This all-American hero would later design the Lindbergh Hour Angle Watch, treasured companion of countless pilots and navigators for many years. It was of course built by none other than Longines.

Inspired ingenuity was also at work in 1945 when Longines' efforts to improve the rotor-driven self-winding system paid off with the first truly bidirectional rotor - a simple enough idea on paper but in reality no mean feat of micro-engineering.

Creative resourcefulness of this kind soon found its way into Longines quartz watches. Instead of merely relying on an integrated electronic circuit - which does only what it's told - Longines came up with a quartz watch design that corrected its own rate automatically, in other words that thought for itself. Called Ultra-Quartz, this 1969 development confirmed that Longines' way with time could flourish even with radically new technology.

Ten years later, the Longines name appeared on a 1.98 mm-thin time-giving wafer called Feuille d'Or, developed in close cooperation with ETA. Today, two decades later, this breathtaking beauty still holds the world's watch thinness record in its category.

After dimensions, performance. By 1984, everybody's quartz watch was comfortably settled in the one-minute-per-year precision range.

dependable movement designs, the kind you built a solid, enduring reputation on. From the beginning, its trademark and winged-hourglass symbol had themselves become valuable commercial assets and Longines duly registered them.

As the twentieth century took off, Longines took off with it. When in 1927 Charles A. Lindbergh pointed his Spirit of St. Louis eastward at the start of his nonstop solo flight across the Atlantic, directly linking America to Europe for the first time, Longines was on hand to record his departure. And waited in Paris to record the last instant of his historic 33 1/2-hour feat.

Longines had other plans: a timepiece called Conquest VHP. It embodied the company's idea of decent quartz performance: give or take a single minute every five years. "VHP", by the way, stands for Very High Precision. Indeed.

What Longines could do for the private individual, it could also do for the individual athlete. And it did so willingly and well, starting in Athens in 1896, timing the first Olympic Games of modern times with simple hand-held chronographs and stopwatches. But by 1912, Longines had (yet again) hit upon a better idea: starting-line and finishing-line tapes that, when broken by the athlete's own body, triggered then stopped the timing device to which they were connected. The system worked like a charm, setting Longines on a course that has kept it happily involved with sport ever since.

Longines' enthusiasm and hard work paid off handsomely in 1954 when its first portable quartz-piloted timing device for competition sports set an utterly unbeatable record at the Neuchatel Observatory: absolute precision. Zero error over 24 hours. Athletes and sportsmen and women could challenge existing records with confidence. Longines was there to time and confirm with exacting precision their every performance. Sports timing was in good hands.

Over the centuries, never have watches been considered mere instruments by their makers or their owners. Beauty always remained a central consideration. Even early models emerged from the pocket to display bejewelled finery. Longines' own wristwatches naturally followed suit. Between 1970 and 1978, no fewer than four gem-set Longines designs won the rarest, most coveted award for originality and stunning styling, the poetically named Golden Rose of Baden-Baden.

Today, the pursuit of elegance remains at the core of Longines' public image. This elusive yet very real quality both dominates its product line and inspires the company's print advertising and public relations activities.

The Longines collection has now been entirely restructured in four distinct lines corresponding to four strategic areas of watch design and market interest.

"La Grande Classique" echoes the serene styling familiar to generations of Longines buyers. Watches in the purest classic spirit reaffirm the company's commitment to traditional case and dial design - slim, sleek, understated and luxurious, incorporating precious metals, finely worked link bracelets and diamond-set bezels.

The Longines DolceVita line, for its part, weds contemporary design to classic-spirited elegance. Here, the rectangle dominates styling, expressed in strongly structured case lines in steel or in gold, crisp dial faces, occasionally enhanced by diamonds on some models, and a broad link bracelet or strap. Above all, Longines DolceVita models, available in five sizes, convey character, a sense of purpose and decisiveness. The Longines DolceVita Gran Turismo goes a step further : this stainless steel chronograph also comes with a rugged rubber strap with deployment clasp that contributes both to its very masculine good looks and to wearing comfort.

Alongside classic elegance, the Longines collections caters to consumers who live life to the full : "active elegance" is their domain, corresponding to a pair of stunning product lines.

Longines Conquest timepieces speak to women and to men with an eye for traditional design but a preference for watches capable of keeping pace with an active lifestyle. Available in five sizes to accommodate every wrist, Conquest Quartz designs in steel or two-tone finish may even sport a diamond-studded dial or diamond-set bezel. The Conquest Automatic comes in three sizes and offers a choice of attractive dial colors. Perpetuating the VHP (Very High Precision) tradition, the quartz-piloted Conquest VHP's Perpetual Calendar is programmed until the year 2100.

PREVIOUS PAGE, LEFT
La Grande Classique.

PREVIOUS PAGE, RIGHT
Longines **o**position.

RIGHT
Longines DolceVita Gold.

CENTER
Conquest VHP Perpetual Calendar.

BELOW
Limited Edition "Honour and Glory".

oposition is Longines' answer to men and women whose active lifestyle and sense of elegance demand uncompromisingly contemporary design. These steel beauties come in four sizes and include chronograph. Subtle symphonies in black and shades of silver and grey, all set new standards in time style for today - and supremely suited for tomorrow.

In addition, the Longines collection includes special models with particular appeal to collectors, connoisseurs and history buffs. The Longines DolceVita

Heritage design harks back to the neat, trim designs of the Thirties: rectangular gold case on a leather strap, understated dial faces featuring a small seconds hand - elegant, nonchalant chic at its best. "Honour and Glory" is the name of a pair of superb chronographs, both featuring a Longines-invented vernier scale for accurately measuring the fraction of a second: an original hand-held late 1960s chronograph and a more recent wrist-worn version built along the same lines. A three-watch set available together in a presentation case comprises replicas of Longines designs from 1915, 1925 and 1930 - nostalgia in time...

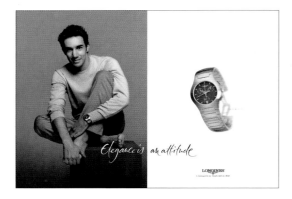

"It's difficult to describe elegance but you know it when you see it", once remarked Longines President Walter von Känel. Nonetheless Longines' sharp eye had no trouble discerning the innate elegance in the five prominent figures featured in the company's print advertising and public relations campaigns.

The classic spirit comes to life with two giants of the silver screen : Audrey Hepburn and Humphrey Bogart. Each in their own way lived a screen life of impeccable elegance - naturally at ease, understated, self-assured, conveying the poise of their polished personality as much as the elegance of their attire or surroundings. They live on today in the hearts of millions as envoys of some golden age of style - and as ambassadors of some of Longines' most classic timepieces.

Three contemporary personalities complete Longines' appealing line-up of its ambassadors of elegance.

Aishwarya Rai, Miss India Femina 1994 and Miss World 1994-1995 is today an established firm star in her native country as well as a very successful model internationally. Her stunning good looks and open, vivacious personality brought her in 1999 to Longines for whose wristwatches and sense of elegance she provides an exceptionally appealing presence.

Tatjana Patitz was born in Germany and brought up in Sweden. Her regal features, sleek figure and cool, self-assured personality led her very early in life to modeling for leading contemporary fashion houses and photographers. Her movie career has also gotten off to an auspicious start. In 1999, she too was happy to represent the style and sophistication that Longines brings to time.

Pedro Diniz, for his part, has driven everything from karts to Formula 1 cars with unabashed Brazilian gusto and panache, moving from car to car and race to race with ease and skill. His trim good looks, ready smile and sunny personality make him a natural choice to represent Longines, with which he obviously forms a winning team.

Obviously, then, Longines keeps good company. As the next millennium unfolds, it looks forward to being good company itself - on the wrists of discerning, elegant men and women everywhere.

MOVADO

As we move into a new era of ever more complex technologies, nothing looks more modern today than the straightforward black dial and the solitary gold dot of the legendary Movado Museum Watch. It is a look that has not lost its impact. In design, simplicity is compacted complexity, the ease of the surface bespeaking a confidence in the mechanical innovation beneath. ■ In embracing this design philosophy, Movado has become synonymous with clean, modern lines that house technological innovations, a marriage of style and workmanship unrivalled. In the international language of Esperanto, movado means "always in motion." From the company's inception in 1881 to its stance at the threshold of a new millennium, Movado then, as now, is always evolving and moving forward. ■ The young and determined Achille Ditesheim founded the company that became Movado in La Chaux-de-Fonds, Switzerland in 1881. He wanted to develop timepieces that would surpass all others in quality and innovation, and within a few years he successfully reached and then exceeded his goals. At the famed Liege Exposition of 1905, his firm was awarded

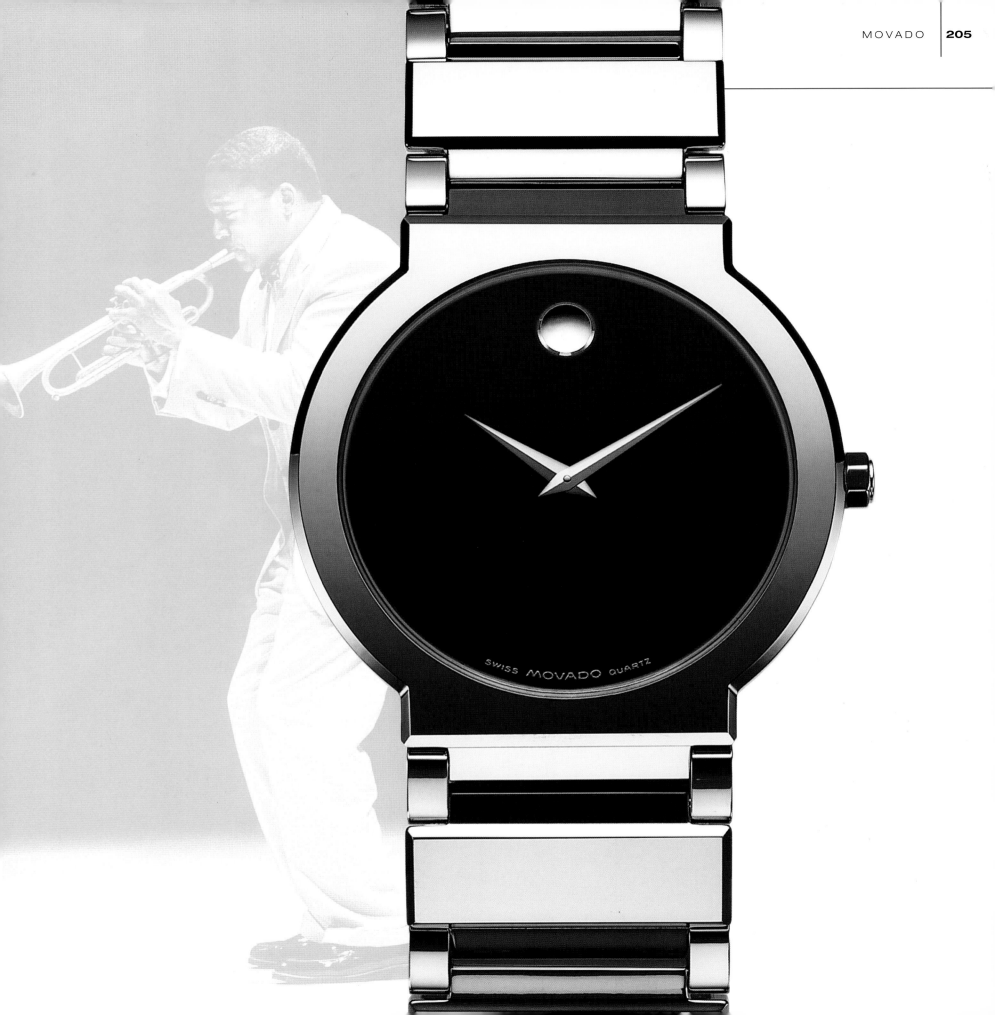

OPENING PAGE
Movado boutiques are an extension of the company's global brand image, integrating the contemporary warm-gray color palette introduced in 1999.

PREVIOUS PAGE
Wynton Marsalis, composer-performer, virtuoso. The Museum Valor watch, crafted of tungsten carbide steel is virtually scratch-proof.

TOP LEFT
View of the Movado factory in 1910.

TOP CENTER
Introduced in the 1920s, the Ermeto watch features a sliding case that winds the movement. Shown here, colored enamel cases made in 1945.

TOP RIGHT
In 1912, Movado patented the design of the Polyplan. The watch movement is constructed on three levels to allow the case to follow the curve of the wrist.

BOTTOM RIGHT
Extremely precious multi-colored Ermeto made in 1925.

BOTTOM LEFT
During the early 1900s, Movado produced ladies' wristwatches featuring thin cases and small movements.

From their early triumphs in ladies' wristwatches featuring thin cases and small movements in the 1900s, Movado staked its reputation on innovation. In 1912, Movado patented the design for the Polyplan, with a watch movement constructed on three levels which allows the case to follow the curve of the wrist. The elongated watch was updated in 1931 as the Curviplan, and continues to have a role in Movado's collections in the current La Nouvelle Sport with its comfortable conformance to the shape of the wrist. With the introduction of the Ermeto in 1927, a timepiece with a sliding case which winds the movement, the company's design philosophy of excellence coupled with groundbreaking mechanical features was firmly established.

Movado made history again in 1945, launching the Tempomatic, the first automatic-

the Gold Medal for quality, creativity and design. That same year, the company chose the name Movado to epitomize their spirit. It proved to be a prophetic choice; in the first 100 years of the company's existence, Movado earned almost 100 patents, testimony to the vigorous innovation of its craftsmen, as well as numerous awards for design excellence.

winding wristwatch. With added sophistication, the Kingmatic followed in 1956. This model remained extremely popular throughout the fifties and sixties, both for its superb functionality and its acknowledgment of that era's ethos of expansive technological advancement.

The American artist Nathan George Horwitt, seeking to embody the Bauhaus dictum of "simplicity, tastefulness and function," created the signature black watch dial defined by a single gold dot in 1947. Horwitt based his design on the understanding that time is not known as a number sequence, but rather by the position of the sun as the earth rotates. He placed a simple gold dot at 12 o'clock to symbolize the sun at high noon; the moving hands suggested the movement of the earth. An amazing image of the eternal renewal inherent in circles, and therefore geocentric measurement of time, the dial design was selected by the Museum of Modern Art for its permanent collection in 1960. It was the first dial ever awarded this distinction, and its appellation, Museum Watch derives from this recognition. Today, Movado Museum Watches are part of the collections of prominent museums around the world.

The legendary gold dot continues to be a resonant and powerful image, distinguishing an entire collection of singular time-

TOP LEFT

Up-to-the-minute technology and unique design are combined in the self-powered Viziomatic.

TOP RIGHT

La Nouvelle Sport has been renewed for the future. Maintaining the design integrity of the rectangular original, a curved case, now in stainless steel, comfortably conforms to the contours of the wrist.

BOTTOM RIGHT

As much jewelry as timepiece, the boldly geometric Eliro Manchette is a sophisticated juxtaposition of avant-garde lines. A square, numberless dial, in high-gloss black or white mother of pearl features a cabochon silvertone dot at 12 o'clock. Stainless steel bezel and bracelet.

BOTTOM LEFT

Featuring a black dial and a tank-style case, available with a diamond bezel for men and women, the Eliro expresses bold elegance.

pieces. The Valor is a bold incorporation of the 50-year design heritage. With a case and bracelet made of highly durable tungsten carbide, it is virtually scratch-proof. This metal casts a cool steel-blue tint and has a high-polish, mirror finish which projects a confident sensibility. The dial is rendered with rhodium hands, with an assured single concave dot in rhodium at 12 o'clock. The highly successful Eliro line made its debut in 1998. In these timepieces, a black dial is integrated into the curved rectangular case rooted in the Polyplan. With an available diamond bezel and its brushed stainless steel casing and bracelet, the Eliro makes a luxurious expression of modern simplicity. The Eliro Manchette is as much jewelry as timepiece, with a geometry that juxtaposes avant-garde lines. A woman's model, it is available with a simple, elegant mother-of-pearl or black dial, as shown, or with a diamond-set bezel and mirror dial detailed by four diamond markers. Other lines featuring the classic Museum Watch dial include the Concerto and the Harmony, also created especially for women. The Concerto is a futuristic interpretation of the cuff watch; its

bangle-looking bracelet, actually striated steel links, creates uniquely modern lines, and gives the functional benefit of adjustability. The Harmony is a jewelry-inspired model, with the signature dial encircled by a smooth bezel which flows into a continual double bangle bracelet with jewelers' clasp.

Technology continues to be an all-important consideration in current Movado designs. The 1996 introduction of the Vizio collection of sport luxury watches has evolved into the Viziomatic. Exemplifying cutting-edge technology, the Viziomatic is powered by natural movements of the wrist, and its battery-free, autoquartz mechanism has the extraordinary energy reserve of 100 days. An unimpeded view of the high quality Swiss movement is afforded by the sapphire crystal caseback. The timepiece is encased in a high polished stainless steel circle, with a bezel formed from durable tungsten carbide. The dial, with sleek, stick hands and markers and two Roman indices, is offered in silver or black. By eliminating the bezel, the smooth-as-glass Stelo has a slim

watch profile that sits unobtrusively on the wrist.

Long recognized as an innovator, Movado's heritage of graceful movement and fine design has evolved into support for the performing arts and other innovators who are "always in motion." A principal sponsor of American Ballet Theatre since 1986, Movado is also affiliated with the Miami City Ballet, the San Francisco Ballet, Lincoln Center, and the Telluride Film Festival. The Artists' Series was established in 1988, with commissioned limited edition timepieces from masters and newcomers alike, including Andy Warhol, Romero Britto and James Rosenquist. Movado continues to salute innovators in other forms — such as the first-ever winner of the Pulitzer Prize for Jazz, Wynton Marsalis, and Pete Sampras, Grand Slam tennis legend. The newest expression of forward motion is in the Movado retail stores, upscale boutiques featuring exclusive jewelry designs, gifts for the home, desktop items, and personal accessories. The new millennium brings with it opportunities for Movado to "push the artform" and remain "always in motion."

TOP LEFT

With a focus on fashion, the Movado Harmony, designed especially for women, features the signature numberless dial with single dot at 12 o'clock and a double bangle bracelet in goldtone or stainless steel.

CENTER

Created in the signature style of modern, uncluttered design, the Movado Stelo incorporates the clean lines and elemental forms celebrated by Movado. The numberless Museum dial lies under a bezel-free sapphire crystal for a slim watch profile.

BOTTOM LEFT

Movado continues to push time design forward with the dramatic and streamlined Museum Concerto. Artistically crafted in sleek stainless steel, this elegant timepiece for women is a stylish accent for day or evening.

BOTTOM RIGHT

Movado's "Pushing the Artform" advertising campaign reinforces its long-standing heritage and affiliation with the performing arts. The Arena di Verona Lyric Season is the world's most spectacular opera festival, performed in a 2,000-year old Roman amphitheater, attracting 16,000 spectators each night. Movado was a principal benefactor of the Arena di Verona 1999 Lyric Season.

PARMIGIANI
FLEURIER

erhaps no other word equates as succinctly with perfection as Parmigiani. This renowned watchmaker crafts in such precise old-world tradition and with such exquisite attention to detail that he is often referred to as the golden hands of Switzerland's watchmaking world. Indeed, the multi-talented Michel Parmigiani is a true master of horology. The manufacture that bears his name, Parmigiani Mesure et Art du Temps (translated as the measurement and art of time), reflects his multiple talents and passions. This incredibly skilled and integrated watchmaking house focuses not only on creating its own line of sophisticated timepieces, but also on the art of making specialized watches for other brands and on the art of restoration. ■ Of Italian descent, the quietly confident Parmigiani — who has a calm, almost serene demeanor — grew up in Switzerland in the Jura Mountains. Schooled in watchmaking, he had a passion that burned within him: the desire to be more than just a watchmaker, to fashion watches in accordance with his vision of the ultimate timepiece. ■ While he had spent 20 years building incredible complicated watches for top luxury brands, and

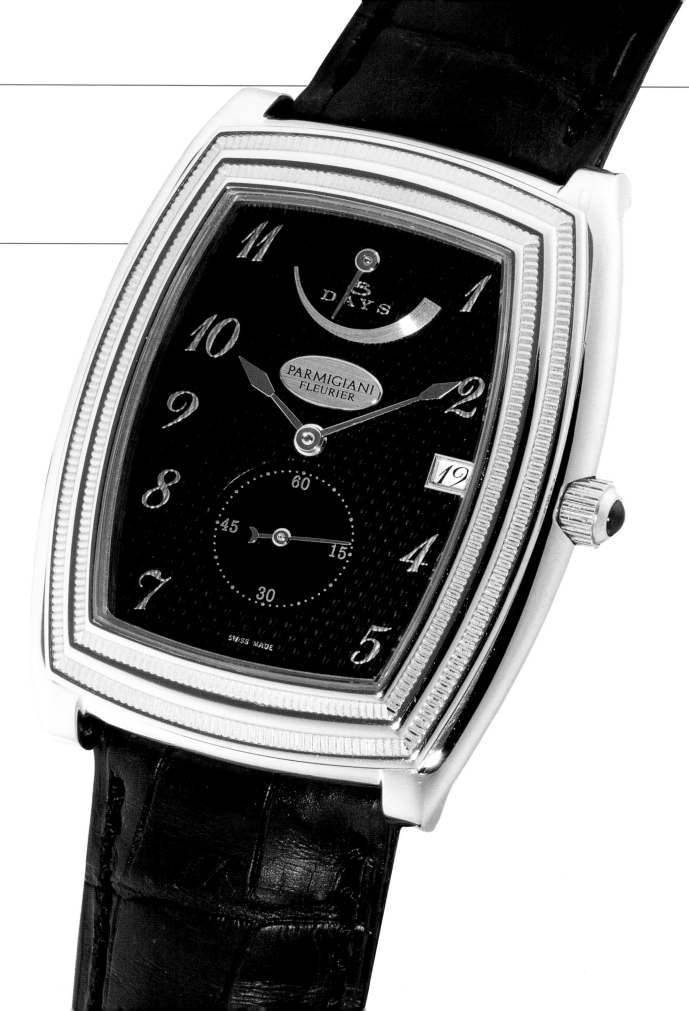

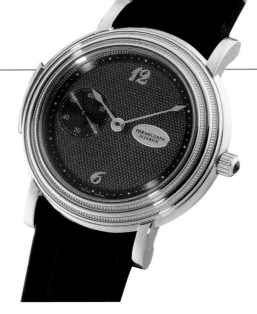

OPENING PAGE
The caseback of the Ionica is transparent, enabling the wearer a view of the movement.

PREVIOUS PAGE
The Ionica wristwatch is distinguished by its eight-day movement. The curved horns recall the classical forms of Ionic capitals.

TOP LEFT
Michel Parmigiani designs his own timepieces.

TOP CENTER
The Calibre 100, inspired by the construction of marine chronometers, features an 8-day power reserve, instantaneous perpetual calendar, grande sonnerie striking and minute repeater.

TOP RIGHT
This Minute Repeater timepiece in platinum attests to the time-honored art of creating musical wonders. The mechanical, hand wound movement features power reserve to 52 hours and strikes the hours quarters and minutes on two gongs. The dial is 18-karat gold with anthracite guilloché design.

BOTTOM (LEFT TO RIGHT)
From its Classic collection, this men's timepiece is elegant simplicity. The automatic movement features a calendar and center seconds hand, crafted in 18-karat white gold with a gold barleycorn guilloché dial in matte eggshell.

The Basica answers a demand to make top of the line watches that offer Parmigiani's well-known aesthetic qualities combined with the accuracy of a chronometer.

Intricately hand carved and engraved, this Skeleton timepiece features an automatic movement with sapphire crystal and caseback. It is cased in 18-karat pink gold and offers flower engraving.

made a name for himself with his intricate and concise restoration work, it was not until 1996 that he introduced his own branded timepieces.

Two years prior to the launch of Parmigiani Fleurier's line, in 1994, the Fondation de Famille Sandoz, acquired a majority holding in Parmigiani Mesure et Art du Temps, in keeping with its policy of investing in excellence. Michel Parmigiani's work had attracted the attention of the foundation, and he had been retained to restore the magnificent clocks it owned. The foundation's desire to acquire a major holding in Parmigiani's business offered him the significant resources he needed to fulfill his dream. He spent two years designing and developing a very select and impressive watch collection.

True to his nature, the master horologist is meticulous and demanding when it comes to the creation of his timepieces. Down to the tiniest details such as the screws that are barely visible to the naked eye, Parmigiani insists on perfection. These screws, for instance, cannot be used until they are hand polished — top, bottom and sides — for at least 15 minutes. It is Parmigiani's insistence on beauty and perfection that has earned him his rightful place of high respect within the watchmaking community. Each and every Parmigiani Fleurier timepiece is crafted in the finest horological traditions, and distin-

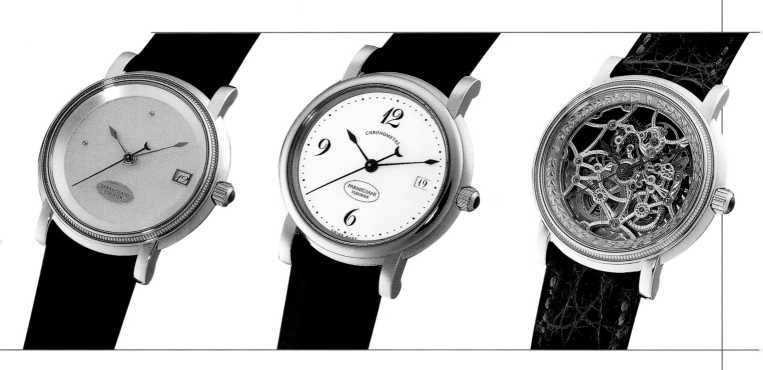

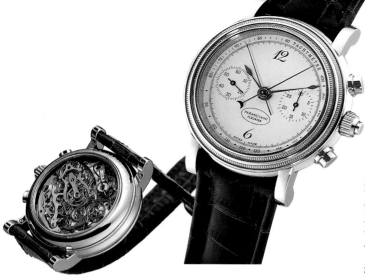

guished by a level of quality and finish that is rarely equaled.

To execute his exquisite watch line, Michel Parmigiani has hand picked some of Switzerland's finest artisans, goldsmiths and watchmakers whose families have practiced their particular art for generations. The manufacture's team consists of 60 craftsmen, engineers and mechanics who patiently create one-of-a-kind and limited-edition wristwatches, pocket watches and clocks to Parmigiani's exacting standards.

Parmigiani Fleurier's concept of haute horlogerie revolves around quality and simplicity. Watches should be as sober as possible, with a focus on only one complication in a timepiece,

and should include all of the high quality and precision for which the brand is known and valued. Parmigiani Fleurier wristwatches are all linked by distinctive signature characteristics, including a bezel with single or double fluting, the brand inscribed in an oval cartouche on the dial, elliptical shaped horns, javelin shaped hands and an 18-karat gold winding crown set with a cabochon sapphire. The manufacture is so secure in its craftsmanship that all watches are accompanied by an international 10-year warranty.

The Parmigiani Fleurier watch line runs the gamut from classically beautiful mechanical watches for men and women, to casually elegant sport watches such as the Crono and Crono Rattrapante, to exquisite complicated timepieces such as skeletons, perpetual calendars and minute repeaters. While Michel Parmigiani has already developed seven special movements and several mechanisms for his complicated watches, as the firm enters the new millennium, it is the company's goal to accelerate its vertical integration by developing and producing its own caliber movement. Currently, when outside movements

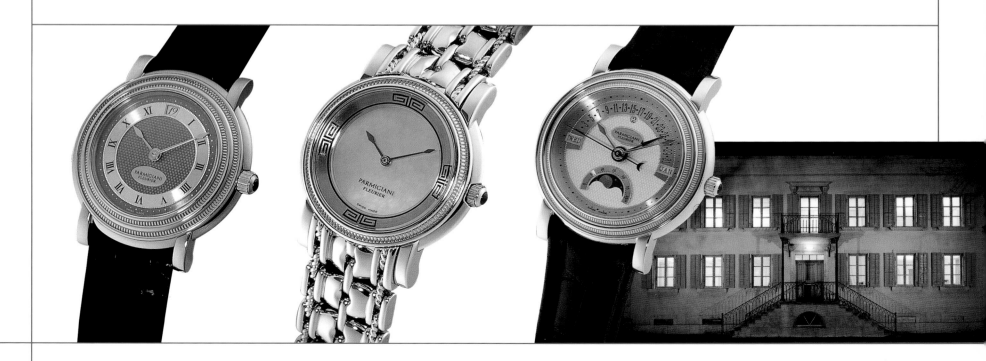

from firms such as Lemania and Piguet are used for Parmigiani Fleurier timepieces, the calibers are redefined to such an extent that they are essentially custom-made.

Because of this high-quality craftsmanship and demanding attention to detail both inside and outside of Parmigiani Fleurier watches, production takes a great deal of time. A minimum of 400 working hours are required to assemble a single watch, and it can take up to 2,000 hours to produce one complicated timepiece. In the case of a quarter-striking minute-repeating table clock, a staggering 10,000 hours of labor go into its creation.

Thus, it is no wonder that this fine house of horological excellence creates just 800 timepieces a year. Nonetheless, the company's goal is to move production to at least 1,200 pieces in the year 2000. These exclusive timepieces need to circumvent the globe, as Parmigiani Fleurier watches are in great demand internationally. The brand is sold all over Europe, North America, South America, the Middle East and Asia. What's more, in the year 2000, marking the pinnacle of Parmigiani Fleurier's success, the brand is opening its own boutique in the heart of Singapore's commercial area — complete with its own restoration workshop that will be dedicated to repairing haute horlogerie watches and clocks.

It is in the area of restoration work that Michel Parmigiani first made his mark and gained his fame. For nearly 25 years, he has restored the finest historical watches and clocks in the world. While watchmaking school taught him

the basics, it was his curiosity and burning desire to exceed the limiting horizons of time that propelled him to begin opening up watches to look within for the answers as to why they didn't work.

The dedicated and determined Michel Parmigiani perfected his craft via self-teaching. Never did he settle. He strove always to improve himself, devouring books on the art of watchmaking, visiting museums and finding his own solutions to watchmaking challenges. One after the other, he slowly solved the problems of old timepieces, restoring them to their natural luster and initial state.

Quickly his reputation spread and he was entrusted not only by private watch collectors, but also by museums internationally to restore some of their premier pieces — often rarities of untold value. In one instance the master horologist spent more than 1,600 hours restoring a 140-year-old classic tabletop Breguet Sympathique

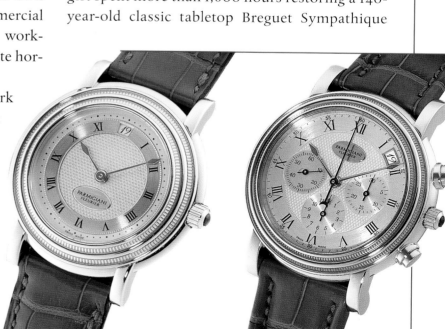

clock, with accompanying pocket watch that other experts had declared irreparable. Following Parmigiani's laborious yet exquisite restoration, the clock sold at a Geneva auction for well over a million dollars.

Regularly, Parmigiani rose gallantly to the challenges of restoring antiques and set to work with an arduous diligence that likened him to the brilliant watch and clock making forefathers of centuries gone by.

As Parmigiani's reputation for precision craftsmanship, perfection and beauty soared, so, too, did the demand for his work. Thus, concur-

rently with restoration, Parmigiani Mesure et Art du Temps began creating specialized timepieces of the highest complexity for top watch brands. Predominantly the manufacture creates minute repeaters, perpetual calendars, tourbillons and multiple-complications for the most prized names in watchmaking.

As Parmigiani Mesure et Art du Temps ventures into the new millennium, the firm continues to develop the three spokes of its business, building its own line, its specialized commissioned pieces, and its restoration work. And, as it has in the past, it will continue its sponsorship of and involvement in arts and exhibitions. In fact, Parmigiani Mesure et Art du Temps is the only watchmaking company to be the sponsor of "The Story of Time" in Greenwich that ushered in the millennium. The international exhibition brought together more than 300 objects from the world's museums, galleries and libraries to present an all-encompassing exploration of ideas about time from the earliest civilizations. Parmigiani Fleurier's unique pocket watch, the Leda, joined the exhibition — attesting to the brand's unique role in time's tradition and its evolution.

PAUL PICOT

As the world focuses on the turning of the millennium, time becomes more important than ever before. And when it comes to time, time measured with true precision, who can we trust more than those craftsmen who have made watchmaking a science as well as an art for centuries? One outstanding leader in the industry is surprisingly new to the field. ■ Celebrating its 25th anniversary in 2001, Paul Picot is a comparatively young company, but one that has already achieved an undeniable stature in its field. Although a newcomer in historical terms, Paul Picot effectively combines two traditions: Swiss precision watchmaking and Italian artistic creativity. With a reputation forged by its well-informed, discerning and decidedly individualistic clientele, the company's special combination of technical prowess, innovation and attentive design will continue to be the best choice for leading citizens in the 21st century.

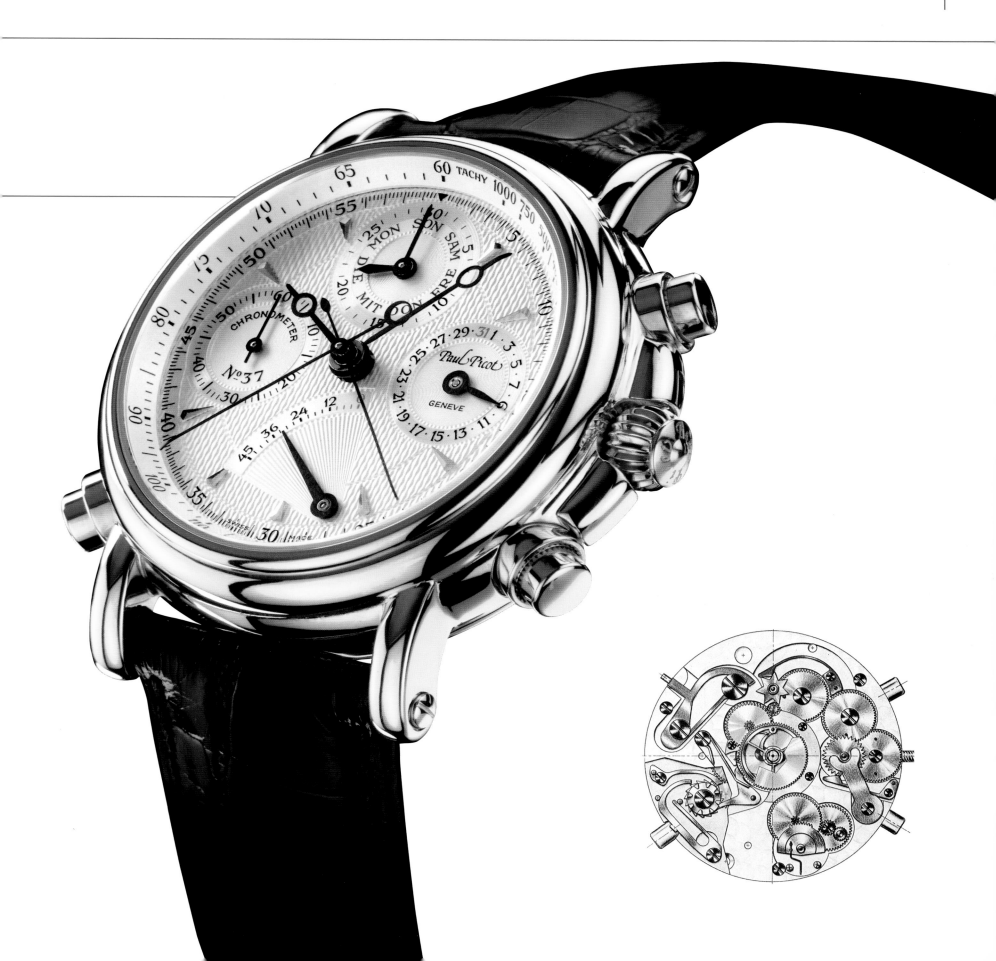

The story of this company began in the seventies, when Japanese and American factory-produced quartz watches hit the Swiss watchmaking industry badly, forcing many historical brands either to go out of business or to accept compromises in their methods. Contemporaries regarded the marketplace as too fragile for a new firm. But Mario Boiocchi focused instead on preserving Switzerland's rich watchmaking tradition of Switzerland, which was really in danger. Boiocchi's ambition was to re-create a true craftsman's company. In 1976, the quality watchmaking company Paul Picot was born. In the following years, the company's philosophy's ummarized in its motto: Nobility of Detail—was reflected in its strict compliance with traditional Swiss standards of quality, combined with Boiocchi's experience as a jeweler and goldsmith in the classic Italian style.

However, the strenuous defense of tradition has not precluded technological innovation. And it is this powerful combination of tradition and innovation that has taken Paul Picot, within its brief life span, into the top ranks of the industry.

In what is truly a craftsman's company, watches are

designed, refined piece by piece and then assembled entirely by hand at the company's own workshops in Le Noirmont. This almost obsessive attention to the making of precision timepieces has contributed to a restoration of the proud traditions of watchmaking. And Paul Picot has done much to preserve the best of tradition.

As part of this effort, many first-quality, extremely complicated movements or the rele-

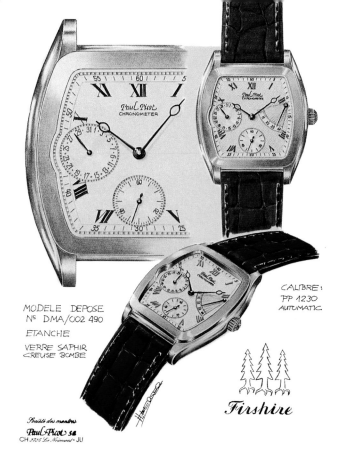

MODELE DEPOSE
Nº DMA/002 490

ETANCHE

VERRE SAPHIR
CREUSE BOMBE

CALIBRE:
PP 1230
AUTOMATIC

Firshire

Société des montres
Paul Picot SA
CH 2725 Le Noirmont - JU

nology and aesthetics, any improvement in the tonneau movement—a true masterpiece—may truly be considered a very remarkable exploit. And yet this is exactly where Paul Picot has excelled. This movement, and others, have been enhanced and technically redesigned, in some cases with the addition of a number of very sophisticated functions.

In the "Firshire 1937" model, jewels were added and a shockproof system adopted. The product reflects the spirit of watchmaking of a by-gone age, but refined and enhanced with the incor-poration of today's high technology.

CENTER

Firshire 1937. JA set consisting of two platinum watches, hand wound with a basic movement made in 1937. Each watch features a double sapphire crystal, crown set with a diamond, dial in solid silver, engine-turned. Ladies, model with a diamond on 3 and 9 o,clock. Limited series of 25 pieces each.

BOTTOM LEFT

Firshire Movement 1937 in platinum, calibre PP 88. Differential power reserve (28 components), pearl-milled openings and hand-beveled bridges.

vant rights have been acquired by the company. The exquisite 1937 tonneau movement featured in the "Firshire 1937" is an excellent example of this policy.

Firshire—a collection for the "nostal-gic"—is dedicated to the region of the Jura Mountains, which provided inspiration for the name and where the tradition of precision watchmaking was born, and three firs are engraved on the back of each piece. A classic from the standpoint of both watchmaking tech-

Then there is the "Firshire Perpetual Calendar," a classic like the other models of the Firshire collection, but featuring a self-winding movement and a perpetual calendar programmed until the year 2100! The movement requires no correction for months or leap years, and it is not affected by the notorious Y2K bug. Each of these watches has a rotating presentation case, and forms part of a limited series of thirty pieces.

The company's flagship model, the "Technicum," is part of the Atelier line. A first time ever, as it incorporates a power-reserve indicator, it is a unique split-second chronograph. An official C.O.S.C. chronometer certificate is issued with each piece. Launched in 1991, it has received numerous awards in the years since then and continues to maintain its distinctive role in the market.

The "Rattrapante 310," another watch in the Atelier line, is fitted with a special calibre movement based on the Venus 179, a movement developed between the two world wars. Paul Picot had the good fortune to buy the last 250 movements, and by refurbishing each original piece and adding 83 new parts, created a master-

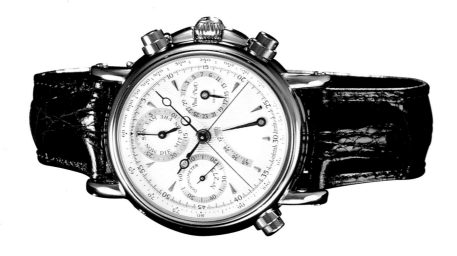

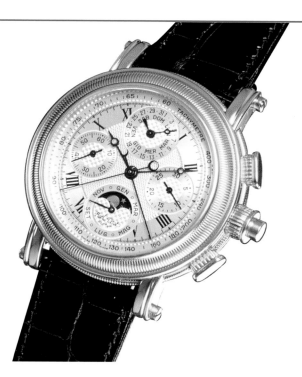

piece called the Paul Picot 310 movement. With a full calendar, including the phases of the moon, the truly unique "Rattrapante 310" was produced in a limited series of 200 pieces, due to the scarcity of the remaining original parts.

These and other pieces crafted by Paul Picot are highly prized by collectors, though by no means limited to that market. The company's steady rise to the top ranks of fine Swiss watchmaking is a result of diligent compliance with its corporate philosophy, rather than a particularly aggressive sales pitch. Paul Picot is dedicated to serve those who prize individuality and uniqueness as qualities inseparable from the Nobility of Details. In the early days of the company, the pieces were sold in Europe only, and they gained an especially strong following in Italy and Germany. Expansion to Middle-Eastern, Far-Eastern and Japan markets came next.

Chairman Boiocchi insists that growth should never interfere with quality and the defense of true craftsmanship. Paul Picot's guiding mission is to preserve the traditions of

aesthetic and technological mastery, the hallmarks of fine watchmaking, by making the highest quality timepieces available on the market. The uniqueness of each Paul Picot timepiece demands strict standards of workmanship, attention to detail, and innovative performance. A young company with classic ideals and thoroughly modern pieces, Paul Picot has a fine future guaranteed in the world of Swiss precision watchmaking.

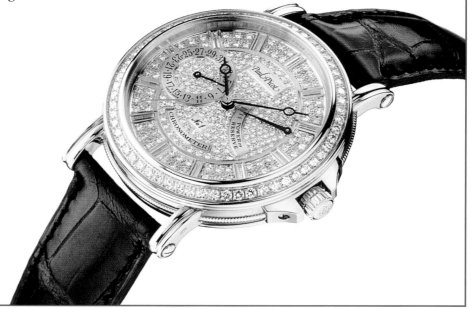

PERRELET

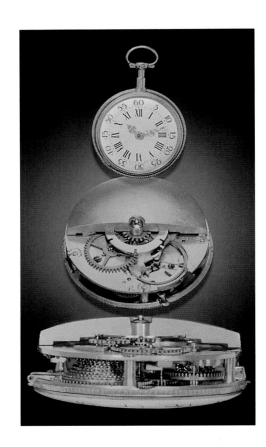

In 1749, deep in the mountainous quiet of Le Locle, Switzerland, young Abraham-Louis Perrelet, determined to become a watchmaker, began an apprenticeship that lasted just a night. It turns out that his master was no match for the 20-year-old genius and Abraham-Louis decided to go it alone... Such is the history of a horological house whose creative spirit has enlivened the art and science of precision watchmaking for the last two hundred and fifty years. Working under the motto of "innovation through tradition," the House of Perrelet stands ready to bridge the third millennium with exceptional pieces that preserve the long tradition begun by Abraham-Louis and continue his pioneering spirit. ■ Abraham-Louis went on to open a workshop—actually, a horological research laboratory—chock full of innovations: utilizing engraving and rounding-off tools of his own invention and the tools necessary to put together cylinder escarpments. His was the first shop in Le Locle to manufacture watches with double-mounted cylinder escapements with day, date and time indicators. Twenty years later, in 1770, he had the "eureka" experience that marks him

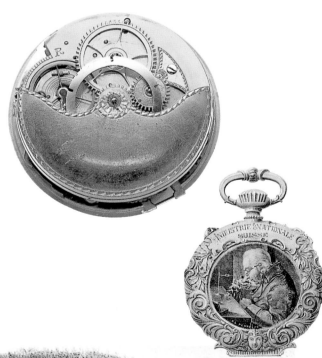

as the father of a technology which still dominates today—creating the first self-winding mechanical watch. By incorporating a freely-oscillating weight that would create the necessary energy to wind the mainspring within the watch's basic movement, Abraham-Louis Perrelet provided the practical solution to the common problem of constant re-winding. To denizens of this highly technological time, his solution sounds rather straightforward. But in reality, this was a highly innovative idea that needed a combination of continuing creativity and skilled craftsmanship to bring it to successful operation. A window on this history has survived to our time, from the diary of Horace-Benedict de Saussure, the renowned scientist and philosopher and contemporary of Perrelet: "we went to M. Perrelet's, the inventor of the watch which is wound by the movement of the person carrying it. He had to remake the first model because he had not installed a stopping mechanism. M. Perrelet has now installed an efficient stopping mechanism, he had a lot of trouble making it, but it suffices. The work is double that required for an ordinary watch."

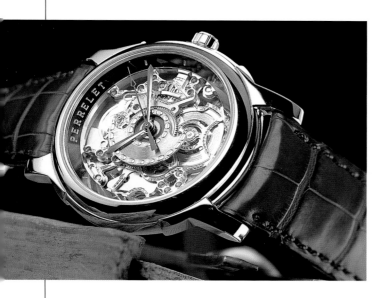

His peers knew well that Abraham-Louis Perrelet was one of the greatest watchmakers of the period. His influence was not confined to inventions and work of his own design; for many years he trained practically every watchmaker in Le Locle. Among his most notable apprentices were Jaques-Frederic Houriet (1743-1830), "Father of the Swiss Chronometer," and Louis-Frederic Perrelet (1781-1854), his grandson, and "Watchmaker to the Kings of France." It has also been said that Abraham-Louis Breguet was one of his apprentices. While this is not confirmed, it is certain that the two men maintained a relationship of mutual influence and esteem.

By 1802, the workshop at Le Locle had become so established that Louis-Frederic, decided to spearhead a different, and more daring future. Emigrating to Paris, he apprenticed himself to Abraham-Louis Breguet. Soon Louis-Frederic was entrusted with the production of complicated pieces, and the training of students. So it was that the grandson of Abraham-Louis Perrelet came to train the son of Abraham-Louis Breguet. Having the same pioneering spirit as his grandfather, Louis Frederic was ready to open his own workshop by 1822.

In keeping with the Perrelet tradition, his workmanship was soon noticed by the Royal Court. He went on to produce time keeping gems

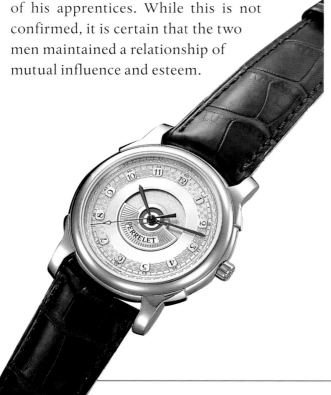

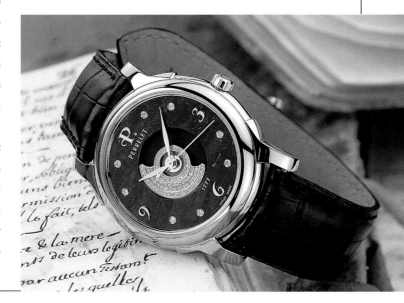

FAR LEFT
Skeleton watch with Perrelet Double Rotor. Perrelet watches are the only watches in the world benefiting from the patented technology of a double rotor, which offers unique technical advantages and, with its visible 18K gold upper rotor, constant fascination.

LEFT
From the James Cook collection, the Limited edition Alaska watch and Cape Horn limited edition watch feature double time-zone function, two-piece guilloché dial, stainless steel and 18K pink or yellow gold case.

BOTTOM
The Serpentine automatic watch with double rotor and 18K white gold case is named for its serpentine dial with 8 diamond-set hour markers.

BOTTOM LEFT
This limited Aurora edition is inspired by the early days of watchmaking with its magnificent dial in delicately guilloché silver or rose.

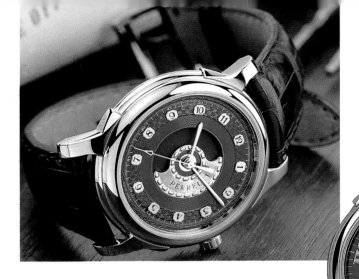

for Louis XVIII, Charles X and Louis-Phillipe, earning the epithet, "Watchmaker to the Kings of France." His son, Louis, carried on the vocation of master watchmaker and royal purveyor.

It was precisely this history and tradition of innovative excellence that inspired Dr. Flavio Audemars, an industrialist and keen watchmaking enthusiast, to present the initial collection of Perrelet S.A. in the spring of 1995. Working with Jean Perrelet, a descendent of the founder, Audemars has successfully re-ignited the fire of creativity which marks the Perrelet spirit. The best craftsmen in the profession collaborate in producing collections of which are distributed in Europe, Asia, the Middle East, Australia and the USA, with developing markets in South America and Russia, and France. Appearing in limited series, the Perrelet watch is completely handcrafted; the work on the strap requiring the same attention and detail as that of the mechanical parts. For Perrelet, design and beauty go hand in hand with complication and tradition.

Still employing the founder's techniques, the current watches feature remarkable inventions of their own. As well, in their names and functions, they pay tribute

to the pioneering spirit that marks the name Perrelet.

The Antarctica model, a self-winding watch with Perrelet's unique double rotor, named in honor of the great sea captain James Cook's three voyages into the Antarctic circle, has been produced in a limited series of 999 pieces. This year, commemorating the 270th anniversary of Abraham-Louis' birth, the world's first skeleton watch with a double rotor was launched. Revealing the full extent of

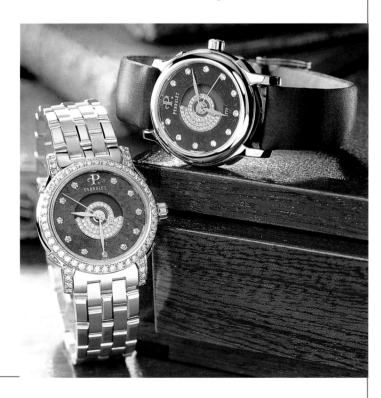

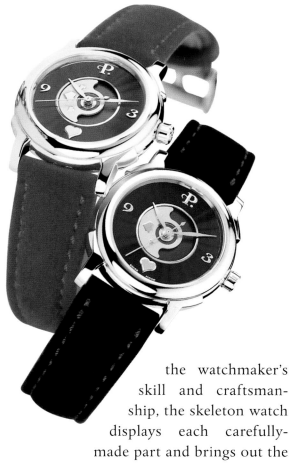

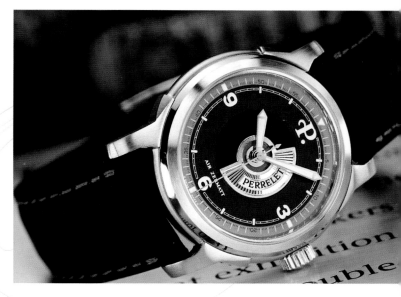

the watchmaker's skill and craftsmanship, the skeleton watch displays each carefully-made part and brings out the finesse of the gear-trains by taking the eye into the heart of the movement and the complexity of its mechanism. As well, the company has honored the home of Swiss horology by naming a new line "Le Locle." Featuring the trademark automatic mechanism and double rotor, this line captures the eye with its finely worked sunray guilloche dial and a visible 18k gold upper rotor.

Other complicated pieces include the Chronometer, COSC, produced in a limited series of only fifty pieces. Its blue openwork guilloche dial harmonizes with the blue precious stone in the center,

which replaces the traditional ruby for the first time. Another limited-edition line, the "Louis-Frederic Perrelet" split-seconds chronograph premiered in 1998. In a first ever accomplishment, 100 individually crafted watch faces, with distinct coloring and guilloche ornamentation, are each justifiably numbered "1." The split-seconds chronograph constitutes one of the five complications of the art of watchmaking, increasing the rarity and value of these pieces. The collection also includes ladies jewelry lines, and technical sports watches, the Air Zermatt line, designed and named for the crews of the official rescue organization of the Matterhorn in Switzerland. At present, new innovations on the working of the double rotor are underway, and shall undoubtedly spawn new lines notable for their excellence of design as well as inventive spirit, carrying Perrelet's tradition of innovation into the 21st century.

TAG HEUER

Internationally recognized as a leader in prestige sports watches, TAG Heuer is a legendary watchmaking house that has reached great heights with a philosophy dedicated to cutting-edge design, innovation and strategy focused on mental strength. Renowned for the accuracy and distinctive styling of its timepieces, TAG Heuer consistently breaks new ground in precision timekeeping devices. TAG Heuer's success stems from three important factors that have propelled it to the forefront of consumer demand : strong, well-defined product design; intense affiliation with sports events and acclaimed athletes; a leadership team that is dedicated to innovation and distinction. Anyone who thinks of sports and watches, in the same moment, thinks of TAG Heuer. The relationship between the brand and sports is a long one. In fact, from its inception in 1860, Heuer was dedicated to creating chronographs and sports instruments. Edouard Heuer directed his watchmaking efforts toward performance, and just about twenty years after the company was founded, Heuer obtained its first patent for improving the chronograph mechanism.

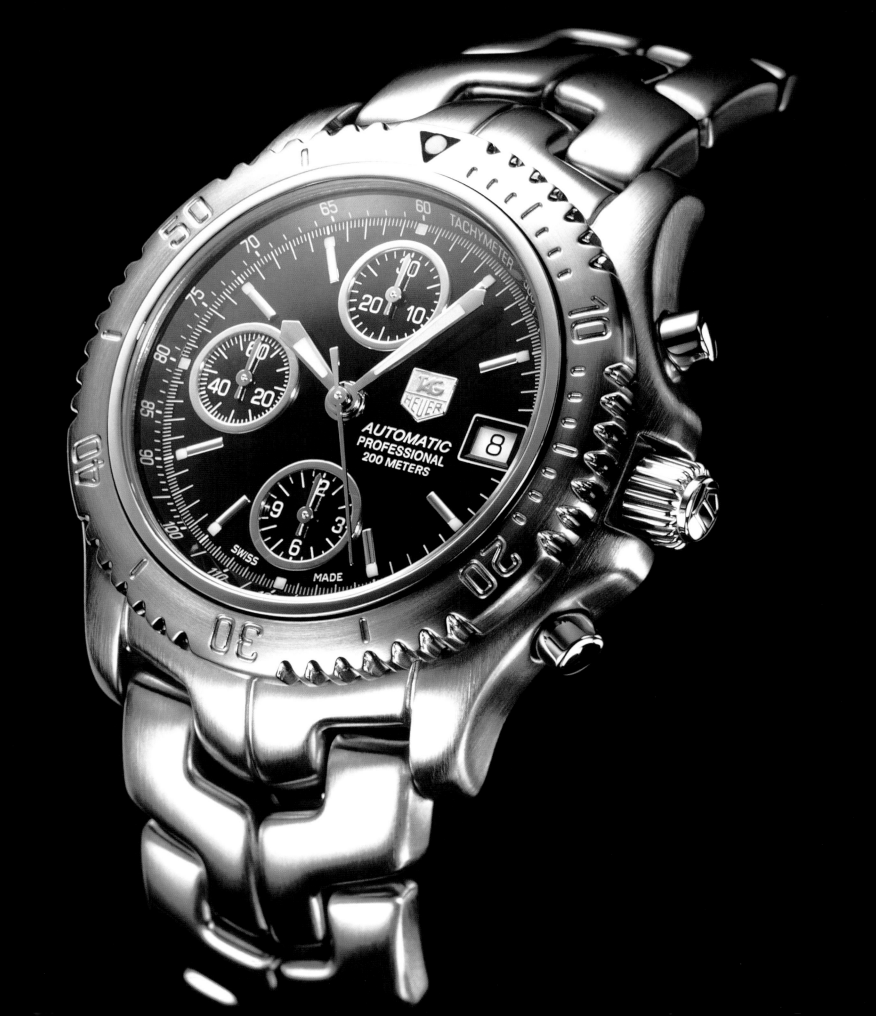

CENTER LEFT
Launched in 1916, the Micrograph, the first sport stopwatch capable of measuring 1/10ths of a second represented a milestone in watchmaking history and in the adventure of sport.

BOTTOM LEFT
Edouard Heuer was the first watchmaker to enter series production of chronographs.

BOTTOM RIGHT
The Heuer Monaco automatic chronograph, embodying a successful blend of tradition, innovation and original design, has earned its place among the great masterpieces in the history of Tag Heuer

Since then, the Heuer company has impressed the world with a number of "firsts" in timekeeping, including creating the first "MICROGRAPH" in 1916 that measured time to the nearest 1/100th of a second — for which Heuer also obtained a patent. What's more, this invention sparked a new dimension in sports. With such a high level of precision, athletes were no longer competing against one another, but also against their own times.

From the early Olympic Games in the 1920s, when Heuer was the Timekeeper, to modern day's Formula 1 races, TAG Heuer has remained intimately involved in sports events. It is a strong contender in the world of competitive sports in such fields as skiing, sailing and yachtracing — often acting as the official timekeeper of many events.

It was in 1985 that Heuer was acquired by the TAG Group (Techniques d'Avant-Garde) and the new management team stepped in to implement new product and marketing strategies that would attract the attention of upscale consumers around the world. It is this team that realigned the brand with the current sports events and athletes, and it was this team that refocused the TAG Heuer watch line as an instantly recognizable symbol of strength and self-expression.

Undeniably original, TAG Heuer has a personality and style that is uniquely its own. Its timepieces are designed to perform with the utmost accuracy under the most strenuous conditions, yet are elegant and distinctive enough to be worn on the most formal occasions.

■ HEUER'S EARLY YEARS IN THE FIELD 1969 HEUER MONACO RE-EDITION

First launched in 1969, the boldly avant-garde design of the Heuer Monaco chronograph made a lasting impression. In keeping with the spirit of technical innovation that has always been the driving force behind Heuer, the original Monaco of the time contained the famous "chronomatic" movement, the world's first automatic chronograph caliber. To this day, this movement represents one of the last remaining challenges of the mechanical watchmaking era, providing a level of precision almost equivalent to the exacting standards set for chronometers. The Heuer Monaco was also the first watch in the world with a water-resistant square case, constituting a feat in its own right. It was to become a very high-profile model worn on the wrists of many celebrities, including Steve McQueen in the film "Le Mans" (1970).

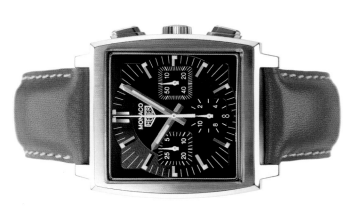

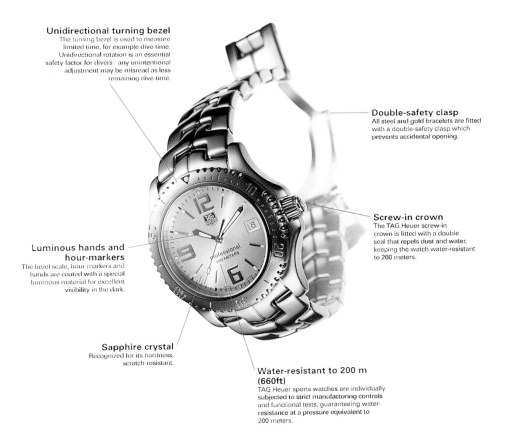

Unidirectional turning bezel
The turning bezel is used to measure limited time, for example dive-time. Unidirectional rotation is an essential safety factor for divers - any unintentional adjustment may be misread as less remaining dive-time.

Double-safety clasp
All steel and gold bracelets are fitted with a double-safety clasp which prevents accidental opening.

Screw-in crown
The TAG Heuer screw-in crown is fitted with a double seal that repels dust and water, keeping the watch water-resistant to 200 meters.

Luminous hands and hour-markers
The bezel scale, hour-markers and hands are coated with a special luminous material for excellent visibility in the dark.

Sapphire crystal
Recognized for its hardness, scratch-resistant.

Water-resistant to 200 m (660ft)
TAG Heuer sports watches are individually subjected to strict manufacturing controls and functional tests, guaranteeing water-resistance at a pressure equivalent to 200 meters.

■ PRODUCT Nearly every TAG Heuer timepiece encompasses six key features that the brand believes an authentic sports watch should possess. These six technical musts include: unidirectional turning bezel, water resistancy to at least 200 meters, luminous hands and markers, screw-in crown, sapphire crystal, and double-security clasp on bracelets.

TAG Heuer watches are submitted to encompromising quality control throughout the manufacturing process, and to more than 60 different precision, resistance and quality tests once completed. The firm exposes its watches to tension tests, chemicals and ultra violet lights via state of the art technology before deeming them capable up to its high standards.

Its top-of-the-line chronometers are individually certified by the Swiss C.O.S.C. (Contrôle Officiel Suisse des Chronomètres) as having achieved chronometer status only after undergoing 15 days of the most rigorous testing relating to performance when subjected to different gravity, pressure and temperature environments. Beyond its stringent standards of excellence, TAG Heuer creates its watches under the company creed that "Technology determines function. Function creates design." Modern designs, coupled with its regular use of high technology space-age materials reinforces its reputation for innovation. This company is a leader in modernism, both in its ideas and its product.

■ THE BRAND IS BUILT AROUND A CORE OF FOUR PRODUCT PILLARS INCLUDING THE 2000 AND 6000, THE KIRIUM LINE AND THE LINK.

The 2000 series, a major success for TAG Heuer, was recently relaunched. The sleek 2000 series is available in three subseries, including the 2000 Sport, 2000 Classic and 2000 Exclusive — each of which offers modern styling with classically simple appeal.

The LINK is one of TAG Heuer's hottest new watches. This suggestive timepiece offers fluid lines in a distinctive design. Inspired by the

ABOVE
The six technical characteristics of a true Sports Watch by Tag Heuer.

very popular S/EL bracelet (S-shape), which made a name for TAG Heuer, and designed by the same designer, Eddy Schöpfer. The LINK offers a daring spirit and is intended to become a key reference for the brand as it transitions into the new millennium. Considered the emblematic sports watch by TAG Heuer, the LINK features radical, daring style indicative of the brand.

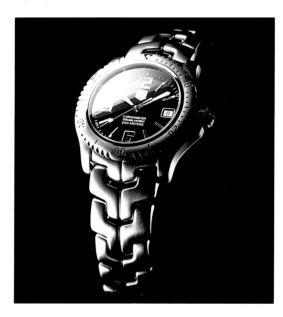

Kirium, the first entirely new collection of professional sports watches to be launched by the brand since 1992, was unveiled in 1997. Designed by world-renowned stylist Jorg Hysek, Kirium is the fruit of a two-year development process. A modern, avant-garde, ergonomically designed timepiece, the Kirium features harmonious lines and a perfectly integrated watch and bracelet design. The links in its worldwide patented metal bracelet allow a revolutionary pattern that is designed avoid any overlap and will not pull hair on the wearer's wrist. It creates a perfect blend of rigidity and flexibility.

Recently TAG Heuer unveiled the newest timepiece in its Kirium line. Leaping into the high-tech realm with vigor is the unique Kirium Ti5. The case of this rugged, durable timepiece is

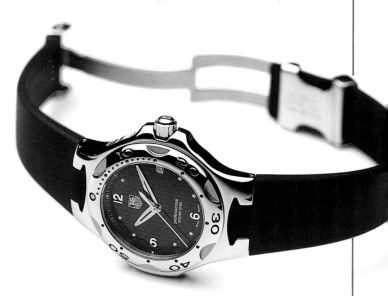

crafted in polished grade 5 titanium — the material of choice for space exploration, high-tech surgery and robotics. The Ti5 is deftly combined with other cutting-edge materials, including a carbon fiber dial and a rubber strap, for an overall futuristic statement of endurance.

■ THE 6000 CHRONOGRAPH

series of stainless steel and 18-karat gold chronograph watches with strap or bracelet is water resistant to 660 feet. The bracelet is an innovative

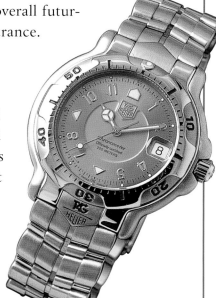

design that features more than 200 hand-finished parts to ensure a soft, supple yet secure fit. There is a tachometer scale on the dial flange (to enable speed calculations); the dials are hand detailed, and the crystals feature an anti-reflection treatment on the inside to allow for perfect readability.

Aside from its innovative product lines, TAG-Heuer chooses to use the arena it supports with these products and sponsorships as the inspiration for its daring, thought-provoking advertising campaigns. First with its "Don't crack under pressure" campaign, then with "Success its a mind game," TAG Heuer has gained international acclaim for its marketing savvy.

Even when TAG Heuer introduced its Kirium watch line, it did so with a gusto that had people around the world talking. TAG-Heuer commissioned world famous photographer Herb Ritts to photograph 13 world-class athletes in the nude — their bodies to be used as metaphors for the clean lines of the watches. Among the athletes photographed for an exhibit that accompanied the launch of the collection were German tennis superstar Boris Becker, America's swimmer, Amy Van Dyken who won four gold medals in the 1996 Olympic Games, decathlete Dan O'Brien, and the United Kingdom's Formula 1 driver, David Coulthard.

TAG Heuer's last ad campaign, Inner Strength, provides a platform for the brand to talk with authority on sports, and particularly the human emotions it demands and inspires. The campaign assembles an international team of athletes to act as brand ambassadors, each of whom shares his or her perspective of what "Inner Strength" is, and how it plays into their overall formula for success. This team consists of eleven athletes, including Grant Hill, Boris Becker, Marion Jones, Barrett Christy and Hakkinen. Each ad also explains what is behind the "inner strength" of a TAG Heuer watch, neatly stating that "TAG Heuer watches are subjected to a program of over 60 different chemical, mechanical and atmospheric tests which exceed industry standards."

With all of this focus on inner self, individuality, classical modernism and innovation, it's no wonder TAG Heuer has grown to a leadership position in the Swiss watch industry, holding rank as the fifth largest watch manufacturer.

VERSACE

Sleek and sophisticated, with inspired touches of boldness and daring. That is the spirit of Versace's new collection of timepieces, which mark an evolution in style since the designer first presented its watches ten years ago. The new collection acknowledges the dawning of the third millennium while carrying on the heritage of classical aesthetics and mythological allusion standard to the House. Promising its wearer a commitment to functionality, the collection at the same time telegraphs the desire to please, while issuing a challenge with seductive audacity. The Millennium watch perhaps best captures this infusion of new energy of the House of Versace, while boasting the exquisite details that are now signature. A shimmer of diamonds gleam from the polished, steel design, at once captivating with its dazzling sophistication, and subtly revealing the Greca frieze adorning the bezel. And the Pink Millennium watch is outstandingly feminine, crafted entirely in rubies. The celebratory timepieces are the crowning glory of the new "Greca" line of watches, whose steel structure inspires as a sleek foundation for countless stylish vantages. Adorned with vivid

PREVIOUS PAGE

The Millennium and "Greca" watches are distinguished creations of unique brilliance with a lustrous steel plate or underscored with diamonds.

TOP LEFT

Colors abound, these bold and dazzling Millennium watches represent the long-standing commitment to personal expression of style.

TOP RIGHT

Gianni Versace.

BOTTOM

From the Fifth collection, this 20-micron gold plated watch brims with ingenuity. The curved and contemporary metallic edges contrast with the oval hour circle within.

stones of bright yellow, green and orange the "Greca" watch becomes a brilliant accessory of eye-catching significance.

Embracing the future with steadfast dedication to the Versace style; this direction is not new to the House of Versace, having been instilled with Gianni Versace's first collection for women just over two decades ago at a history making show at the Palazzo della Permanente in Milan. It is now under the direction of Donatella Versace that the fashion empire grows forward. Yet the story of Gianni's career continues to be told in the details of each item produced at the House of Versace, including the timepiece. Legend has it that Gianni began by making costumes for puppets out of the scraps he gathered in his mother's dress shop in Reggio Calabria, Italy. His sister Donatella was even then his confidante and playmate. In 1972, at the age of 25, Gianni moved to Milan to embark upon his career as a fashion designer. Within six short years, he was able to launch his first signed collection. By 1982, he had garnered "L'Occhio d'Oro," the first of a series of awards that crowned his career. In the winning collection of 1982/83 Fall/Winter collection for women, he premiered the famous metal

garments, which are now a classic feature of his fashion.

In the same year, he began a collaboration with the Teatro alla Scala, designing costumes for productions of ballet and opera; work which testifies Versace's influence as an artist as well as a leader in the world of fashion. For the launching of the fragrance for men, "Versace l'Homme," the Belgian choreographer and longtime collaborator, Maurice Bejart, created a triptych dance performed at the Piccolo Teatro di Milano. The marriage between forms of fashion and forms of

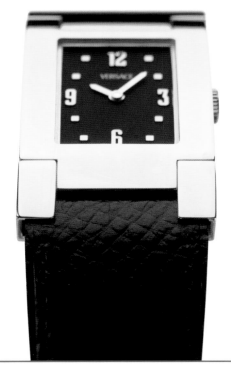

TOP

Versace Fifth Avenue models brim with ingenuity, eluding conformity through asymmetric design with the Grecian frieze encasing the curved and contemporary metallic edges.

CENTER

The Fifth models, available in steel or 20-micron gold plate and black or brown strap, feature a rectangular case that is engraved on the sides with the signature Grecian frieze.

BOTTOM RIGHT

The Fifth model in steel with black goatskin strap.

BOTTOM LEFT

The Millennium watch in diamonds is made for those who recognize style, distinction and character.

art continued with an art show organized in Paris, 1985, bringing internationally renowned artists for the European presentation of the fragrance. His vision ranged many disciplines, incorporating the influence of close friends like Elton John, Madonna, Princess Diana, and Richard Avedon. In the remaining 17 years of his life, Gianni Versace's huge achievements amounted to a legacy of epic proportions. He published books, created "Home Signature," a line of ceramics and products for the home, was the subject of major museum exhibitions (includ-ing a show at the Metropolitan Museum of Art in New York City which was followed by a posthumous retrospective of both his fashion work and costume designs), inaugurated the gala "Rock 'N Rule" charity supporting the Amfar Anti-AIDS Association, and all the while worked with top fashion houses creating new lines, fragrances, and opening opulent boutiques in the fashion centers of the world.

The legacy he created and which continues on today does not indulge in trends. The Versace look bespeaks a vision unafraid of either the old or the avant-garde, in a spirit completely its own. In the new collection of watches, this

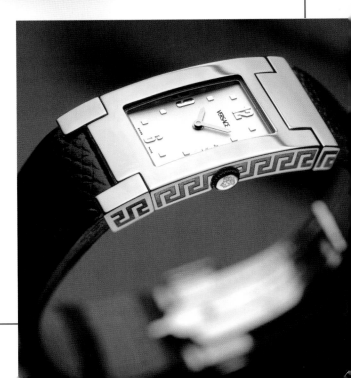

TOP

Greca, decidedly feminine, owes its name to the Grecian frieze, the signature so dear to Versace, engraved on this model into the gently curving sides of the watch and bracelet.

BOTTOM

The Greca with its rectangular case is perfectly aligned with links to form a semi-rigid band designed to be worn like a bracelet.

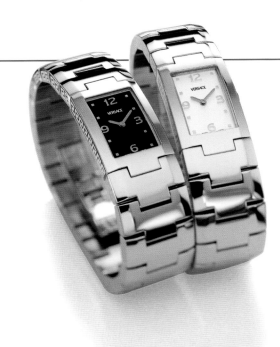

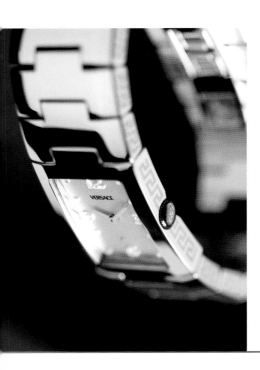

spirit is evident in the sharp contours, smooth surfaces, and a refined adornment saved for the Versace signature. They are distinguished by their asymmetry, the Medusa brand symbol on the crown, and the Greek friezes and metallic inserts. All models are water resistant to 30 meters, with Swiss-made movements.

The "Fifth" line inspires the wearer with its decidedly androgynous and elusive style that raises great pique. Available in ladies' or men's models, its rectangular cambered steel or gold micron case is cut away at 12 o'clock, making room for the T-shaped attachment, and then extended at 6 o'clock to ease between the horns. At the heart of its straight lines, the black or silvered dials create an oval hour circle. The numerals are rendered in Arabic numerals, and a Greek frieze decorates the subtly curved edges of the case. Cross-grained goatskin straps in brown or black complete the look.

For men who embrace an active lifestyle, the "Madison" line features classical lines with a sporty presence. Its easy to read matte black dial, the most technical in the collection, with recessed small seconds at 6 o'clock, places functionality literally in the center. This emphasis is

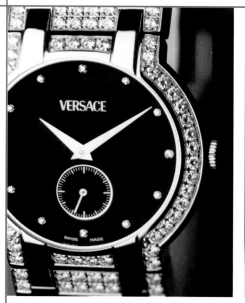

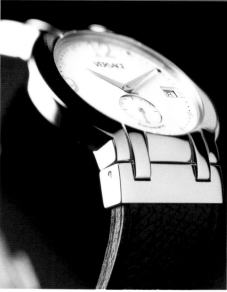

underlined by the round case in steel or solid gold, and given volume by the wide bezel and the metal inserts that flow into the black or brown leather strap. In this piece, the Medusa brand symbol etched onto the crown works as a quiet assertion of the power operating just beneath the forms of function.

Designed to be worn a little loosely, like a real bracelet, the "Greca" model adorns a woman's wrist without equivocating on its or her formidable presence. Named for the Greek frieze so dear to Versace, which is engraved on the curved sides of the watch and the bracelet, the "Greca" is delicacy of line rendered in the strength of polished steel. The semi-rigid band moves with the wearer, illuminating her actions with the glow of its surface and the facets of the precious stones on the case and bezel of the diamond-set versions. With

faceted hands, pyramidal hour markers, and Arabic numerals, this is a timepiece as functional as it is disturbingly feminine.

When a man or woman wears a timepiece from this collection, there is never any doubt about what time it is: it is their time.

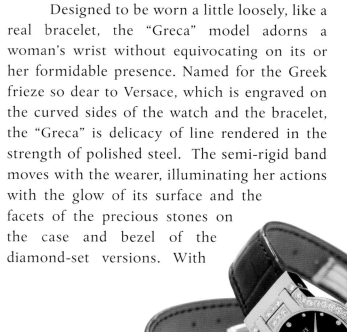

Photo Credits

Front and back cover, Longines; Front and back flap, Longines; Title Page, Girard Perregaux; p.**2**, Chopard; p.**4**, Chopard; p.**5**, Chopard; p.**7**, deGrisogono; p.**9**, Bedat & Co.; p.**11**, Breitling; p.**13**, Boucheron; p.**15**, Bedat & Co.; p.**17**, Longines; p.**19**, Concord; p.**21**, Patek Philippe.

CHAPTER **1**: LUXURY & TECHNOLOGY p.**2**, Girard Perregaux; p.**23**, Girard Perregaux; p.**24**, Patek Philippe; p.**25**, Boucheron, Patek Philippe, Vacheron Constantin; p.**26**, Patek Philippe, Van Cleef & Arpels, Chanel; p.**27**, Cartier, Longines; p.**28**, Chopard, Sacar, Hublot; p.**29**, Jacquet Droz, Paul Picot, Hublot; p.**30**, Boucheron; p.**31**, Chopard, Roger DuBuis, Daniel Roth; p.**32**, Girard Perregaux, Piaget, Boucheron, Cartier; p.**33**, Henry Dunay, Van Cleef & Arpels, Patek Philippe; p.**34**, Concord, Audemars Piguet, Delaneau; p.**35**, Boucheron, Clerc, Omega, Chaumet; p.**36**, Clerc, Philippe Charriol, Franck Muller, Paul Picot; p.**37**, Piaget, Parmigiani Fleurier; p.**38**, Longines, Girard Perregaux; p.**39**, Audemars Piguet, Breguet, Piaget, Girard Perregaux; p.**40**, Omega, Ulysse Nardin, Girard Perregaux, Jacquet Droz; p.**41**, Chronoswiss, Perrelet, Breguet, Girard Perregaux; p.**42**, Daniel Roth, Chronoswiss, Kelek, Chopard; p.**43**, Omega, Piaget, Parmigiani Fleurier, Blancpain; p.**44**, Breguet, Blancpain; p.**45**, Daniel Roth, Jaeger Lecoultre, IWC, Audemars Piguet; p.**46**, Breguet, Audemars Piguet, IWC; p.**47**, Franck Muller, Girard Perregaux, IWC; p.**48**, Blancpain, Audemars Piguet; p.**49**, Concord, Patek Philippe, Breguet; p.**50**, Parmigiani Fleurier, Kelek, Piaget; p.**51**, Daniel Roth, Girard Perregaux, Audemars Piguet; p.**52**, Kelek, Longines; p.**53**, Jaeger Lecoultre, Breitling; p.**54**, Oris, Omega, Patek Philippe, Parmigiani Fleurier; p.**55**, Omega, Chopard, Roger DuBuis; p.**56**, Paul Picot, Daniel Jean-Richard, Longines; p.**57**, Longines, Baume & Mercier, Hamilton, Paul Picot; p.**58**, Girard Perregaux, Daniel JeanRichard, Franck Muller, Kelek; p.**59**, Philippe Charriol, TAG Heuer, Audemars Piguet, Krieger; p.**60**, Bedat & Co., Breitling, Chopard; p.**61**, Clerc, Concord, Chaumet, Van Cleef & Arpels; p.**62**, Chopard, Ulysse Nardin; p.**63**, Chopard, Breguet, Perrelet, Paul Picot, Panerai; p.**64**, Omega, Breguet, TAG Heuer, Vacheron Constantin; p.**65**, Breitling, Krieger; p.**66**, Jaeger Lecoultre, Franck Muller; p.**67**, Hamilton, Girard Perregaux, Gerald Genta, Ebel; p.**68**, Delaneau, Longines; p.**69**, Bedat & Co., Daniel Roth, Corum, Girard Perregaux; p.**70**, Breitling, Omega; p.**71**, Audemars Piguet.

CHAPTER **2** DESIGN & FASHION p.**72**, Versace; p.**73**, Versace; p.**74**, Boucheron, Cartier; p.**75**, Fred, Chaumet, Versace;

p.**76**, Piaget, Chaumet, Audemars Piguet, Fred, Movado; p.**77**, Movado, Boucheron, Chopard; p.**78**, Chopard, Movado, Piaget; p.**79**, Chopard, Boucheron; p.**80**, Chanel; p.**81**, Christian Dior, Fred, Coach; p.**82**, Chanel, Hermès; p.**83**, Hermès, Christian Dior, Calvin Klein; p.**84**, Versace; p.**85**, Versace; p.**86**, Swatch, Alfred Dunhill, Breitling, Coach; p.**87**, Chanel.

CHAPTER **3**: FUTURE MASTERPIECES p.**88**, Chopard; p.**89**, Chopard; p.**90**, Kelek; p.**91**, Rolex, Audemars Piguet, Krieger; p.**92**, Bertolucci, Omega; p.**93**, TAG Heuer, Tutima Pacific, Externa, Bell & Ross; p.**94**, IWC, Krieger, Oris, Breitling; p.**95**, Panerai, Ebel, Bell & Ross, TAG Heuer; p.**96**, Revue Thommen, Longines, Breitling; p.**97**, Blancpain, Fortis, Revue Thommen; p.**98**, Revue Thommen, Omega, Bell & Ross, Universal Genève; p.**99**, Oris, Omega, Tutima; p.**100**, Versace; p.**101**, Chopard, Cartier; p.**102**, Parmigiani Fleurier, Frank Muller, IWC; p.**103**, Girard Perregaux, de Grisogono, Cedric Johner; p.**104**, Chronoswiss, Frank Muller; p.**105**, Perrelet, Paul Picot, Jacquet Droz, Sauer; p.**106**, Daniel Roth, TAG Heuer, Baume & Mercier; p.**107**, Bulgari, Chopard, Audemars Piguet; p.**108**, Rado, Eterna, Movado, Breitling, Bulgari; p.**109**, Girard Perregaux, Daniel Roth, Eterna, Xemex; p.**110**, Bedat & Co., Movado, Versace, Chaumet, Boucheron; p.**111**, Movado, TAG Heuer, Patek Philippe, Hublot; p.**112**, Concord; p.**113**, Daniel JeanRichard, Clerc, Delaneau, Patek Philippe; p.**114**, Vacheron Constantin, Movado, Philippe Charriol; p.**115**, Perrelet, Ventura, Jean d, Eve, Longines; p.**116**, A. Lange & Sohne, Jorg Hysek, Frank Muller; p.**117**, Xemex, Ventura, Ikepod, Chaumet; p.**118**, Longines, TAG Heuer, Rado, Chopard; p.**119**, Movado, Bunz, Zodiac, Movado.

120, 121. **Audemars Piguet** 122, 123, 124, 125, 126, 127. **Bedat & Co.** 128, 129, 130, 131, 132, 133, 134, 135. **Boucheron** 136, 137, 138, 139, 140, 141. **Breitling** 142, 143, 144, 145, 146, 147, 148, 149. **Chopard** 150, 151, 152, 153, 154, 155 ,156, 157. **Clerc** 158, 159, 160, 161, 162, 163. **Concord** 164, 165, 166, 167, 168, 169. **Daniel JeanRichard** 170, 171, 172, 173, 174, 175. **de Grisogono** 176, 177, 178, 179, 180, 181. **Girard Perregaux** 182, 183, 184, 185, 186, 187, 188, 189. **Kelek** 190, 191, 192, 193, 194 ,195. **Longines** 196, 197, 198, 199, 200, 201, 202, 203. **Movado** 204, 205, 206, 207, 208, 209. **Parmigiani** 210, 211, 212, 213, 214, 215. Paul Picot 216, 217, 218, 219, 220, 221. **Perrelet** 222, 223, 224, 225, 226, 227. **TAG Heuer** 228, 229, 230, 231, 232, 233. **Versace** 234, 235, 236, 237, 238, 239. Photo Credits, TAG Heuer 242, 243. Bibliograqphy, Boucheron 240, 241.

Bibliography

Audemars Piguet. *Masterpieces of Classical Watchmaking*. Gisbert Brunner, Christina Pfeiffer-Belli, Martin K. Wehrli Audemars Piguet, 1993

Boucheron. *The Jeweller of Time*. Gilles Neret/ Office du Livre Rizzoli, 1994

Breguet. *Watchmakers Since 1775*. Emannuel Breguet Paris:Alain de Gourvuff, editeur, 1997

Breitling. *The History of a Great Brand of Watches*. Benno Richter Atglen, PA: Schiffer Publishing, Ltd., 1995

Bulgari. Daniella Mascetti and Amanda Triossi Leonardo Arte, 1996

Chaumet. *Master Jewellers since 1780*. Diana Scarisbrick Alain de Gourcuff Editeur, 1995

Chaumet. *Two Centuries of Fine Jewelry*. Roselyn Flurel, Amanda Triossi Paris Musee, Musee Carnavalet, 1998

Chronograph Wristwatches to Stop Time. Gerd-R Lang, Reimhard Meis Atglen, PA: Schiffer Publishing, Ltd., 1993

IWC. *International Watch Co.*, Schaffhausen Hans F. Tolke, Jurgen King Zurich, Switzerland: Verlag Ine-ichen, 1987

Le Temps de Cartier. Jader Barraca, Gimapiero Negretti, Franco Nencici Wrist International S.r.l., 1989

Mastering Time. Gisbert L. Brunner, Marc Sich Paris, France: Editions Assouline, 1997

Patek Phillipe. Geneve Martin Huber, Alan Banberry in collaboration with Gisbert L. Brunner Antiquorum, 1988

Piaget Watches and Wonders. Franco Cologni, Gimapiero Negertti, Franco Nencini Abbeville Press Publishers, 1994

Platinum by Cartier. Triumphs of the Jewelers, Franco Cologni, Eric Nussbaum Harry N. Abrams, Inc., Publishers, 1995

Reverso. *The Living Legend*. Manfred Fritz Jaeger-Le Coultre. Edition Braus, 1992

The Chronograph; Its Mechanism and Repair. B. Humbert La Conversion (Switzerland) Editions Scriptar S.A., 1990

The Movado History. Fritz von Osterhausen Atglen, PA: Schiffer Publishing, Ltd., 1996

The World of Vacheron Constantin. Geneve Carole Lembelet, Lorette Coen Scriptar SA/Vacheron Constantin Geneve, 1992

Van Cleef & Arpels. Paris Musée Palais Galiera, 1992

Wristwatch Chronometers. Fritz von Osterhausen Atglen, PA: Schiffer Publishing, Ltd., 1997

THÉOPS, 2000 BC

LE LOUVRE, 2000 AD

RIGHT
The UNESCO World Heritage watch is a rare object in two series. One series of 23 watches in platinum represents, with engravings on the caseback, 23 of 582 endangered natural sites that are listed on the World Heritage list. The second series in yellow gold consists of 200 watches representing 5 exceptionally endangered sites: Angkor, Everglades, St. Sophie, Alhambra and Abou-Simbel.

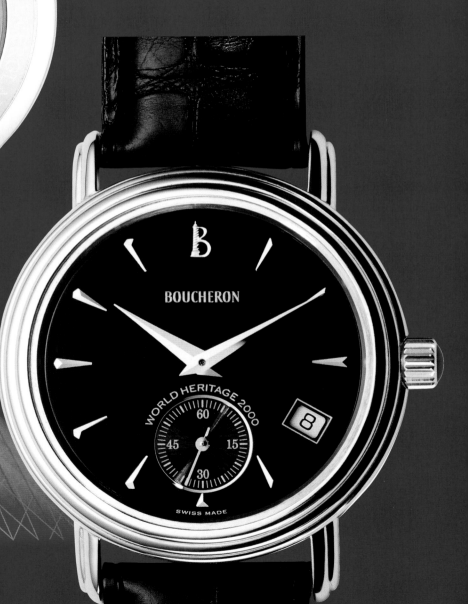